the amazing world of

carmine ⚡ infantino

an autobiography

the amazing world of

vanguard productions, lebanon, new jersey

Infantino

an autobiography

compiled & edited by j. david spurlock

design & production by jon b. cooke

color section written & designed by arlen schumer

the amazing world of carmine infantino: an autobiography

Transcriptions by Jon B. Knutson • Interviews conducted by J. David Spurlock and Jon B. Cooke • Photography by Marc Witz

Special Thanks to: Neal Adams, Terry Austin, Dennis Calero, Nick Cardy, Mark Chiarello, John Coates, Shel Dorf, Arnold Drake, William Gaines, Mark Hanerfeld, Irwin Hasen, Tom Horvitz, Michael W. Kaluta, Robert Kanigher, Patrick M. Kochanek, M.D., Joe Kubert, Stan Lee, Paul Levitz, Joe & Nadia Mannarino, Sheldon Mayer, Nick Meglin, Allen Milgrom, Joe Orlando, Jeff Rovin, Julie Schwartz, Bill Sienkiewicz, Joe Simon, Walter Simonson, Steranko, Roy Thomas, Sam Viviano, Mark Waid, James Warren, and Bernie Wrightson.

Published by Vanguard Productions, 59-A Philhower Rd., Lebanon NJ 08833. Second printing April 2001.

Hardcover ISBN 1-887591-11-7. Trade softcover ISBN 1-887591-12-5.

Printed in China

Table of Contents

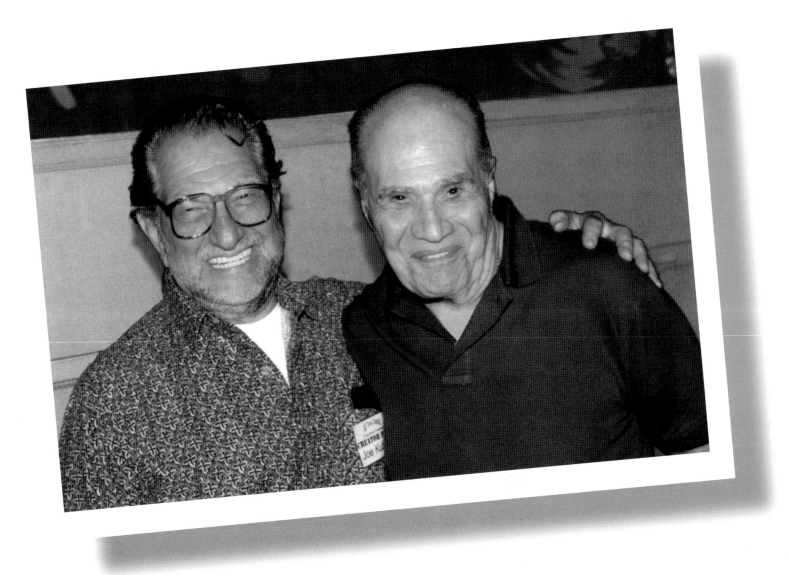

Joe Kubert with Infantino
White Plains, New York
June 10th, 2000

Introduction by Joe Kubert

How do you describe a friendship that has extended for over fifty years, and then use the description as an introduction to a book containing your friend's work?

Carmine and I met when we started at All-American Comics back in the 1940s. Shelly Mayer was our editor. Carmine was penciling The Flash and Frank Giacoia was inking his pencils. I remember driving up to Toronto for a weekend with Carmine and Joe Giella. We got caught in a snowstorm, which kept us in Canada for two or three days more than we'd planned. The delay played havoc with our deadlines, but we survived the storm and our editor's remonstrations.

In the '50s, Carmine and I did a Western together, *Jesse James*. Carmine took two days to pencil the book. He says I inked his pencils in one day. I don't remember, but I'll take his word for it. Carmine's pencils have always made the inker look good. His pencils are complete and detailed. He leaves no doubt about basic construction, anatomy, foreshortening, or perspective. His use of negative space has been a lesson in balance for his contemporaries.

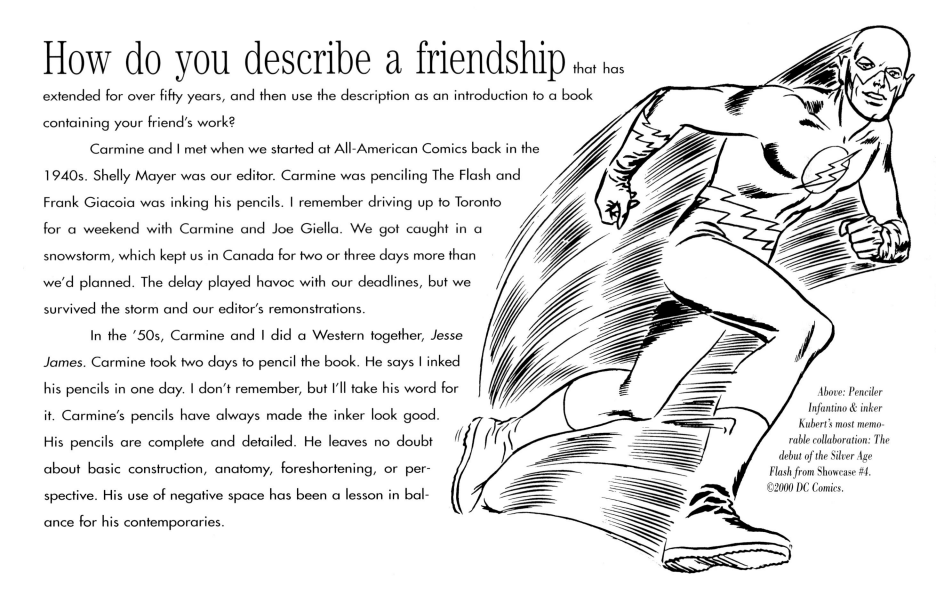

Above: Penciler Infantino & inker Kubert's most memorable collaboration: The debut of the Silver Age Flash from Showcase #4. ©2000 DC Comics.

9

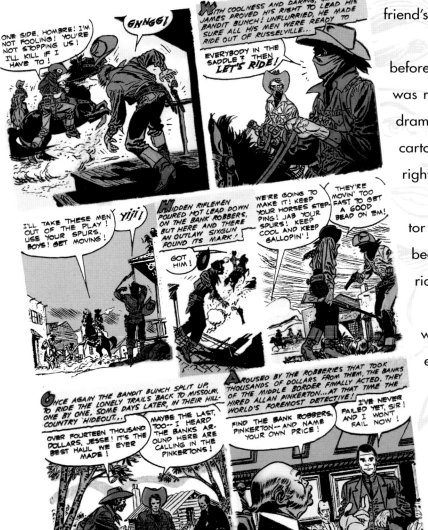

Years later, Julius Schwartz — our esteemed editor — coupled us in doing the revival of The Flash. It was then that I came to fully appreciate my friend's artistic abilities.

It's difficult to really assess Carmine's pencil work, unless you see it before it's inked. His pencils for The Flash were impressive. His eye for design was remarkable. He used panel variations to increase the momentum and dramatics, never forgetting that clarity of storytelling is paramount to the cartoonist and the reader. Facial expressions and characterization were right on the mark, adding to the story's credibility.

In the 1970s, when Carmine took on the mantle of editorial director and publisher of DC Comics, he asked me if I'd be interested in becoming editor of the war book titles. I was and I did. Part of my editorial responsibilities extended to doing the covers for the books I edited.

Carmine and I would discuss the subject matter, after which he would sketch his layout ideas. The guy had an eye. With those sketches as guides, my job became simpler and much more rewarding.

Carmine is one of the most conscientious artists I've ever known. He'll tell you, "There's no easy way or hard way to do a drawing. There's only the *right* way."

And, y'know what? He's right.

Joe Kubert has worked in the comics field for over sixty years—since the age of 11!—and is widely considered to be an international master of the art form. Renowned for his exceptional artwork on the Golden & Silver Age Hawkmen, Tor, Sgt. Rock, Enemy Ace, Tales of the Green Berets, Firehair, Tarzan, and many other strips, Joe also runs the lauded Joe Kubert School of Cartoon and Graphic Art in Dover, N.J. A lifelong friend of Carmine's, Joe's recent graphic album is Fax from Sarajevo.

Preface

In his unprecedented 60-year career, Carmine Infantino has practiced nearly every job there is in the field of comic books for a Who's Who list of publishers. As a young freelance artist, he contributed to The Golden Age of Comics with his memorable renditions of Green Lantern, Flash, Airboy, The Heap, and Black Canary. But there is no doubt Carmine will always be remembered as the personification of The Silver Age of DC Comics. His definitive contributions of The Flash, Batman, Adam Strange, Batgirl, and The Elongated Man are but a few of a very long list of Carmine's accomplishments.

The story that follows is Infantino's own personal history of American comics, with the artist sharing his experiences during the industry's primordial Golden Age beginnings, through his 1950s and '60s achievements as a premier artist, his reign as innovative Editorial Director and eventual Publisher of DC Comics (leading the company into its most creative era), and up to his freelancing years including animation work, teaching, his return as a top artist to DC, and the *Batman* newspaper strip. A living embodiment of American comic book history, ladies and gentlemen, I give you, Carmine Infantino!

—*J. David Spurlock*

Background image: The Justice League of America penciled by Carmine, inked by Murphy Anderson. Commission piece. ©2000 DC Comics.

One: Formative Years

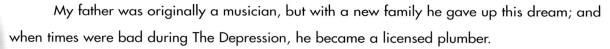

I was born on May 24, 1925, in an apartment in the east sector of Brooklyn, New York. A midwife who had come to the house delivered me. I lived in that apartment until I was three years old, when we moved to 359 Central Avenue.

My father was originally a musician, but with a new family he gave up this dream; and when times were bad during The Depression, he became a licensed plumber.

My mother was born in Italy. My paternal grandfather was from a little town just north of Naples and migrated to America. My father was born in New York. My father was a great student; then his mother died when he was 18, and there were six children, so as the oldest, he had to stop school and work. He went out and got odd jobs, just to keep the family fed, getting whatever money he could get. Those were tough times.

The neighborhood I grew up in was mixed. There were a lot of Jewish, Italian, some black families, and some Irish. We all knew each other pretty well. It was really a Lower East Side-type mix, but this was Brooklyn. It was a rough neighborhood with a sprinkling of hoodlums. It was an interesting group.

As I was growing up, I wasn't sure what I was going to do for a career. But it was my uncle who first saw my drawing abilities and encouraged me in that direction. I had been doing my imitation of *Little Orphan Annie* when he showed my drawings to my father and said, "Have you seen what your son is doing?" But my father was too busy looking for work. Some weeks my father would work 60 hours, other weeks there was no work at all — it was a very sad time. To help out during these ter-

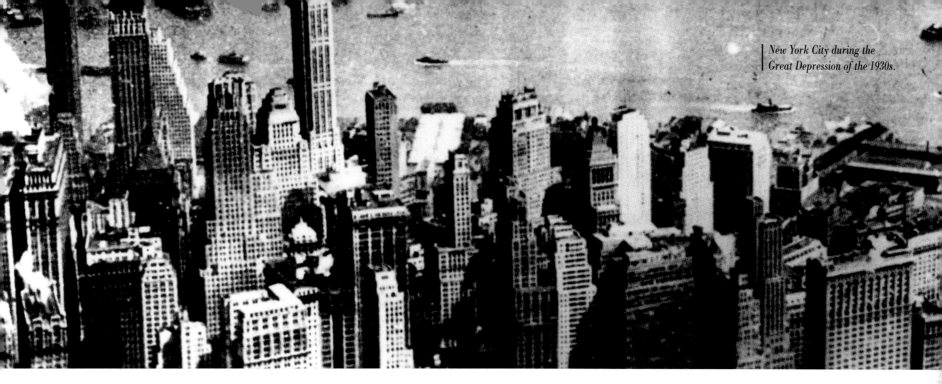

rible days, I would take on odd jobs around the neighborhood. My grandfather ran a shoeshine stand, so I'd shine shoes and make a couple of bucks to help the family out. We lived in a three-room cold water flat — four people in three rooms — and the community bathroom was down the hall. My grandfather owned the tenement, with his shoeshine business on the ground floor. We lived on the third floor with the uncle who'd encouraged me to draw. My grandfather was not a good landlord. Sometimes we didn't have the $18 a month rent to pay, and he would get quite nasty about it.

My father's name was Pasquali Infantino (though later he changed it to Patrick). He taught himself the sax, clarinet, and violin. He had an orchestra with a man named Harry Warren (who became a famous songwriter). My father worked days and played music at night. My mother complained of being alone, so he gave up his dream.

Below: Carmine's father, Pasquali Infantino, 1919.

My parents were married in 1923 or '24. My brother James was born seven years after me in 1932. While the Infantino family wasn't renowned for creativity, my father did have a cousin who was deaf and dumb, but painted brilliantly. He couldn't speak, but he composed these beautiful paintings! My father was a musician. My brother Jimmy, who recently passed away, was a very talented advertising agency art director. One of Jimmy's sons,

13

John Infantino, is an artist and writer who has sold a show to VH1, and my other nephew, Jim Infantino, is a fine musician and composer who lives up in Boston. So maybe you can see the talent in the genes.

When my father was playing with his band, they would perform on the ballroom circuit. Now, I was too young to watch them play, of course, but he would tell me this story of performing before a group of deaf mutes! I'd say, "What the hell were they doing there?" He said, "Even though they can't *hear* the music, they can *feel* the beat, so they dance!" My mother said it was pretty eerie: The whole place is silent but all these people dancing… very strange.

After he left the band, Pop would occasionally play music at home. Every once in a while he'd sit by the window and play his saxophone, very mournfully. He missed playing with the band a lot. He never said anything, but I know he missed it. One day he stopped playing, permanently. Some days when I feel down I almost hear that sad sax playing in the distance.

My father was a very quiet guy, and he never spoke much. In those days, with the Depression, there just wasn't much work to go around. My father tried hard just to make a couple of bucks, and remember: He had two kids and a wife, so he worried all the time. There was just no money, and he was desperate. I remember, one Christmas, my parents had to wait for me to come home and to get the few meager pennies I made working at the food store to go get Christmas dinner. Those were dark days. Then, of course, life got better slowly. I went to school, but one of my uncles was dead-set against my going to an art school.

My mother's maiden name was Rose Dellabadia. Her family shortened the last name to Badia, dropping the "Della" part. She was one of six children. Her father was first to come to America, and then he brought the children over, one at a time. But in those days, the kids would have to work in factories. Parents took their kids out of school at 12 or 13 years old. It was a matter of fact

Right: Little Orphan Annie by Harold Grey was an important influence on young Carmine. ©2000 News Syndicate Co, Inc. Background: The Brooklyn Bridge in the early-'40s, linking Carmine's city to the Big Apple, home of the U.S. comics industry.

EXTRA!

that you'd work in the factory if you were a kid. There were no laws to prevent it.

My mother worked as a seamstress in a factory, making men's pants (I would stay with my grandmother). She got so much for every pair of pants she made. But I never saw her at work because she never wanted us there. The factory was right around the corner. We lived on Central Avenue in Brooklyn. That building is gone... it's just a hole in the ground now.

Even though we slowly started lifting ourselves out of the Depression, my mother didn't want to stop working. So my grandmother raised me. My mother liked getting out of the house and she got to see friends at work, but we forced her to stop, and I'm sorry we did. But times were getting better, things were picking up, and Pop went into business with some friends of his, and they started making some money. We moved from there to a house at 82 Pametto Street in Brooklyn. It was an old beat-up house; my father bought and rebuilt. He was good at that.

When I was a kid, I went to work for my uncle delivering groceries, to help the family out. We'd get up at four in the morning, and we'd go down to the market, buy things, and then deliver them. It was rough, but it helps you grow — at the time I just thought it was rough. I attended grade school PS 75 and junior high school PS 85.

As a kid, I started drawing Dick Tracy's head, Orphan Annie's face, from the comic strips. I really enjoyed it. My father thought I was tracing; he couldn't believe I had drawn these things. Harold Gray and Chester Gould were major early influences on me. That's what started me toward comics. I also liked films.

I went a couple of times to the 1939 World's Fair, which was lovely. What intrigued me most was the General Motors display, The World of Tomorrow. It was incredible. They built a whole city of the future, cars were flying through the air, and giant spires were on all the buildings. It made me want to be an architect.

I wanted to be Frank Lloyd Wright! Whenever I saw anything of his, I would jump into it. But you had to go to college to become an architect! You had to study engineering, but there was no way I could do that during the Depression. Yet architecture was my true desire, so I drew my buildings in comics! That was my burning passion. I enjoyed designing the buildings. The School of Industrial Arts was a public school. I wanted to go there.

Another seminal influence: Dick Tracy by Chester Gould. ©2000 Tribune Media Services.

15

Two: Breaking Into Comics

School of Industrial Arts.

When I pleaded with my parents to allow me to go to the School of Industrial Arts, they finally relented. (Today the institution is called the School of Art and Design.) It was there I met Frank Giacoia. We were drawn to each other because of our mutual desire to draw comics.

Frank and I would each get a quarter a day for lunch and the subway, and we'd buy a comic book for a dime and share a single 15¢ meal of eggs and french fries. Some days we'd get crazy and *both* buy a comic book. On those days we had to walk home. I walked from school in Manhattan to Brooklyn, which was long enough, but he walked to Astoria in Queens! That's about 20 miles! We were tired but happy with our growing comic collection.

Those were the earliest days of SIA, which was located on 42nd Street. It had once been an old Civil War hospital that they converted. It was an early, experimental vocational art school at the high school level. I went to school in Manhattan, because I had this yearning to draw and there was nothing like SIA in Brooklyn. But my folks were dead set against it because, in their mind, all artists lived in attics and starved to death in a world tough and hard.

Frank and I were into Lou Fine's "The Ray," "Black Condor" — most of the Quality stuff. I think The Ray [in *Crack Comics*] was the first comic I bought. We didn't like DC in those days. *The New York Mirror* ran Foster's *Tarzan* strip on Sundays. Frank was a fan of Alex Raymond, and I liked Hal Foster. I would copy Foster, and Frank started copying Raymond. *Prince Valiant* came later on. I studied

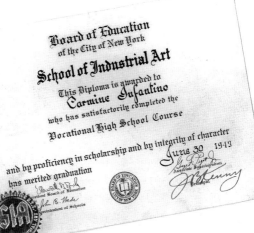

Below: Carmine's 1949 diploma from New York City's School of Industrial Art.

the artists; Foster's composition was incredible. That was the thing about his work I loved the most.

Fox.
I got my first drawing assignment from Victor Fox of Fox Features Periodicals. An editor came out, and he gave me a story to draw. When I brought it back, he rejected it outright! *Six pages!* Fox was only paying about six bucks a page, but I didn't get paid! But it didn't deter me. When you're young, you bounce back quickly. I went back home and worked harder than ever.

Harry "A" Chesler.
My entrance into the art field was with Harry Chesler. As a youngster, I used to canvass companies and try to meet artists. A chance meeting with an artist — Ken Battefield — in a coffee shop took me to this old broken-down warehouse on 23rd Street, and there I met the legendary Harry "A" Chesler. Battefield had said, "Why don't you come up and look around? Maybe you'll learn something." But he added, "Harry's tough. I don't know if he'll let you stay. But just take a chance." So I did. I was told Chesler was a cold fish who conned artists into working cheaply.

Chesler's shop was in an old factory building, and there was this broken elevator, and it rattled its way up to the fourth floor of the five-story building. And as you got off the elevator, you faced a brick wall. In front of the brick wall was Harry Chesler sitting with his cigar behind an old broken-down desk, puffing away. A Milton Caniff *Terry and the Pirates* original hung on the wall behind him. That was one room. When you went in, to your right there was a larger room where about five or six artists and letterers sat, doing their work. They worked most of the day, and didn't talk much. I was the kid, and they were all very nice to me, but they rarely kidded around, because Harry would be sitting out there watching everybody, and puffing his nickel cigars.

Harry said, "Look, kid: You come up here and I'll give you five dollars a week to just study art and learn." He did that for me for a whole summer and he didn't have to. He wasn't profiting off me; it was extremely giving of him. So Harry, this "cold fish" others had described, was very sweet to me.

I hung around Chesler's during my first year in high school, when I was 14 or 15. I'd met artists there and learned from watching them work. And a buck a day was a lot of money in those days. Chesler's shop packaged books for people. I understand he didn't pay very well. There were all sorts of stories about him. But I personally

Above: Carmine's high school graduation picture, mid-1940s.

Center inset background: Lou Fine's exquisite art for Quality inspired an entire generation of cartoonists. Here's a vignette of Black Condor from Crack Comics. ©2000 DC Comics.

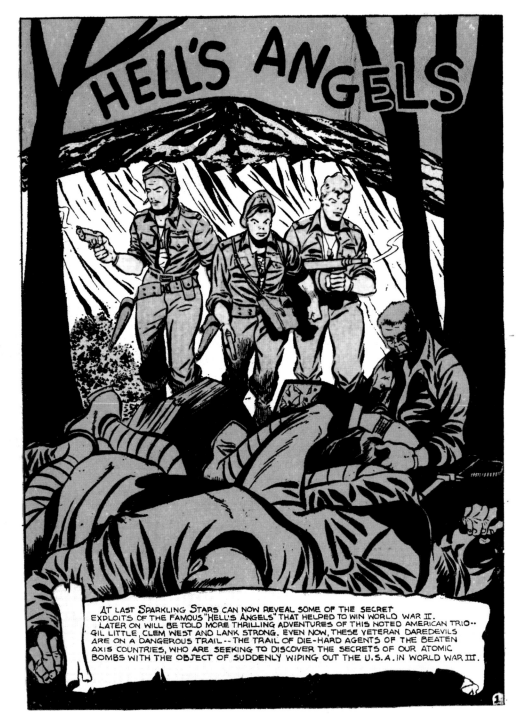

HELL'S ANGELS

AT LAST SPARKLING STARS CAN NOW REVEAL SOME OF THE SECRET EXPLOITS OF THE FAMOUS "HELL'S ANGELS" THAT HELPED TO WIN WORLD WAR II. LATER ON WILL BE TOLD MORE THRILLING ADVENTURES OF THIS NOTED AMERICAN TRIO-- GIL LITTLE, CLEM WEST AND LANK STRONG. EVEN NOW, THESE VETERAN DAREDEVILS ARE ON A DANGEROUS TRAIL -- THE TRAIL OF DIE-HARD AGENTS OF THE BEATEN AXIS COUNTRIES, WHO ARE SEEKING TO DISCOVER THE SECRETS OF OUR ATOMIC BOMBS WITH THE OBJECT OF SUDDENLY WIPING OUT THE U.S.A. IN WORLD WAR III.

had a nice arrangement with the man. He did for me something he didn't have to do: He paid me to learn.

So I just sat and studied the art of people there: Ken Battefield, Dan Zolnerowich, and others. I'd study their artwork, practice my inking, and then they'd come over and make corrections for me. They'd show me what I was doing wrong and why it was wrong. Battefield used to tell me, "You're wasting your time, this business is dead, finished. Go get a job somewhere, forget about drawing." In the 1940s he was saying this! Harry would tell him, "Leave the kid alone." Ken'd say, "I'm doing it for his own good." They talked back and forth. Dan was an out-and-out devout Communist. He and another fellow really preached Communism, and nearly signed me up.

Harry was in the alcove keeping an eye on everybody. When he left to get coffee, people screwed around a little, and when he came back, *boom!* they stopped. Joe Kubert had a similar arrangement at the Chesler shop, shortly after I was there. I asked Kubert recently about the building, and he said, "It's still there!" But I can't find it. Later on, Harry became a real estate magnate in New Jersey. I hear he ended up owning half of the state!

The guys at Chesler's encouraged me to go to the Art Students League at night. It was a little tough at that time — I was still going to high school during the day. But they pushed me and I knew I needed it, so I started. So

during the day I'd go to regular classes, then go to Chesler's for a couple of hours, then I'd run down to the Art Students League at night. It was a very long day. But when you're young, you can handle that kind of thing.

Quality.
The following summer I got a job over at Quality Comics, the same Quality that published "The Ray" and "Black Condor" by Lou Fine and *Blackhawk* by Reed Crandall. Busy Arnold, the owner, didn't like any little black lines sticking outside of panels. He had a fetish about it. My job was to erase pages and white out the little lines that stuck out, and add blacks where blacks were missing. I would get a quarter a page for that. At the end of the week my fingers were down to the bone. But I got to see Reed Crandall's Blackhawks come in. I saw great work by Eisner and Fine, and all sorts of wonderful art. And that inspired me tremendously. That was worth the effort and energy of wearing my fingers to the bone. It was great. Crandall and Fine and Eisner never came in; they sent their beautiful work in. And I soaked it up like a sponge.

Timely/Marvel.
All this time, Frank Giacoia and I were in constant contact. One day in '40 we decided to go to go up to Timely Comics, which later became Marvel, to see if we could get some work. They gave us a script called "Jack Frost" and that story became our first published work. Frank did the pencils and I did the inking. Joe Simon was the editor and he offered us both a staff job. Frank quit school and took the job. I wanted desperately to quit school and I told my father that it was a great opportunity. He said, "No way! You're gonna finish school." Things were very bad, he was desperate for money, but he wouldn't let me quit school. He said, "School comes first. If you're that good, the job will be there later." I can't love the man enough for that. So Frank took the job, and I didn't. I was 15 or 16, and I just kept making my rounds in the early '40s, looking for freelance work while continuing my studies.

Previous page: Carmine's splash panel from "Hell's Angels," from Sparkling Stars *#10, Feb. 1946, published by Holyoke. ©2000 the respective copyright holder. Center inset background: Early Timely character Jack Frost, penciled and inked by Frank Giacoia and Carmine. ©2000 Marvel Characters, Inc. Above: Carmine at 16*

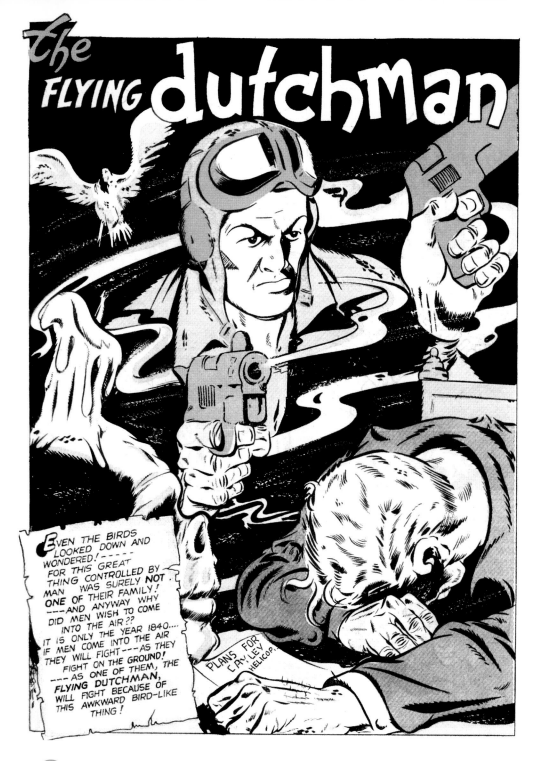

Al Capp.

Around the same time, the famous *Li'l Abner* cartoonist Al Capp called. He came to New York and I believe his brother Jerry Caplin knew about my work. When I went to see Al, he had a Chinese butler with a very bad toupee. Al called me in; Capp and his gorgeous young Israeli girlfriend had just gotten out of bed. He said, "I'll hire you right now." He was a real showman. He offered me $300 a week, and in those days, that was really big money. I wanted the job, but he wanted me to come to Beacon Hill in Boston to work for him. My father said, "No, no," though we needed the money! Whatever money I made, I poured it right into the family; you had to in those days. Pop said, "I don't care what we need; you're staying in school!" And that was it. Some great talent passed through Capp's studio, including (years later), Frank Frazetta. Later, Capp and I got to know each other fairly well and we bumped into each other from time to time.

Biro.

From Quality and after the Fox fiasco, I got work with Charles Biro. Charlie Biro and Bob Wood had a partnership with a publisher named Lev Gleason, and they packaged crime comics, *Daredevil*, and a crime Western book called *Desperado* —

SOME TIME AGO WHEN THE WHOLE WORLD WAS ENGAGED IN WARFARE, AN EVIL MAN OF THE SKIES, BARON VON EMMELMAN, WAS SHOT DOWN INTO A SWAMP AND SHOULD HAVE DIED—BUT NATURE PLAYED A PRANK AND DECIDED INSTEAD THAT SHE'D UNITE HIS HALF-DEAD BODY WITH HER OWN MYSTERIES AND SEND HIM ABOUT THE EARTH AS A CREATURE OF GOOD--A CREATURE THAT IS CALLED THE *HEAP*- AND ONE THAT WILL DEAL WITH ALL EVIL AS IT SEES FIT....

I did one of those stories later. But initially with Biro, I was inking straight lines in the backgrounds: chairs, tables, lamps, and buildings. Charlie would write dialogue directly on the page, then he penciled and inked the main figures. Norman Maurer would ink the other figures and I'd do the backgrounds. Biro penciled it all out, and we'd ink. Biro was a fine writer who wrote the original Daredevil, who was constantly with this group of orphans, the Little Wise Guys. It was good stuff; ultimately the Little Wise Guys took over the book. I was soon working on backgrounds for *Boy Comics* and *Daredevil Comics*. That's where I met Norman Maurer for the first time. Biro had so much work that Norman and I would go to Charlie's house and we'd work all night long, meeting the deadlines. Biro lived in an apartment in Forest Hills. His wife had just had a baby, and they'd be in the living room, so Charlie, Norman and I would be in anoth-

Above: Carmine's rendition of the legendary Hillman character, The Heap. From Airboy Comics Vol. 5 #3, April 1948. Below: Panel detail from Airboy Vol. 3, #8, Sept. 1946.

Previous page: Carmine's splash page from Airboy Comics, Vol. 3 #3, June 1946. ©2000 the respective copyright holder. All Airboy Comics images ©2000 the respective copyright holder.

er room working away all night. We'd do this for a couple of days in a row just to get the stuff out. Norman did more than I did for Biro. (Joe Kubert knew Maurer very well — I was not as close with Norman as Joe was — and they even became partners later on.) Norman was a favorite of Charlie, who had a lot of respect for him. I was paid three or four bucks a page. It was strictly a learning curve; it wasn't really about money. I was growing and developing. This is all in the very early '40s while I was a teenager in high school. I had to give up going to night school for a while, but I went back later.

Below: Panel from Airboy Vol. 3, #8, Sept. 1946. Art by Carmine. Center inset: Three panels by Carmine from The Heap story in Airboy Comics, vol. 5 #3, April 1948

Binder Shop. Jack Binder

was a packager who had a low-paying shop like a factory, and somebody suggested I approach him for work. I went up there and got a staff job penciling. There were some fine, talented people there, such as Ruben Moreira, a fine, young Puerto Rican talent. And another guy up there at that time was Nick Cardy (whose real name was Nicholas Viscardi; he changed it later on). He was doing a series called "Lady Luck," in which he drew these beautiful women. That strip ran in Will Eisner's weekly newspaper insert, *The Spirit,* a tabloid comics supplement. I was drawing silly comedy strips for Jack Binder. I was still in high school and worked at Binder's in the summer and after school.

Holyoke. Right after Binder I went to Holyoke. A letterer named

VON EMMELMAN IS DEAD, JOSE! I KNOW FOR CERTAIN THAT HE'S DEAD! I READ THE REPORT OF HIS DEATH.. I WENT TO THE SCENE OF THE CRASH.. I SAW HIS BODY! HE WAS THE ONLY LIVING SOUL BESIDE **YOU** WHO KNEW WHO I AM... BUT HE'S DEAD...DO YOU HEAR.. *DEAD!*

WHILE OUTSIDE THE WINDOW THE BURNING EYES OF THE HEAP WATCH THE WOMAN INSIDE ---

Milton Cohen (who sometimes went by the name Milton Kane) introduced me to them. This fellow Kane was friendly with Lou Fine and had done a beautiful, unsold *Cisco Kid* strip with Lou. Holyoke was a small subsidiary of a large company, which mostly put out paperbacks, but they would do a couple of comic books a year. I did some teen humor strips for them. They were in the Times Building in Times Square. My tenure at Holyoke was about a year.

Hillman.
Hillman was a publishing house with a variety of magazines, and comics were just one division. They did *Photoplay* and magazines like that. Ed Cronin, the Hillman comics editor, was in a back office. I was working as an artist but Cronin said, "I want to see you write. Don't confine yourself to one area; you've got to learn all aspects of the business." That turned out to be the best advice I could get.

I'd go in to see Ed Cronin, and he'd tell me to "Bring me a 'Heap' plot and let's see what you come up with." So I'd come in with two or three different plots and he'd choose one. Then I'd script it, show it to him, then go home and draw it.

With Hillman, I did a lot of *Airboy,* some crime stories, and "The Flying Dutchman." I wrote and drew "The Heap," which Leonard Starr inked (though we didn't meet until years later). I actually did more writing than drawing there. Cronin really enjoyed my writing. He would correct some of the scripts, and he taught me the basics about writing, plotting, and characterization.

Three: The Golden Age

DC/All-American: Mayer & the Young Guns.

All this time, Frank Giacoia and I kept in contact. We'd meet for coffee at night and talk, kid around, and look at each other's work. He showed me his artistic growth at Timely and I was very impressed. Then one day he and I decided to just go into DC Comics; "What the hell, why not?" We went to 480 Lexington Avenue — the company's first location — where Superman and Batman were being done. Walking into the foyer, the first thing you saw was this giant painting of Superman, unbelievably huge, hanging on the wall. One corner was filled with the licensing of all the characters, toys. It was nice, clean, lovely. A comfortable couch was out in front. We were so impressed with this and we asked to see the art director. Eddie Eisenberg came out, looked at our stuff, and said, "You've got nice stuff, but we can't use you here. Go down the hall; there's a company called All-American Comics. It's a sister company, and talk to a guy named Shelly Mayer — he's the editor. Tell him I sent you." So we went down the hall, where it wasn't nice at all. The offices down there were nothing. There was just a little girl sitting in the corner; it was really barren, a big wide-open hall. We asked for Shelly, he brought us in, and he liked what we had. This was 1946. Max Gaines (Bill's father) was the original owner and he was just about to sell his share of the company at the time.

Shelly was an early supporter of Superman before National bought the strip, and, as Editorial Director, he supervised the creation of Green Lantern, Wonder Woman, and The Justice Society of America, which later became the Justice League of America. Shelly said to me, "Your stuff is good. I could give you work today if you want-

ed." My eyes lit up. But he said, "I really think it would do you a world of good to go back for six months and study. Come back, and I promise I'll give you work then. But if you want it now, I'll give it to you." He reminded me of Sheldon Moldoff, who did lots of copying rather than drawing, and he said, "It's better to go home and learn to draw." That was the point. Because Sheldon used to copy Alex Raymond, Foster, Caniff, everybody, and lost himself. I went back to study, but Frank left Timely for DC.

That first meeting with Shelly, Frank and I were sitting in his office with our portfolios in our hands, and he's sitting in his chair, with his desk between us, talking to us and looking at our artwork. Suddenly, we heard the door opening behind us, and we hear, *"En garde!"* We didn't know what the hell was going on! We looked around and there was little Irwin Hasen. He's got a T-square in his hand, wielding it like a sword, and with his dramatic entrance, Shelly leaps up on his desk brandishing his own T-square, and they start dueling, over desks and across the room. Welcome to Shelly's world!

Frank and I sat there, literally stunned. These two started dueling away, then I think Shelly tagged Irwin on the

Shelly Mayer on Infantino

As to my most successful achievement, I suppose you could say it's Carmine Infantino. That's not a comic strip, but a man. But when I first met him, he was a long, gangling kid whose arms had grown too long for his sleeves. He was standing at my desk with another youngster, and both of them wanted to be comic magazine artists. They were freshmen from the High School of Industrial Arts, where I had given a lecture the day before. They had come to my office to get jobs, convinced that the Industry awaited them with bated breath! The fact is, they weren't bad. Both had talent, but they had a lot to learn, too. I'm convinced I made deadly enemies of them within five minutes.

My first question was: "Is your father working?" Both nodded yes. (In those days most kids were expected to help out with the family expenses.) "Does he mind feeding you while you stay in school and finish learning your trade?" They both saw what was coming, and cautiously shook their heads no.

"Okay," I said. "Then stay in school. Do a lot of life-sketching. Draw *everything* you see. Get so good that nothing stumps you." I could tell by the looks I was getting that they thought they were that good already. "Sure," I said, "there are publishers who would hire you right now, because you'd probably be glad to work cheap. But don't do it! You'll stop learning, and you'll stay at the bottom of your profession all your lives. It would be a waste of talent."

The two boys were very disgusted with me. I made an appointment to see them a year later. A year is a long time to a teen-ager. It seemed like an empty promise, but the year passed, and Carmine showed up. The other kid didn't. (He had started working as

an inker. He became one of the best inkers in the business…)

Carmine must have doubted my sanity many times when he'd bring in his best work, and I'd pull it apart. But if he did, he never said so. I wish he had. Because now I could say, "See? I was right!" But he never doubted. He was always so sure I was right that I began to wonder if I really was! But my fear was groundless. The first assignment I gave him was an important one, and he came through fairly well. I left him in the hands of Julie Schwartz when I resigned in 1948.

In no time, the kid started walking off with National Cartoonists Society awards. Just when he was really starting to get good, he stopped drawing and became Editorial Director of DC. Too bad. But I suppose *somebody* has to do the dirty work! And he is exceptionally good at it. I spent a delightful afternoon, sitting on the corner of his desk, dropping ashes in his wastebasket, and watching him in action. I got a real charge out of it. He handles himself very well, and he knows his business.

So, I guess I have to say that of all the work I've done in this field, the hours I spent beating Carmine Infantino's brains in seem to have produced the most satisfying results.

butt or something, and the thing was over. They kissed and Irwin left just as suddenly as he came in, without a word! Shelly just went back to looking at our work as if nothing had happened. It was the weirdest experience! The place was a *madhouse!*

Six months later, I returned and Shelly kept his word, and I began at DC, around '46, when I was16 or 17. He put me on "The Ghost Patrol," then drawing "Johnny Thunder" — both back-up features. I met Joe Kubert and Alex Toth up there. We were the young guns moving in. Guys like Marty Nodell and Irwin Hasen were already established there. I went in one day and Shelly suddenly put me on The Flash. I was working for DC from then on.

Shelly was a genius. Joe Kubert, Alex Toth, Frank Giacoia, and I all have him to thank for whatever advancement we got. This man was just great. He was our mentor: he'd focus us on storytelling, and if we missed the boat, he'd make us explain why we did it the way we did. But he would show you where you went wrong. He wouldn't just say, "Go away and do it over." He'd *show* you why and how you did it incorrectly. He was a great cartoonist himself; he wrote, and he drew some beautiful things, including

DINAH HURRIES TO THE BACK OF THE SHOP WHERE SHE SWIFTLY CHANGES INTO THE *BLACK CANARY!*

SOON AFTER THE **BLACK CANARY** ARRIVES AT THE LANDALL ESTATE...

THE DRAWING ROOM HAS A WINDOW ON THIS SIDE. I'LL MAKE MY ENTRANCE THROUGH IT!

"Scribbly" and *Sugar and Spike.* I revered him — we all did. He could analyze and dissect a story, then tell you what was wrong with it in ten minutes. And he was only 30 years old! He molded us, groomed us, and then moved us forward quickly to take over lead features. Again, Shelly was sheer genius.

Frank and I dealt strictly with Shelly, who oversaw everything, made corrections, and taught us to think. Julie Schwartz and Bob Kanigher did their work and handed it in to him. He'd go over every script, correct and change them. Then when we came in, he would hand us the finished script. Bob and Julie worked in another room. I saw them there, but we didn't speak because I never dealt with them. It was a little strange when we got notice that

Far left and left: Unpublished Black Canary panels by Carmine, circa 1948. Above: Another regular Carmine assignment—Johnny Thunder. Panel detail from Flash Comics #86, Aug. 1947. Below: The Flash from All-Star Comics #37, Nov. 1947. ©2000 DC Comics

Shelly was going to leave the company. He wanted to get back to cartooning. We were in shock because his was our world, too. We were told we'd be working with Julie and Bob, and Shelly introduced us, and thereafter Julie became my editor.

Kanigher.

At DC, in the mid-to late-'40s, I'd been drawing "Johnny Thunder," "The Flash," "Green Lantern," "Black Canary," and "The Ghost Patrol." By the late-'40s, when super-heroes where losing ground, I drew "The Trigger Twins" and "Pow-Wow Smith" Westerns and the spy character "King Faraday." King Faraday was Bob Kanigher's creation. It was a good scripting — I liked Bob's writing. He challenged an artist to be different.

Kanigher was an editor as well as a writer, and Julie Schwartz and he sat across from each other in one office. Bob had a way of bringing the best out of people. He would prod, and some people he would lean on a lot. If Bob thought an artist was goofing off, or that an artist had more in him than he showed, Bob would

really work the artist over. And he'd bring the best out! Because he felt they needed it. And others, like Joe Kubert and myself, he wouldn't say a word to. He felt that we didn't need it. I enjoyed working with him and thought he was so talented — Bob was a great writer and editor.

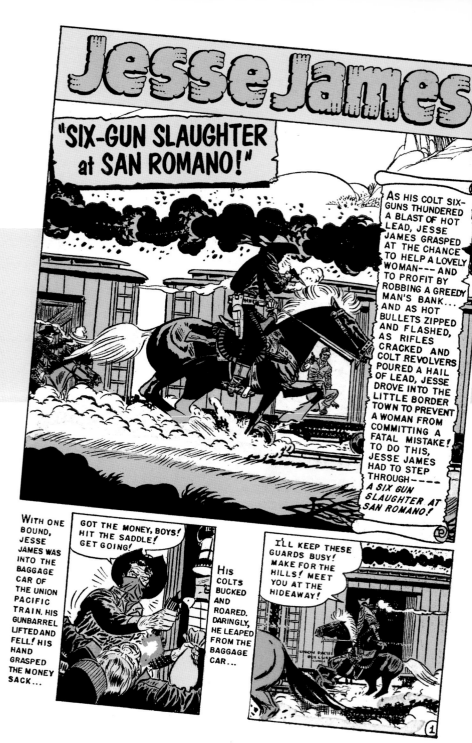

Bob Kanigher on Infantino

Carmine Infantino's style is unique. He cannot be imitated. He is the essence of comics; that's why I call him "Mr. Comics."

Avon. During this early period at DC, I also freelanced for Avon. Joe Kubert and I had met at DC/All-American and become good friends. We started working together on *Jesse James* for Avon. I penciled one whole *Jesse James* book in *one* day, and Joe inked it in *one* day. We did it so fast, we didn't even put borders on the pages! I told him, "Joe, I did this in one day!" He said, "I'll match you!" And Joe did! It was *amazing!*

Far right and following three pages: Jesse James story, penciled by Carmine and inked by Joe Kubert. ©2000 Avon Publications.

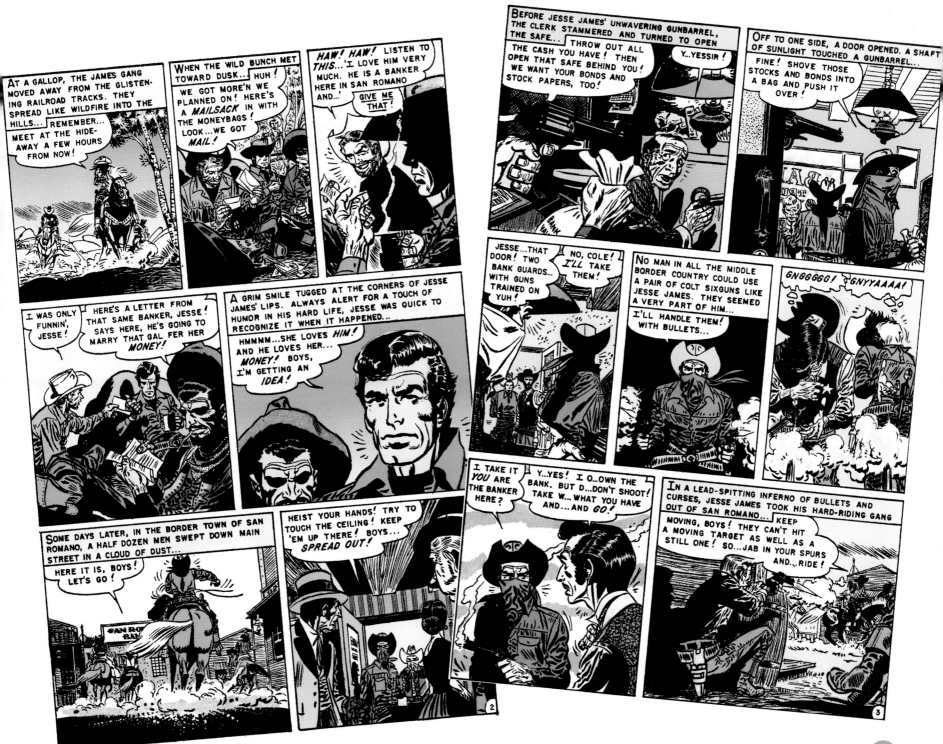

MEN GRABBED RIFLES AND SIXGUNS...AND MEN DIED, FOR THOSE WHO RODE THE LONESOME TRAILS WITH JESSE JAMES SHOT WITH THE ACCURACY OF A TRICK MARKSMAN!

AAAAAGGH!

SOME HOURS LATER, IN THE QUIET OF THE MISSOURI COUNTRYSIDE...

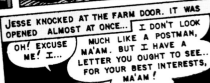

THAT'S AMELIA HART'S FARM! SHE'S THE ONE WHO HOPES TO MARRY THAT PASTY-FACED BANKER. WELL, WONDER WHAT SHE'LL SAY WHEN I SHOW HER THOSE LETTERS?

JESSE KNOCKED AT THE FARM DOOR. IT WAS OPENED ALMOST AT ONCE...

OH! EXCUSE ME! I...

I DON'T LOOK MUCH LIKE A POSTMAN, MA'AM. BUT I HAVE A LETTER YOU OUGHT TO SEE... FOR YOUR BEST INTERESTS, MA'AM!

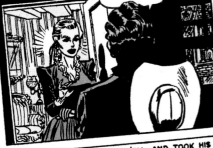

I...I CAN HARDLY BELIEVE IT! JOHN...MARRYING ME ONLY FOR...MY MONEY!

I JUST HELD UP HIS BANK, MA'AM...AND TOOK HIS MONEY! ALL HIS MONEY! HE'LL BE OUT HERE SOON, RECKON...WANTING TO MARRY YOU...PLUMB FAST! THAT WILL HELP YOU BELIEVE THAT I SPEAK THE TRUTH!

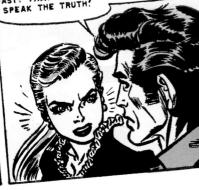

YOU--ROBBED THE BANK? YOU COME HERE AND TELL ME--THAT? B-BUT SOME OF MY MONEY WAS IN THE BANK!

YOU'LL GET YOUR MONEY BACK, MA'AM! I DON'T WANT IT. I'M SATISFIED WITH YOUR BOYFRIEND'S MONEY! AAAH! HERE HE COMES NOW!

AS HE CAME IN THE FARM DOORWAY, JOHN ROMLEY WAS EAGER, IMPETUOUS. HE WAS SO EAGER HE DID NOT SEE THE GLEAM IN AMELIA HART'S E---

AMELIA, DEAR! I RODE OUT TO ASK YOU TO MARRY ME AT ONCE!

JOHN--WHY SUCH HURRY? ARE YOU HAV--- TROUBLE AT THE BA---

OF COURSE NOT! EVERYTHING IS SPLENDID. NEVER BETTER!

JOHN, YOU'RE LYING! I KNOW YOUR BANK WAS ROBBED AND MY MONEY WAS IN YOUR BANK, JOHN! MY MONEY IS GONE NOW!

I'M POOR, NOW, JOHN! POOR!

I UNDERSTAND, AMELIA! IN THAT CASE---WE'LL FORGET OUR MARRIAGE PLANS!

IN THE SUDDEN SILENCE OF THE FARMHOUSE LIVING ROOM AMELIA HART SOBBED DRILY. A SYMPATHETIC HAND SUDDENLY RESTED ON HER SHOULDER...

I TOLD YOU SO, MA'AM! NOW DON'T CRY! YOU'RE A LOT BETTER OFF NOT MARRYING SOMEBODY LIKE HIM!

HERE ARE YOUR STOCKS AND BONDS. I WENT OVER THEM AND TOOK THEM OUT OF THE MONEY SACKS WE TOOK FROM THE BANK. WITH THE CASH I TOSSED IN, YOU'RE A RICH WOMAN AGAIN!

BEHIND THEM, THE DOOR SWUNG OPEN ON WELL-OILED HINGES, SOUNDLESSLY...

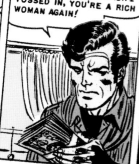

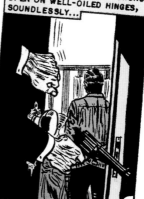

5

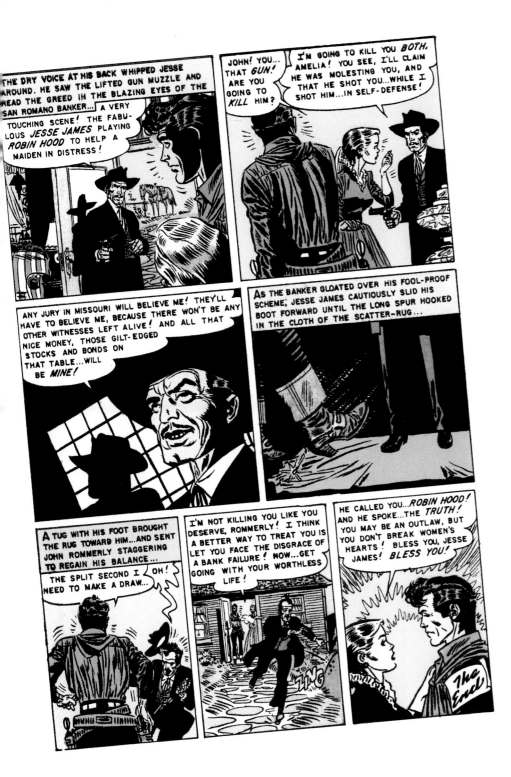

Irwin Hasen on Infantino

Carmine Infantino and I go way back. Since I mainly live in the present, I mostly forgot what went on in the past, but I do know Carmine was one of the most talented artists and cover designers in comic books. He was also an astute, creative publisher—a rare combination!

Most cartoonists are gregarious chaps, offsetting the loneliness of their monastic working life. Unlike writers who share that same venue, the cartoonist is a huggy, kissy, open, warm creature.

Carmine was a contradiction: away from the board he was distant, an iconoclast, and a perfectionist. Since my pleasure in life is to make people laugh, Carmine was my perfect foil. It wasn't easy to break through, but I'm good at that. That's why we've gotten along these past 40 years.

Carmine always insists on traveling first class. Most cartoonists are grateful just to take a cross-town bus on a transfer.

Carmine was loyal to his personal responsibilities. He cared for his parents until they passed on, and he tended to his younger brother's last days.

When Carmine and I visited Florence, Italy, in 1999, we spent time in the tomb of the Medicis. We sat on a stone bench mesmerized at the genius of Michelangelo's work. I looked up at the face of the patron, Cosimo de Medici. There was a tear streaming down his marble face. He'd seen Carmine and was moved by the visit of his "goombah."

Golden Age Sketches

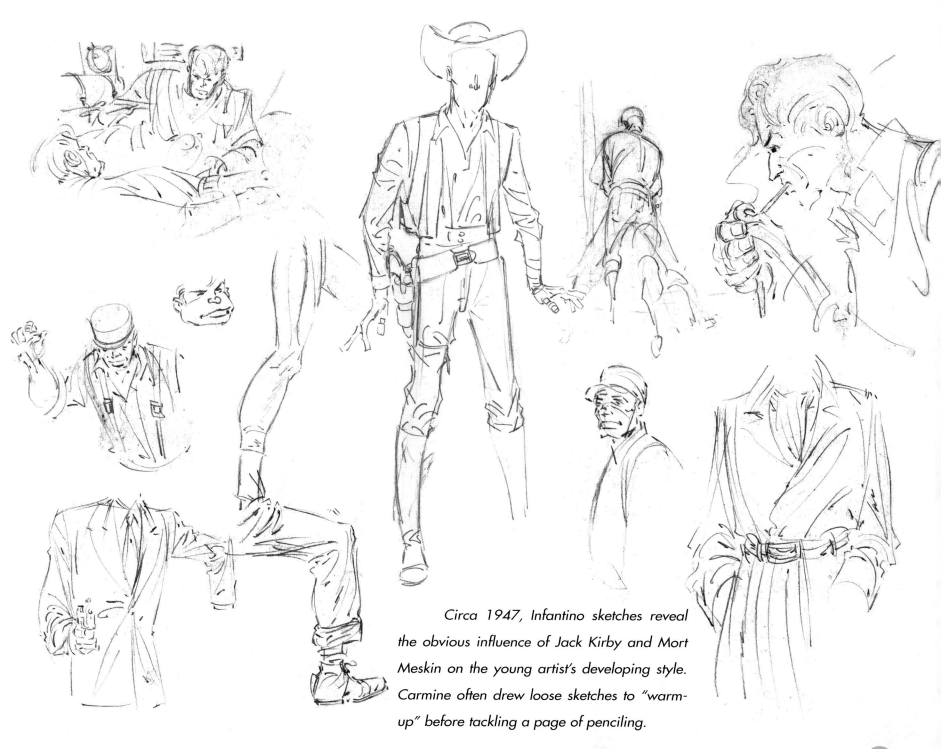

Circa 1947, Infantino sketches reveal the obvious influence of Jack Kirby and Mort Meskin on the young artist's developing style. Carmine often drew loose sketches to "warm-up" before tackling a page of penciling.

Four: Moonlighting

Simon & Kirby.

Even though I had a great account with DC, I would do occasional work for others. I did some work for St. John between 1950-53. And I accepted an invitation to work with Simon & Kirby when they had their company, Crestwood.

Frank Giacoia and I first met Jack Kirby way back in the '40s. We used to go up to Tudor City as kids, and we would bother him up there, and watch him work. Joe and Jack had an apartment they used for an office when they were doing *Stuntman, Boy Commandos,* and the Newsboy Legion work for National/DC. Jack and Joe were always terrific with us. They were kind to anybody and always had time for people. Anything you asked of them, they'd help you with.

In the '50s, while I was working for DC, Joe Simon called me up and asked me to come do some work for them. The pay wasn't that great, but I did it because I wanted to work with Jack; I wanted to learn from and study him. So I worked with Jack, Mort Meskin, and Bill Draut — three brilliant guys. Mort was a strange man, but very talented, and his work had a nice, delicate flair to it. While Jack's style was powerful, Mort's was subtle. The people Mort drew were always very pretty. When I met him, I found out he was, like myself, a fan of Edd Cartier, artist on *The Shadow* pulps. Then when I looked at his work, I could see the resemblance. Mort was a good teacher, and a nice man. I learned a lot from all of them.

I drew *Charlie Chan* at Crestwood. The pay didn't compare to either DC or what Capp had offered, but I had a great respect for Joe's business savvy and relished the idea of learning what I could art-wise from Jack! I kept up my work for DC at night and worked at Jack and Joe's during the day. Frank did work for

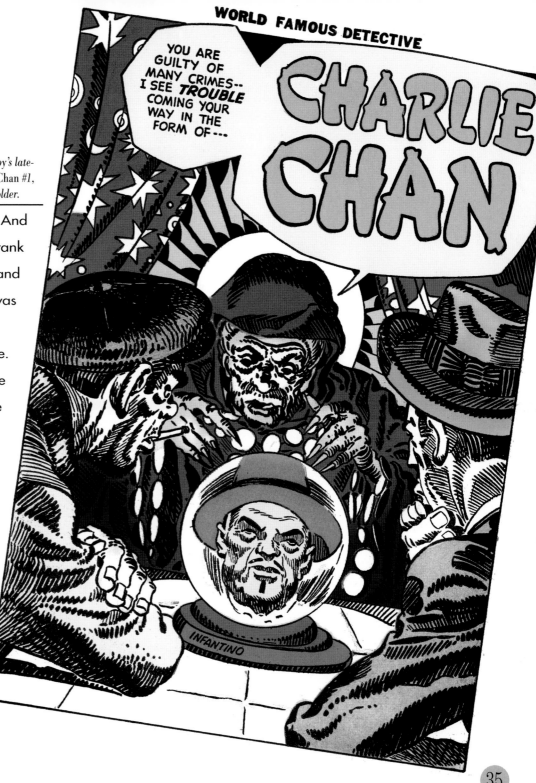

them, too. He was a very good but frustrated penciler. And he drew a couple of strips, including *Johnny Reb.* But Frank was slow as a penciler. His inking was in constant demand so in the long run he ended up doing more inking and was one of the greatest inkers the industry has ever known.

The artwork Jack was doing was just incredible. When I was working at Crestwood, Joe would hand me a script, and I would draw it. Joe seemed to coordinate the scripts, but Jack was writing all the time also. Mort would get a script, though Jack would draw his own stories. But I think Simon went back later and he'd tighten-up Jack's text. There were also writers working there, including Jack Oleck.

One time I did a drawing of a guy hitting a woman. I showed it to Jack and asked what he thought. He says, "No, try it like this: Do the scene, but don't show the people; just put the shadow on the wall. Let the reader's imagination fill in the details." I did it and it worked great! He was a tremendous help. We did a newspaper strip

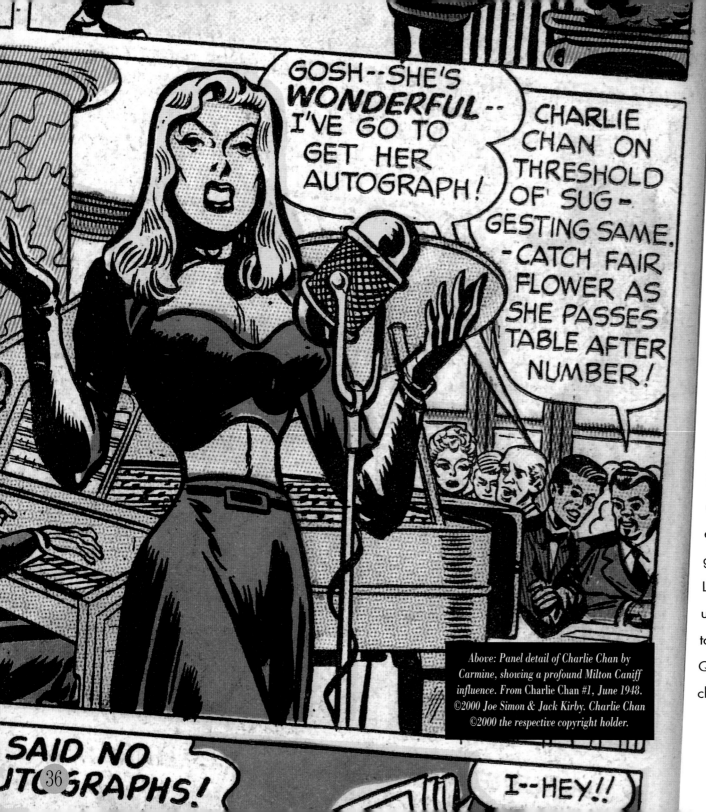

GOSH--SHE'S **WONDERFUL**-- I'VE GO TO GET HER AUTOGRAPH!

CHARLIE CHAN ON THRESHOLD OF SUG - GESTING SAME. - CATCH FAIR FLOWER AS SHE PASSES TABLE AFTER NUMBER!

Above: Panel detail of Charlie Chan by Carmine, showing a profound Milton Caniff influence. From Charlie Chan #1, June 1948.

SAID NO JTCGRAPHS!

I--HEY!!

together one time, with Jack writing and me drawing. It was a Western and we tried to sell it, but the syndicates didn't pick it up.

Now I worked on this schedule for nearly a year; working at Crestwood during the day, and then all night keeping up my DC assignments. Although I loved working with those guys, I had to get back to DC because I was losing money. And I just couldn't keep it up; I wasn't getting any sleep. So I told Simon & Kirby and they understood. When I went back exclusively to DC, I also started going to the Art Student's League at night, studying figure drawing. Much later, I went to the Brooklyn Museum of Art, Queen's College for evening classes.

Above: Panel detail from 1954 Steve Canyon Sunday strip by the great Milton Caniff. ©2000 Milton Caniff & News America Syndicate. Below: More evidence of Caniff's influence, this time on Carmine's Trigger Twins strip. From All Star Western #105, June 1960. ©2000 DC Comics.

Milton Caniff. In 1954 I

was getting known and I got an offer from the great newspaper strip artist of *Terry and the Pirates* and *Steve Canyon*, Milton Caniff. Caniff was one of my all-time heroes and I would have loved to work with him, but he offered me $220.22 a week to pencil *Steve Canyon* for him. I was making more than that doing comic books, so I had to turn him down.

Joe Simon on Infantino

Carmine and I go way back: he was working for various publishers in the '40s and was a big Simon & Kirby fan. When Jack Kirby and I were running Crestwood, I invited Carmine over to help us out. Carmine's *Charlie Chan* art was great! Unfortunately, the *Charlie Chan* project was never successful in comic books, having been attempted by probably a half dozen publishers. So Carmine had to return to his primary account, DC Comics.

I knew Carmine and his whole family well. They lived in Queens. His brother, Jimmy, worked for us when we were doing *Young Romance, Black Magic, Justice Traps the Guilty,* and all the others at Crestwood. Jim was great but left comics for advertising. Carmine's father was in the plumbing parts business. I'd often drive my family out to Queens to visit. We'd discuss the house I was building in Old Westbury, Long Island. Sometimes we would all drive out to the building site and discuss the architecture (an interest of Carmine's) and the construction (an interest of his father's).

Later on, when Carmine was running DC, we did some books together, including *Brother Power, The Geek* and *Prez.* I enjoyed working with Carmine. I thought he was a terrific editor and we had a good time bouncing ideas off each other. (I also liked the women he dragged out to my studio, when they weren't working the stewardess schedules!) Best of luck to my old friend and his forthcoming autobiography, which is long overdue. I look forward to reading it!

Seduction of the Innocent.

Super-heroes were losing ground, little by little, after World War II and into the late '40s. Publishers were getting into romance, horror, crime, science-fiction, Westerns, and war titles. After a while there became quite an outcry that comics, and especially the crime and horror variety, were bad for kids. The psychiatrist Dr. Fredric Wertham wrote the book, *Seduction of the Innocent,* and he spearheaded the stink. In April 1954, the televised Senate sub-committee hearings on crime and juvenile delinquency, led by Senator Estes Kefauver, turned to comic books. And they called EC publisher Bill Gaines in to testify. Bill's books were very influential with good stories and art, but his horror books definitely pushed the envelope. (Some of his competitors left out the "good stories and art" and just imitated EC's gore.) I believed that Bill thought he was being clever at the hearings, but I've come to understand since that Bill was on Valium during his testimony. The committee seemed to have taken offense at some of the things he said. I didn't follow it that closely, but right after those hearings, the business took a severe nosedive! I mean, really bad. Bill's books were thrown completely off the stands, and the only thing he had left was *Mad.*

At DC, we were trying to get by on Westerns, romance, and science-fiction. We were trying to get anything going. Gil Kane was doing *Rex the Wonder Dog.* We did a lot of romance; I did "Pow-Wow Smith" and "The Trigger Twins," and a number of science-fiction stories. But none of it sold very well. The business was wounded pretty badly by the Kefauver hearings and Wertham, really doing a number on us. DC called everyone in and told us we had to take a two- or three-dollar page rate reduction. We were naturally upset, but they said it was either that or no work.

They said they had to save money because they were getting beaten up with all the bad publicity and nothing was selling. DC saved a lot of money that way — two bucks' savings on every page adds up. That's how DC got through, while many companies went under.

Kefauver wanted to run for President. He was looking for publicity and he needed a hook. He thought, here's this weak business that's just right for attack, and he moved in like a wild dog. At the same time, the crime titles Charlie Biro and Bob Wood were doing were pretty rough stuff.

The same game is played now with television, only TV has the money to fight back. Because of the heat from Kefauver, the surviving publishers got together and started the Comics Code Authority. They put this guy in charge; there was this big fanfare. They said there would be no more blood and no more this and that. Apparently this appeased the critics, because comics quietly went back on the stands. But sales were down and the whole thing left a bad taste with parents. It was scary: the business was in trouble and we were ashamed to tell people what we did for a living; it was that bad. So we kept our mouths shut pretty much, took the pay cut, and did what we could. DC became a closed shop for years. New artists came by looking for work, including Neal Adams, but no new talent was hired for years. Those of us who were there were lucky to be getting work.

DC After Shelly.

At DC I was just drawing now; I wasn't writing as I had for Cronin at Hillman. But I read a lot. I got onto Somerset Maugham and Mark Twain. Somerset Maugham wrote great short stories and Mark Twain was sheer genius. I learned a lot from them. Cronin told me, "If you really want to learn how to write, you've got to read these people." So that's what I was reading in my early 20s.

I'd worked with Shelly at DC for about three years. When he left Julie became my editor and Bob Kanigher was a writer and editor. At the beginning it was a little tough because, while Shelly used to go over everything we did, these fellows didn't. They would hand us a script and we'd just take it home to work on it. I guess we were ready, but Joe Kubert, Alex Toth, Frank Giacoia, and I used to meet regularly in the office. We'd talk to each other, look at each other's work, and always comment on and appreciate our work and the work of others. Frank Robbins was a big favorite at one time, as was Noel Sickles. Frank loved Alex Raymond. We'd debate with each other on the merits of the artist's work. Nobody was envious of anybody else, but there was some friendly competition.

Joe, Alex, Frank, and I were the young guns out to prove ourselves and there was a definite camaraderie. We'd meet and have coffee together. Outside the office, sometimes I went to Alex's home, and he came to mine. Everybody used to hang around in the city. Joe had rented studio space on the top floor of a little brownstone with fashion photographer Brad Smith on Park Avenue. Alex and I would go up and see him, maybe do some work up there. If an all-nighter was pulled to meet a rough deadline, an unusual awakening might come shortly after falling asleep at daybreak, caused by a beautiful young model looking for Brad Smith. We were all young bachelors then and we'd occasionally have parties there at the studio.

Above: Circa early-1950s Christmas party photo. Far left: Julius & Jean Schwartz, Carmine standing behind his father and mother, plus Bernie & Bernice Sachs and Jim Infantino

THIS IS THE STORY OF A TOWN. IT MAY BE YOUR TOWN, IT MAY BE MINE...

...AND OF ITS PEOPLE THE RICH, THE POOR, THE YOUNG AND THE OLD! THE WARM HUMAN STORIES OF PEOPLE LIKE YOU AND I !

7:13 A.M.--A COLD WET RAIN BEGINS...

AT 7:50 A.M., A TRAIN FROM THE EAST ROARS INTO HOMETOWN STATION ...

8:05 A.M.--THE RAIN CONTINUES. PASSENGERS HURRY TO AND FROM THE TRAIN. A YOUNG LADY IN A CHECKERED RAINCOAT, UNAWARE OF THE DRAMA THAT AWAITS HER ... WALKS SLOWLY TOWARD A ONCE FAMILIAR WAITING ROOM ...

TIME: 8:15 A.M. PLACE: HOMETOWN, RAILROAD STATION...

...HELLO, TONY!

NAN--!

NAN--!

TONY...YOU'RE AS WHITE AS A SHEET! DID I STARTLE YOU SO ?

SORRY! BUT IT'S NOT EVERY DAY I RUN INTO MY EX-WIFE !

Syndicate Dreams

Like many of his comic book artist contemporaries, Carmine Infantino longed for a regular syndicated daily newspaper comic strip — the "Holy Grail" of regular assignments for sequential artists toiling in the often-shaky, maligned world of "funny books" — and the artist rigorously sought to make a break into a more prestigious employment situation in the "funny pages." At immediate left are samples of a proposed daily strip Hometown (no doubt inspired by the popularity of the melodramatic book Peyton Place) Carmine unsuccessfully pitched to syndicates in the late 1950s. And during the '50s, the artist scored a temporary gig ghosting for such artists as Dan Barry on Flash Gordon.

Five: A New Approach

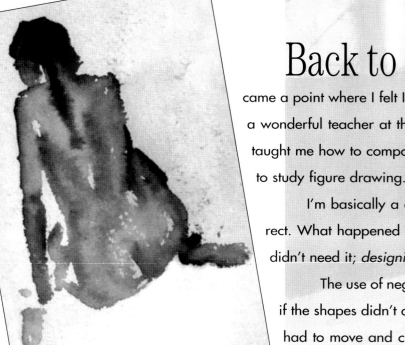

Above: Life figure wash drawing by Carmine (circa late-'50s). Right inset and background: Edward Degas' renowned painting The Absinth Drinkers *(1876).*

Back to School: Art Students' League. There

came a point where I felt I had to get back to school. I just felt there was something missing and I found a wonderful teacher at the Art Student's League, John McNulty. He was a genius at composition and taught me how to compose. I'd go there four nights a week: two nights with McNulty, and two nights to study figure drawing.

I'm basically a designer. If you look at my work, you'll see the anatomy is never totally correct. What happened is: After I learned the anatomy, I just threw it out. Go figure that one! I felt I didn't need it; *designing* was the key.

The use of negative and positive shapes inside the panel had to mean something. So, to me, if the shapes didn't draw the eye in, then they weren't worthwhile. I had to move and change the shape to make it work for me. And that's what I did. For me beforehand, the figure was the most important thing, and nothing else in the panel mattered. But later on, I found out that it was the *total picture* I had to worry about. I modified the anatomy of the figure, and then other things went to work for me. That comes from trial and error.

I became essentially a designer more than anything else, and that's when I started studying the French Impressionists. Degas was the king for me; I was into him like mad! My teacher at the Art Student's League put me onto him. Once I understood Degas, I realized he was a genius of design.

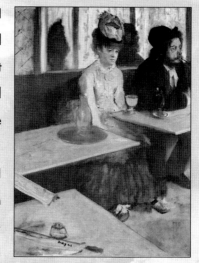

Right: This unidentified Pow-Wow Smith page adjoined Carmine's submitted biography for inclusion in the National Cartoonists Society membership book (circa late-'50s). Pow-Wow Smith ©2000 DC Comics

CARMINE INFANTINO

BORN MAY 24, 1925 IN THE BOROUGH OF BROOKLYN. STUDIED AT THE SCHOOL OF INDUSTRIAL ART, ART STUDENTS LEAGUE, BROOKLYN MUSEUM OF ART AND QUEENS COLLEGE! BEGAN WORKING FOR NATIONAL COMICS SOME ELEVEN YEARS AGO... AN ASSOCIATION THAT CONTINUES TO THE PRESENT TIME!... MY AMBITION IS TO SYNDICATE A STRIP, READ AS MUCH AS POSSIBLE IN ONE LIFETIME AND TRAVEL, TRAVEL, TRAVEL...

Below: King Faraday panel detail from World's Finest Comics #64, May 1953. Pencils by Carmine, inks by Sy Barry. ©2000 DC Comics.

My teacher, McNulty, would take a painting of Degas' — do you remember *The Absinthe Drinkers?* In that particular painting, if you look carefully, you'll see how the green table forms a V-shape that takes you right into the figure. And he had little spots of red around the figure, and everything worked in unison in his work, and the more you looked at it, the more you saw. So I said, "Mother of God! This guy drives me nuts!" So McNulty explained how to take it apart and understand it. The more I knew, the more I admired Degas. He was pure genius. You know, he was the master of that whole group of Impressionists.

So I really studied Degas. I moved from comics into these Fine Art paintings. At one point I thought, these fine art guys can't help me; but the more I studied them, the more I could apply what they did into what I did. So I learned more from them than from anyone else.

The National Cartoonists Society.

In those days, my biggest joy would have been to have a newspaper strip, and, believe me, I tried. I did some work on *The Lone Ranger* very early on. I did one Sunday page of *The Phantom,* but Dan Barry's brother had the inside track there, and Sy (Seymour) Barry got the strip; that kind of thing happens. I drew a few weeks of *Flash Gordon* dailies for Dan Barry. And I tried a couple of strips of my own, and the Western I did with Jack Kirby, but I just couldn't sell them.

Back then, strip cartoonists made a lot of money. Comic book artists were not respected as much as newspaper strips artists. I joined the Cartoonists Society and even there, the newspaper strip artists commanded the most respect. I think the advertising cartoonists and comic book artists were only allowed in because the club needed the

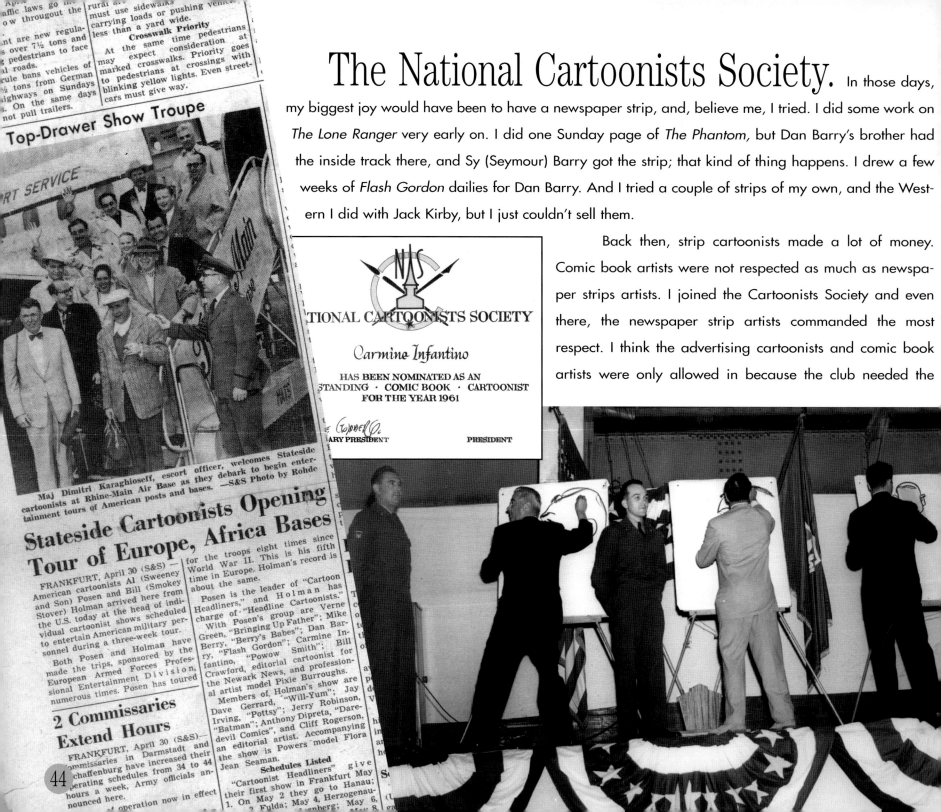

dues money. Especially during and after the Congressional hearings, we were actually ashamed to tell people what we did for a living. Joe Orlando used to tell people he drew children's books.

The Cartoonists Society has an annual awards ceremony. Until 1956, they gave only one award, the Reuben for Outstanding Cartoonist of the Year. But, starting in 1957, they expanded into various categories, and to their credit they added an award for Best Comic Book Artist. In '57, it went to Jerry Robinson for his work on *Bat Masterson*. I was there in 1958 when Wally Wood won for his work on *Mad*. In 1959, I wasn't sure I would be attending the affair when the Society's secretary called to see if I was coming. She said, "Carmine, I think you should come. That's all I can say." I went and received the award for Best Comic Book Artist of 1958. And I must say, it was quite an honor to be recognized by all the top cartoonists in the country.

Sometimes I'd have to get away from work. I loved to travel; it was in my blood. I started traveling with the Cartoonists Society, too. They had tours to Army bases in Europe and in Asia. The Army would give you a GF-17, and they'd ship you over there to draw cartoons for and entertain the soldiers. They were very appreciative; I even received commendations from the Department of Defense. I traveled quite a bit. It actually enhanced my work. It's inspiring to see other lives and other cultures.

This was from the '40s and well into the '50s.

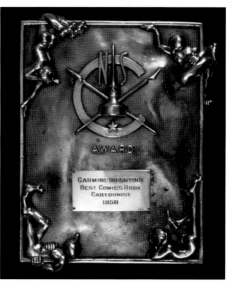

Opposite, far left: Article from Stars and Stripes, May 1, 1956, promoting cartoonist shows entertaining American troops abroad. Opposite inset: Plaque received by Carmine as Outstanding Comic Book Artist of 1958 from the NCS. Far left and opposite bottom: Carmine and fellow artists during the cartoonist shows in 1956. Below: Certificate of esteem given to Carmine recognizing his participation by the Department of Defense.

The Department of Defense
presents this
Certificate of Esteem
to
Carmine M. Infantino
for Patriotic Service in providing Entertainment
to Members of the Armed Forces in
Europe
during the period
1956

Washington D.C.

Secretary of Defense

Influences

Certainly Carmine Infantino was a man of his time, heavily influenced by the prevailing modern design of the 1950s in everything from architecture, interior design, to even the then-current fad of cars with tail fins (bottom right). But the artist also found inspiration in such diverse places as the paintings of Edgar Degas (left), Alex Raymond's Flash Gordon (immediate right), and in the work of Italian painter Amedeo Modigliani (far right).

Background: The Green Dancers (1877-79) by Edgar Degas. Right: The Heroes of Rann, from Mystery in Space. Pencils by Carmine, inks by Murphy Anderson. ©2000 DC Comics

WHEN MING SOU
LAWS BY TURNIN
NELS, HE UNDER

Above: Rannian architecture from Mystery in Space. Pencils by Carmine, inks by Murphy Anderson. ©2000 DC Comics

Below: Live model sketch, circa 1950s. ©2000 Carmine Infantino.

D DROWN THE OUT-
ER INTO THEIR TUN-
PART OF THE CITY.

Above: 1938 panel from Alex Raymond's Flash Gordon. ©2000 King Features Syndicate, Inc.

Above: At the height of the American automobile "tail fin" craze, Cadillac produced the sleek 1959 Eldorado.

Background: Rose Caryatid (L'Audace) (1913) by Amedeo Modigliani.

47

Six: The Silver Age

Julius Schwartz.

Julie Schwartz was a very important editor to DC. When I was working for him, he would leave me alone as much as possible. He would hand me a script, I would deliver the art, and that would be it. I had been used to positive critiques when Shelly was my editor. One time, very early on (but after Shelly left), I brought work in that I was very proud of. I asked Julie what he thought of it. He looked at me and said, "You're a professional; you're getting paid for it. What more do you want?" And that was the last time I asked him about my work. His point was valid: It was his job to say if there was a problem, not to give out compliments. Recently, Julie related that he originally only worked with text. As he was leaving the company, Shelly told Julie, "You have to oversee the art now as well." Julie admitted to Shelly that he knew nothing about art. So Shelly suggested that Julie never critique the art but if he recognized a problem to tell the artist to fix it — but just not *how* to fix it, as Julie hadn't a clue. This way Julie wouldn't expose his ignorance of art. Shelly told him the problems he was able to spot are the same ones the kids buying the books would find, so it would be okay.

After a while, I didn't see the boys — Joe, Frank, and Alex — so much any more. We all moved in our own directions. I had my group of friends, none of whom were in comics. I think it was the same with the others. We all kind of went our own way. Occasionally, I'd see one of them in the office, and we were always very friendly. Sometimes we'd have coffee,

Bill Crawford's fine portrait of Carmine in 1958.

49

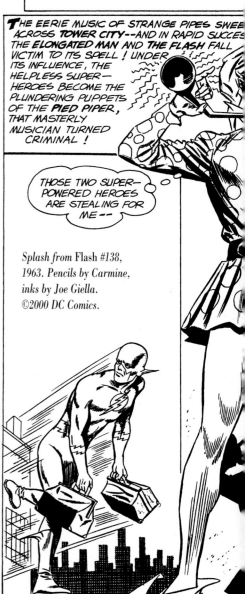

THE EERIE MUSIC OF STRANGE PIPES SWEE
ACROSS *TOWER CITY*—AND IN RAPID SUCCES
THE *ELONGATED MAN* AND THE *FLASH* FALL
VICTIM TO ITS SPELL! UNDER
ITS INFLUENCE, THE
HELPLESS SUPER-
HEROES BECOME THE
PLUNDERING PUPPETS
OF THE *PIED PIPER,*
THAT MASTERLY
MUSICIAN TURNED
CRIMINAL!

THOSE TWO SUPER-
POWERED HEROES
ARE STEALING FOR
ME —

Splash from Flash #138,
*1963. Pencils by Carmine,
inks by Joe Giella.
©2000 DC Comics.*

I'M COMING!

or we'd just kid around for a few minutes, and that would be it. Then it was back to work.

As time went along, I saw Julie more than the other artists. On rare occasions, Julie and I might get together away from the office. One time he and his beautiful redheaded wife came to a Christmas party at my parents' house in Queens. Another time they came out to Long Island with us. My brother shot home movies of everyone, including Julie's wife jumping around, doing gymnastics.

Back in the city, Julie and I would see each other every week when I'd pick up my scripts. We had lunch together on a regular basis. The funny thing is, he always had navy bean soup — every single day. I'd go home and come back the next week: Art, script, lunch, navy bean soup! This routine went on for years and years.

The New Flash.
One day in 1956, I brought a job in — I think it was a romance — and, without fanfare, Julie said to me, "You're going to draw a super-hero again." I was surprised because they hadn't been selling. Of the hundreds of costumed characters created in the '40s, only Superman, Batman, and Wonder Woman survived in their own titles. Julie said, "You're going to be doing The Flash."

Writer Gardner Fox and artist Harry Lampert created the original Flash, who appeared in the first issue of *Flash Comics,* 1940. I had worked on the Golden Age Flash early in my career under Shelly Mayer. I thought it was the

THE PIED PIPER'S DOUBLE DOOM!

--AND ARE NOT EVEN AWARE THAT THEY'RE DOING SO!

old Flash Julie wanted me to draw and I was bewildered as to why they were pulling the character out again. Then he told me it was to be a totally new Flash and Julie wanted me to design the character as well as draw the story.

Bob Kanigher handed me the script, and had even laid-out a stick-figure idea of the first cover. Bob sat with me and asked, "If there's anything in the script that you don't quite understand, ask me." And we went over it a little. That's how I know it was Bob's script. No matter what anybody else says, Bob Kanigher introduced the ring that contained the uniform. Julie may have helped Bob come up with the combination of lightning and chemicals giving The Flash his abilities and I believe Julie came up with the character's name, Barry Allen (after talk show hosts Barry Gray and Steve Allen). But if you look at the very first script, you can tell it was Kanigher's type of story. He had a style to his stories that was distinctive. Whether you liked them or not, his tales were pure Kanigher.

Then Kanigher said to me, "Go create a costume for this guy; forget the old character. You go create something new." So I went home and designed the red outfit that you see today. And it works because I tried to keep the design simple and colorful so people could easily recognize him. I also designed the character streamlined for speed. Everyone liked it and said, "Okay, let's go with it." I also designed Flash's "Rogues Gallery" of villains. So the creation of the new character, was a group effort between Julie, Bob, and myself.

I'M COMING!

Far left opposite and above: Cover vignettes from the classic Flash #123, "The Flash of Two Worlds," Sept. 1961. Pencils by Carmine, inks by Murphy Anderson. ©2000 DC Comics.

HOW I DRAW

FLASH'S HEAD. STEP 1 — I BEGIN WITH AN OVAL AND THEN LIGHTLY DRAW IN GUIDE-LINES FOR THE EARS, NOSE AND MOUTH.

FLASH'S HEAD. STEP 2 — I THEN ROUGH IN EYES, NOSE, MOUTH WITHIN SHAPE OF HEAD, INDICATING MASK AND EXPRESSION HE WILL ASSUME.

FLASH'S HEAD. STEP 3 — SHARPEN ALL FEATURES DISTINCTLY, INCLUDING MASK AND WINGED EAR-PIECES. LASTLY, I SHARPLY DEFINE THE ALL-IMPORTANT EXPRESSION.

FLASH'S FIGURE. STEP 1 — I BEGIN BY BLOCKING OUT LIGHTLY A FIGURE OF APPROXIMATELY 7½ HEADS HIGH, THEN SUG-GESTING WITH MANY ARMS AND LEGS THE FINAL POSE.

FLASH'S FIGURE. STEP 2 — AFTER CHOOSING THE FIGURE FOR THE FINAL DRAWING, I BEGIN ROUGHING IN THE MUSCLE-STRUCTURE FOR THE FINAL PHASE.

FLASH'S FIGURE. STEP 3 — I THEN TRIM THE MUSCULAR FRAME TO A TRIM, SLEEK ONE; ADD COSTUME AND EX-PRESSION AND REMOVE ALL EXCESS LINES!

Julius Schwartz

Carmine and I first met in the 1940s. For the large majority of his career as an artist at DC, I was his editor. In 1966, Carmine told me he was quitting DC and wouldn't be finishing his current Batman story. I was shocked. Then DC owner Jack Liebowitz got word of Carmine's exodus. He called me into his office and asked, "How important is Carmine Infantino to DC?" I told him, "Carmine is more important than anyone else I work with."

Liebowitz told me he would do what he had to do to keep Carmine. After that, Murphy Anderson and I went to Carmine's house, where I told him, "Liebowitz met your terms, now can I get you to finish the Batman job?"

As an artist he was very conscientious. He co-created the Flash, which launched the Silver Age. I remember him coming in in the mornings and looking at the pages he drew the day before. If he didn't like one or had a better idea, he'd redraw the *entire* page. He came up with the best cover layouts. I started getting him to dream up original cover ideas and then had stories written around them. My favorite cover idea of his was a stark close-up of the Flash holding up his hand like a traffic cop saying, "Stop! Don't pass this magazine by! My life depends on it." After a while he was

on Infantino

doing this for all the editors. He was my top penciler. Sometimes he'd push me to let him ink, but he was too valuable as a penciler to let him do much inking.

Carmine revived Batman artistically with what we called the "New Look." This led to the TV show, which was a smash hit. When the TV producers wanted another female character, Carmine and I created Batgirl. I called that the "Million Dollar Debut of Batgirl." Carmine also designed the sleek new Batmobile, Batgirl's motorcycle, and Poison Ivy. Most often, when a writer or I would come up with an idea for a new character or villain, it would be Carmine who would come up with the perfect design.

When he became publisher at DC, he honored employees by having custom DC watches made and inscribed for everyone who'd been with the company for a quarter of a century. We also had very good Christmas parties when Carmine was in charge. When I'm asked, "What was the best thing Carmine did for DC?," the answer is: "*Everything* Carmine did was the best for DC!"

Opposite left and right: Carmine explains how he handles Flash from a 1960s Flash Annual. Opposite and right: Vignette of Elongated Man from the cover of The Flash *#112, April 1960. ©2000 DC Comics.*

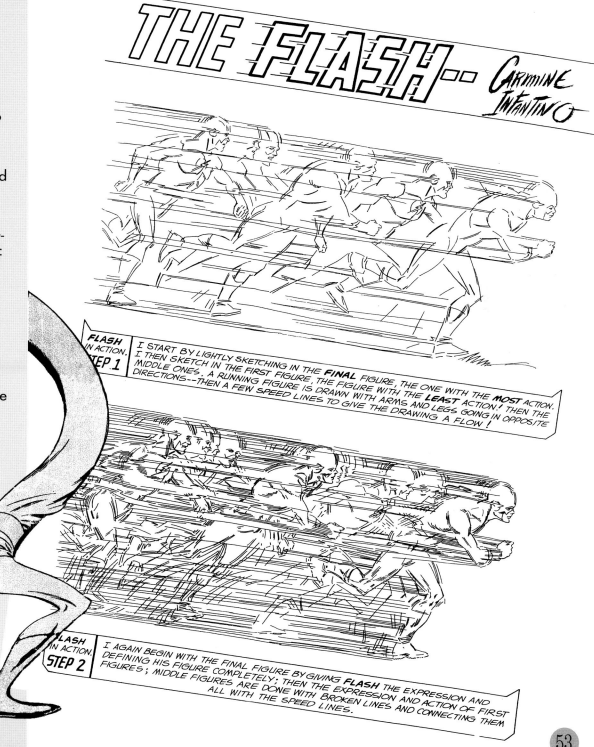

THE FLASH -- Carmine Infantino

FLASH IN ACTION. STEP 1
I START BY LIGHTLY SKETCHING IN THE **FINAL** FIGURE, THE ONE WITH THE **MOST** ACTION. I THEN SKETCH IN THE FIRST FIGURE, THE FIGURE WITH THE **LEAST** ACTION! THEN THE MIDDLE ONES. A RUNNING FIGURE IS DRAWN WITH ARMS AND LEGS GOING IN OPPOSITE DIRECTIONS--THEN A FEW SPEED LINES TO GIVE THE DRAWING A FLOW!

FLASH IN ACTION. STEP 2
I AGAIN BEGIN WITH THE FINAL FIGURE BY GIVING **FLASH** THE EXPRESSION AND DEFINING HIS FIGURE COMPLETELY; THEN THE EXPRESSION AND ACTION OF FIRST FIGURES; MIDDLE FIGURES ARE DONE WITH BROKEN LINES AND CONNECTING THEM ALL WITH THE SPEED LINES.

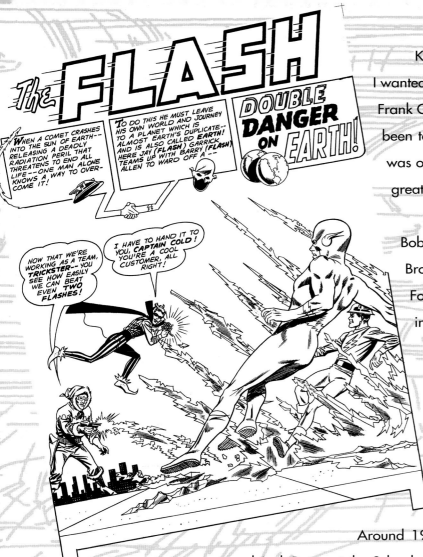

Above: Splash page from The Flash #129, 1962. Background image: The Flash in action from "How I Draw the Flash" by Carmine, circa 1960s. Opposite far right: Memorable Flash cover by Carmine and Joe Giella. ©2000 DC Comics.

Kanigher was very good to work with. He gave me plenty of room to do what I wanted. Joe Kubert was assigned to ink the first story, which ran in *Showcase #4*. Frank Giacoia was the natural choice to ink my pencils but the deadline may have been too tight for him. I'm very pleased it was Joe who got to ink my pencils. I was on the third Flash issue of *Showcase* [#13] when I learned the first one sold great. Julie said to me, "You're going to be doing a lot more of these."

I didn't understand why, but after the four *Showcase* issues, Julie took Bob off the Flash. Bob wasn't happy about it, but it was Julie's decision. John Broome became the writer when Flash got his own title and I believe Gardner Fox also wrote a few. *The Flash* was the first successful, new super-hero title in quite a few years, kicking off the so-called "Silver Age of Comics."

The Flash jump-started the whole super-hero business again and went a long way in saving the comic book business from extinction. DC followed with Green Lantern and then the whole group of super-heroes. They were dragging these things out one after another. So The Flash started the super-hero party all over again, changing the course of the entire industry.

Back to School (again): SVA.

Around 1960, I went back to school again, this time to study under a gentleman named Jack Potter at the School of Visual Arts. What Jack taught me about design was monumental, and I went through a metamorphosis working with him. I'd sit there confused and he'd tear the work apart. But then it was like a light bulb going off — *bam!* — and I'd understand everything he was getting at.

Burne Hogarth was also at SVA. I liked his work but I never met him. I knew of his talent from when he took over the *Tarzan* strip from Hal Foster (I was crazy about Foster's work and used to copy it that time). Hogarth was a major influence on the work of my fellow DC artist Gil Kane.

After studying with Potter at the SVA, my work started to grow by leaps and bounds. I was achieving indi-

viduality in my work that wasn't there before.

I threw all the basics of cartooning out the window and focused on pure design. Everything I did was design-oriented. That was quite the challenging task. But that's where Potter's teaching took me. I'd create muscles that didn't exist, but they were believable. My figures in that period were designed like ballet dancers.

After I studied with Potter, I started putting gesturing hands in captions; that was decorative. He taught us to do everything decoratively. I'd always found captions very dull. So I thought I'd break the captions into smaller paragraphs and use hands to get people to read them. I regularly pushed design and perspective to the extreme.

I love great illustrators like Sickles and Dorne; great strip artists such as Foster, Caniff, and Raymond; and great comics artists such as Joe Kubert, Jack Kirby, Nick Cardy, Neal Adams, Alex Toth, Alex Niño, and Nestor Redondo. They are all marvelous artists. I always appreciated and I continue to hold their work in regard. But what I came to appreciate more with time was Edgar Degas and his fellow French Impressionists. As I have said, Degas was an absolute design genius. And Norman Rockwell, as popular as he is, is under-appreciated for his masterful design.

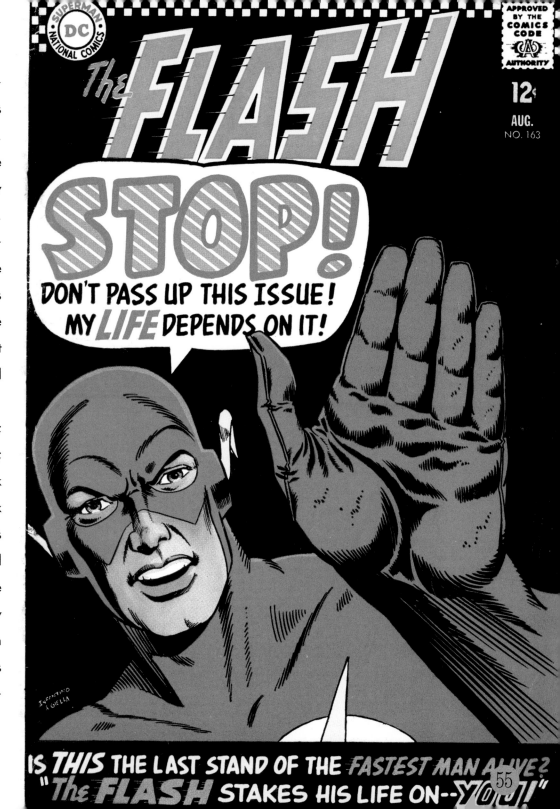

Strange Adventurers

Comics inherently have their fair share of bizarre characters, and Carmine Infantino has drawn any number of strange adventurers, especially for DC Comics in the 1950s and '60s. On this page is featured Flying Stag, the mightiest hunter of The Nations tribe, who for one hour a day is granted super-powers by Manitou, the Great Spirit, and he becomes... Super-Chief! As written by Gardner Fox, the short-lived series was set in the years before white men set foot on the North American continent. Only three episodes were produced, respectively in All-Star Western #117-119, 1961.

Above: Super-Chief stands ready to defend his beloved tribe against alien warriors, warring Algonkins, and giant, club-wielding Mohawks. This panel detail is from Chiefy's last appearance in All-Star Western #119, June 1961. ©2000 DC Comics.

Above: The Nations' greatest super-hero takes on Native American giants in this panel detail from All-Star Western #118, April 1961. ©2000 DC Comics.

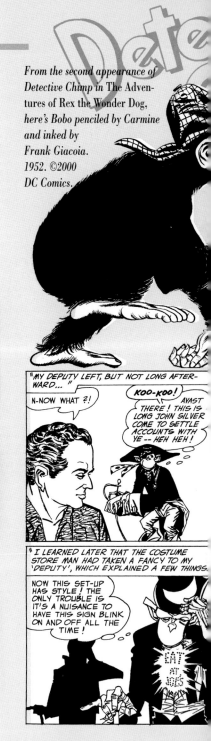

From the second appearance of Detective Chimp in The Adventures of Rex the Wonder Dog, here's Bobo penciled by Carmine and inked by Frank Giacoia. 1952. ©2000 DC Comics.

"MY DEPUTY LEFT, BUT NOT LONG AFTERWARD..."

N-NOW WHAT ?!

KOO-KOO! AVAST THERE! THIS IS LONG JOHN SILVER COME TO SETTLE ACCOUNTS WITH YE -- HEH HEH!

"I LEARNED LATER THAT THE COSTUME STORE MAN HAD TAKEN A FANCY TO MY 'DEPUTY', WHICH EXPLAINED A FEW THINGS.

NOW THIS SET-UP HAS STYLE! THE ONLY TROUBLE IS IT'S A NUISANCE TO HAVE THIS SIGN BLINK ON AND OFF ALL THE TIME!

EAT AT JOE'S

Another odd series was "Detective Chimp," from Rex the Wonder Dog, as penciled and inked by Carmine. The artist considers the adventures of Bobo the chimpanzee to be his favorite work. The series was scripted by John Broome.

THAT'S A ROUGH IDEA OF WHAT WENT ON ALL WEEK! BOBO JUST COULDN'T MAKE UP HIS MIND ABOUT HIS COSTUME ..."

I WONDER IF I'D WOW 'EM WITH THIS SERGEANT SPACE OUTFIT?

Panels featuring Carmine's pencils & inks from The Adventures of Rex the Wonder Dog *#21, 1954. ©2000 DC Comics.*

AT LONG LAST, THE PARADE OF COSTUMES ENDED ..."

YAAAHEEEEEE!

THAT'S MY WAR WHOOP!

LIGHTNING ARROW— THE FAMOUS SEMINOLE INDIAN CHIEF! I COULD HAVE STOOD ANYTHING BUT THIS!

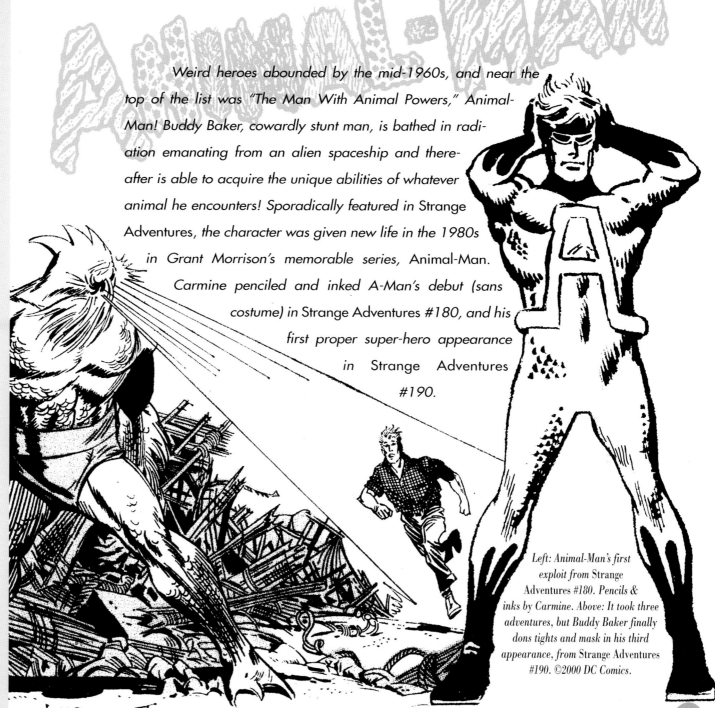

Weird heroes abounded by the mid-1960s, and near the top of the list was "The Man With Animal Powers," Animal-Man! Buddy Baker, cowardly stunt man, is bathed in radiation emanating from an alien spaceship and thereafter is able to acquire the unique abilities of whatever animal he encounters! Sporadically featured in Strange Adventures, the character was given new life in the 1980s in Grant Morrison's memorable series, Animal-Man. Carmine penciled and inked A-Man's debut (sans costume) in Strange Adventures #180, and his first proper super-hero appearance in Strange Adventures #190.

Left: Animal-Man's first exploit from Strange Adventures #180. Pencils & inks by Carmine. Above: It took three adventures, but Buddy Baker finally dons tights and mask in his third appearance, from Strange Adventures #190. ©2000 DC Comics.

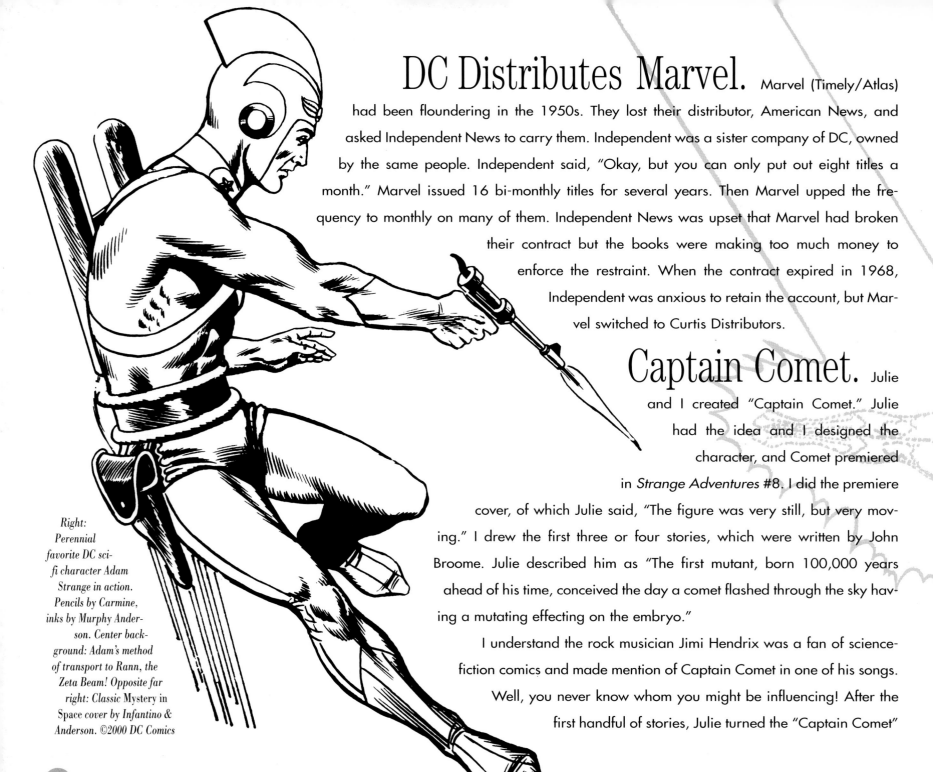

DC Distributes Marvel.

Marvel (Timely/Atlas) had been floundering in the 1950s. They lost their distributor, American News, and asked Independent News to carry them. Independent was a sister company of DC, owned by the same people. Independent said, "Okay, but you can only put out eight titles a month." Marvel issued 16 bi-monthly titles for several years. Then Marvel upped the frequency to monthly on many of them. Independent News was upset that Marvel had broken their contract but the books were making too much money to enforce the restraint. When the contract expired in 1968, Independent was anxious to retain the account, but Marvel switched to Curtis Distributors.

Captain Comet.

Julie and I created "Captain Comet." Julie had the idea and I designed the character, and Comet premiered in *Strange Adventures* #8. I did the premiere cover, of which Julie said, "The figure was very still, but very moving." I drew the first three or four stories, which were written by John Broome. Julie described him as "The first mutant, born 100,000 years ahead of his time, conceived the day a comet flashed through the sky having a mutating effecting on the embryo."

I understand the rock musician Jimi Hendrix was a fan of science-fiction comics and made mention of Captain Comet in one of his songs. Well, you never know whom you might be influencing! After the first handful of stories, Julie turned the "Captain Comet"

Right: Perennial favorite DC sci-fi character Adam Strange in action. Pencils by Carmine, inks by Murphy Anderson. Center background: Adam's method of transport to Rann, the Zeta Beam! Opposite far right: Classic Mystery in Space cover by Infantino & Anderson. ©2000 DC Comics

art chores over to Murphy Anderson.

Adam Strange.

I was scheduled to draw the "Adam Strange" strip from the beginning but I was overseas entertaining troops in Korea and Japan with the National Cartoonists Society. So Mike Sekowsky started it in *Showcase*. When I came back, Julie said to me, "You're going to be doing 'Adam Strange' in *Mystery in Space* now." I said, "Good, so we'll be getting rid of the other assignment?" "No, no. You're doing both." So I said, "Okay, great." I was now doing both "Adam Strange" and *The Flash* on a regular basis. Gardner Fox wrote "Adam Strange."

As I didn't want to take any work away from Mike, I checked with Sekowsky before I took over the series. He said, "Oh, there's no problem; they told me I was just filling in till you got back." So, from the beginning, it was to be my strip. I'm proud to say it's one of the most fondly remembered science-fiction comics of all time. I know Julie loved it too, as he was involved in science-fiction since even before he got into comics. I especially enjoyed designing the architecture of the futuristic buildings. Science-fiction isn't normally a big seller — EC's *Weird Science* didn't last, and *Flash Gordon* didn't last as a comic book — so I expected "Adam Strange" to be cancelled, but Julie kept giving me scripts! Sales were growing, and we had a nice run. I'm proud of that work.

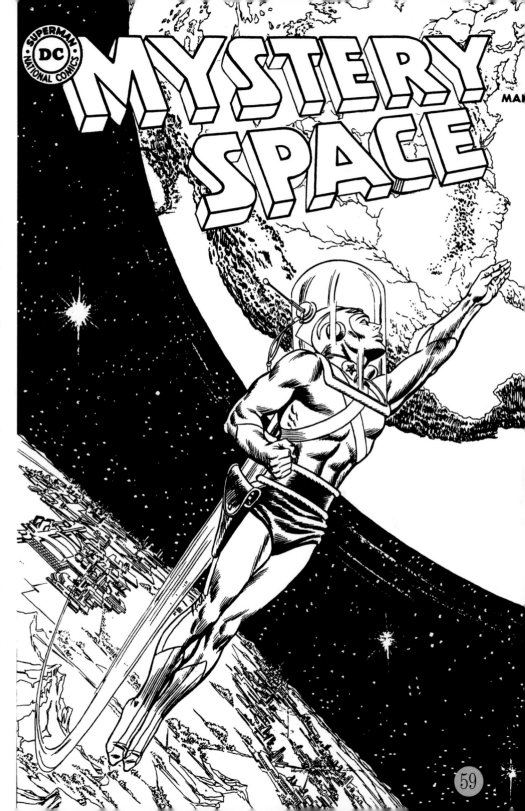

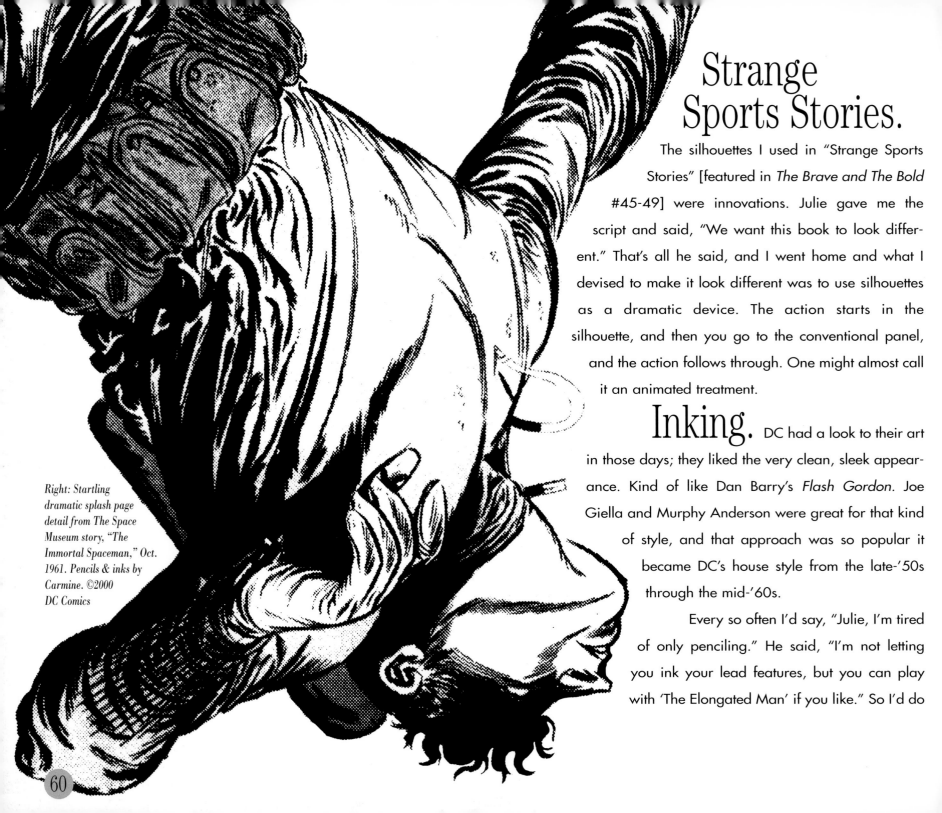

Strange Sports Stories.

The silhouettes I used in "Strange Sports Stories" [featured in *The Brave and The Bold* #45-49] were innovations. Julie gave me the script and said, "We want this book to look different." That's all he said, and I went home and what I devised to make it look different was to use silhouettes as a dramatic device. The action starts in the silhouette, and then you go to the conventional panel, and the action follows through. One might almost call it an animated treatment.

Inking.
DC had a look to their art in those days; they liked the very clean, sleek appearance. Kind of like Dan Barry's *Flash Gordon*. Joe Giella and Murphy Anderson were great for that kind of style, and that approach was so popular it became DC's house style from the late-'50s through the mid-'60s.

Every so often I'd say, "Julie, I'm tired of only penciling." He said, "I'm not letting you ink your lead features, but you can play with 'The Elongated Man' if you like." So I'd do

Right: Startling dramatic splash page detail from The Space Museum story, "The Immortal Spaceman," Oct. 1961. Pencils & inks by Carmine. ©2000 DC Comics

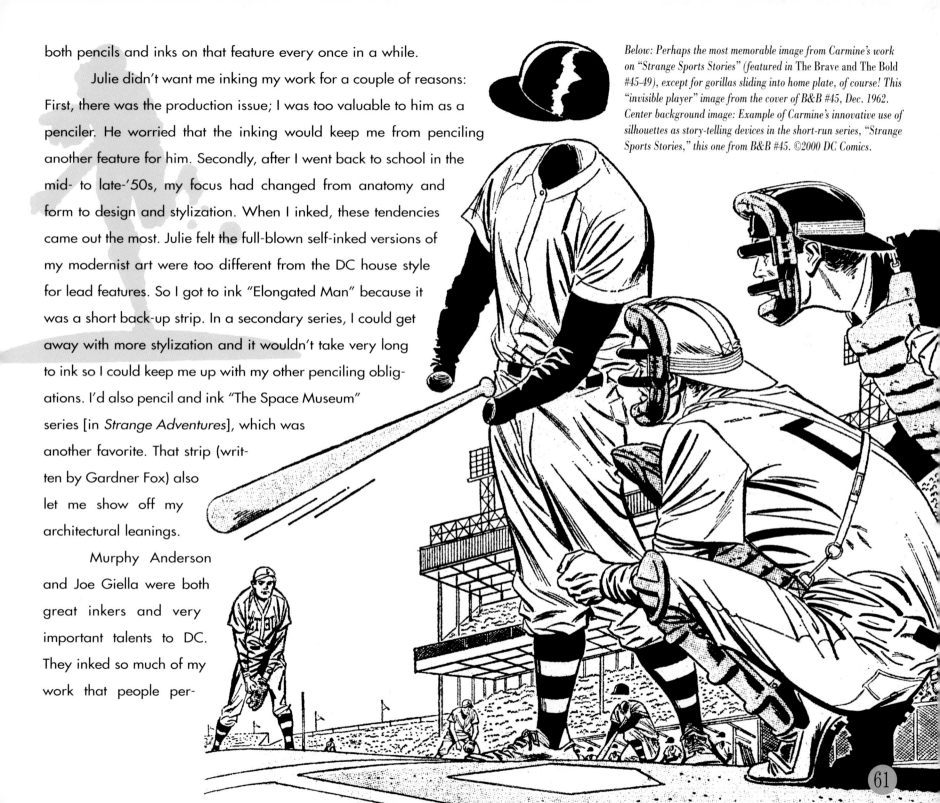

both pencils and inks on that feature every once in a while.

Julie didn't want me inking my work for a couple of reasons: First, there was the production issue; I was too valuable to him as a penciler. He worried that the inking would keep me from penciling another feature for him. Secondly, after I went back to school in the mid- to late-'50s, my focus had changed from anatomy and form to design and stylization. When I inked, these tendencies came out the most. Julie felt the full-blown self-inked versions of my modernist art were too different from the DC house style for lead features. So I got to ink "Elongated Man" because it was a short back-up strip. In a secondary series, I could get away with more stylization and it wouldn't take very long to ink so I could keep me up with my other penciling obligations. I'd also pencil and ink "The Space Museum" series [in *Strange Adventures*], which was another favorite. That strip (written by Gardner Fox) also let me show off my architectural leanings.

Murphy Anderson and Joe Giella were both great inkers and very important talents to DC. They inked so much of my work that people per-

Below: Perhaps the most memorable image from Carmine's work on "Strange Sports Stories" (featured in The Brave and The Bold *#45-49), except for gorillas sliding into home plate, of course! This "invisible player" image from the cover of B&B #45, Dec. 1962. Center background image: Example of Carmine's innovative use of silhouettes as story-telling devices in the short-run series, "Strange Sports Stories," this one from B&B #45. ©2000 DC Comics.*

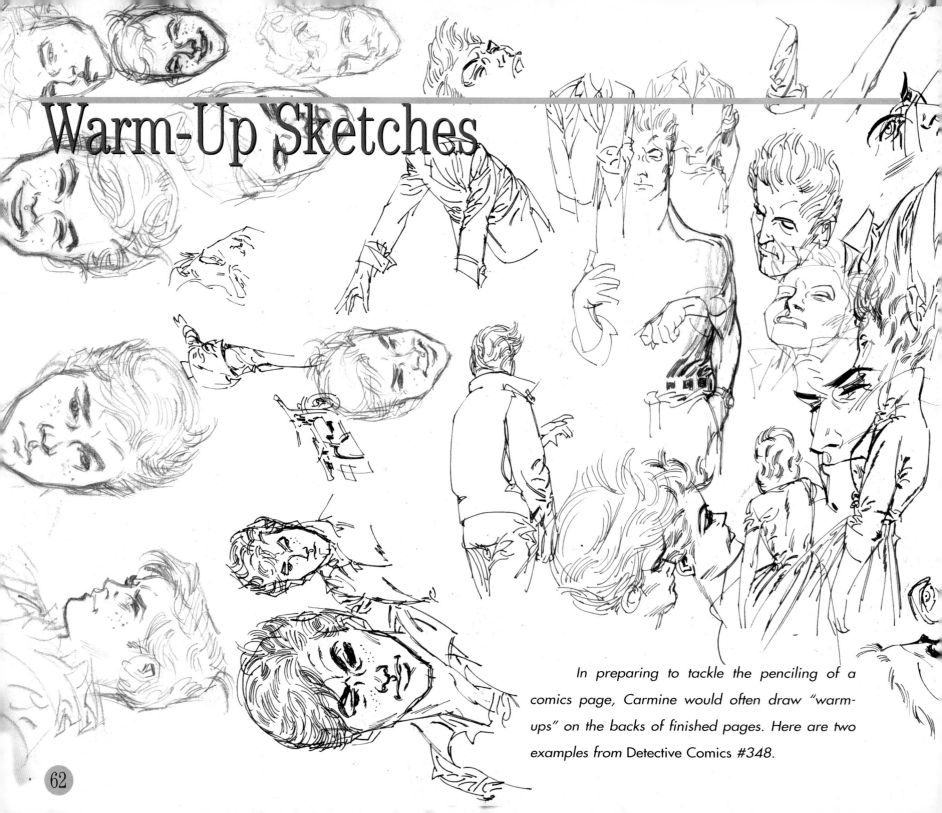

Warm-Up Sketches

In preparing to tackle the penciling of a comics page, Carmine would often draw "warm-ups" on the backs of finished pages. Here are two examples from Detective Comics #348.

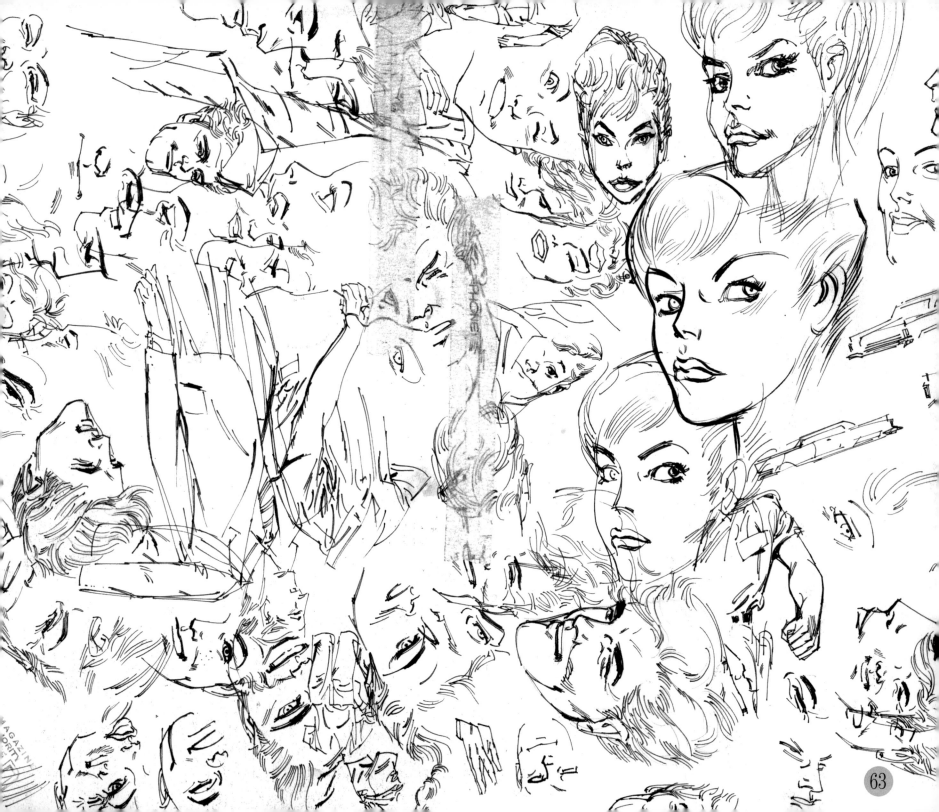

THEN, A *PHONE-Y* ENDING TO THE FIGHT...

POLICE? I'VE GOT QUITE A HAUL FOR YOU? 212 RIVER STREET...

LATER THAT NIGHT, BACK ON THE *MAIN STEM*...

ALL RIGHT, RALPH-- SOLUTION TIME! WHO WAS *LIETAG*-- WHAT WAS HIS CONNECTION WITH THE EXHIBIT OWNER, COURTNEY? WHY DID--

HOLD THE *WHO, WHAT,* AND *WHY,* SUE-- AND LET ME START FROM THE BEGINNING...

SOME TIME AGO, COURTNEY WENT TO LIETAG --A CRACK COUNTERFEITER OF JEWELS, AND GOT HIM TO MAKE A PERFECT COPY OF THE *CROWN JEWELS OF ENGLAND!* THEN DURING A TRIP ABROAD, COURTNEY FULFILLED A LIFETIME'S AMBITION...

ceived their style as part of my own. I was beginning to experiment at the time and I threw anatomy out in favor of a higher level of design. Murphy was an excellent draftsman and I'd try to explain what I was trying to achieve to him but this was quite contrary to his own sensibilities. The more stylized I became, the more he thought the work had to be "fixed up." At one point, he asked for a raise because he had to change my work so much. What he thought he had to "fix" was the new style I was most excited about. While I thought Murphy's work was great, I just wanted people to see what I was *really* going for.

My inks were so different from the standard Anderson or Giella inks people were used to seeing

Above: A three-panel example of Carmine's brilliant pencil & ink work on "The Elongated Man," backing up Detective Comics in the mid-'60s. ©2000 DC Comics.

on my pencils, that I often signed "The Elongated Man" stories I inked, "Rouge Enfant," my surname in French.

Often on my "Space Museum" work, I would sign "Cinfa." DC would get letters saying, "Who's the guy named Cinfa, and who's this other guy, Rouge Enfant?" One fan complained, "These guys are copying Infantino! Why are you using them when you could get the real thing?" I think, after a while, Julie let the cat out of the bag and told them. I've worked with many great inkers over the years, but if I were to pick my all-time favorite, it would be my good friend, the late Frank Giacoia.

John Broome.

John Broome wrote "Elongated Man" in the early *Flash* stories. A delightful writer who also wrote *The Flash,* John likewise scribed those "Detective Chimp" stories which were so charming. We got to know each other pretty well. He always looked like Gary Cooper to me. It took him forever to write because he slaved over every word, but the final product was always meticulous. He left DC, moved to France, and after traveling the world he ended up teaching English at Tokyo University.

Elongated Man vs. Plastic Man.

I also started doing "The Elongated Man" as a backup strip in *Detective Comics.* Julie was still my editor at the time and he gave me the assignment. I really liked "Elongated Man" because it was comical and I enjoyed drawing comedy. It also one of my favorite strips, because it was about as close to animation as I could do in a comic book. I liked being able to test the limits of the comic book form and this strip allowed me to do that.

Obviously, Elongated Man was a take-off on Jack Cole's original Plastic Man from the '40s and '50s. Cole was a great artist and DC now owned Plastic Man, but every time we tried to bring Plas back, he wouldn't sell. The only thing I can put my finger on is that it was *too* humorous; kids wanted their super-heroes very straight. I enjoyed doing humor; I would have enjoyed doing a humor strip. I had tried a couple for syndication before, many years prior, but I could never sell them. One was called *Buddies,* very similar to the current TV show *Friends* — a bunch of youngsters living together and kidding around. "Detective Chimp" [in *Rex the Wonder Dog*] and "Elongated Man" were as close to humor as I got. By the way, "Detective Chimp" may be my all-time favorite feature.

Later in the '60s, when I was in charge, I tried to revive *Plastic Man* again with Bob Oksner doing the art. Oksner was a fine artist and his version was absolutely great — as good as Jack Cole's — and that's saying a lot! But the damn thing just would not sell.

The Caped Crusader. In the

early-'60s, Bob Kane, who had created Batman in the late-'30s with the aid of writer Bill Finger and had further developed the mythos with art assistant Jerry Robinson, was still handling production of all of the Batman material. I didn't know for sure and I couldn't prove it, but I believed that Kane was farming-out almost all of the Batman work to unknown, uncredited "ghost" artists. And the work just wasn't good.

I was working on "Adam Strange" and Julie phoned me about coming in to see him. I said, "Let me just finish this job I'm on first," And he said, "You should come up *now*. Irwin wants to see you." Irwin Donenfeld was the Editorial Director and Publisher of DC Comics then. So Julie and I went in, and Irwin told us that Batman was in terrible shape. He said, "I'm going to give you six months to save the character. If you can pull it out, fine; but if you can't get the sales up, we want to drop it." That's how bad it was.

I had not been a big fan of the character; but in 1964, with Julie Schwartz as editor, I started on Batman. I began drawing all the Batman covers with *Detective Comics*. Julie said, "You better come up with some cover ideas; we need something different." So, the first one was a

©2000 DC Comics.

©2000 DC Comic.

departure. It was different with a three-panel layout and people liked it. Julie suggested I make some changes to Batman's costume as part of our character update. We developed what was called the "New Look." This included changes to the ears and nose of Batman's cowl, as well Julie's suggestion of adding the yellow circle around the insignia on Batman's chest. That was the first step in saving the book from cancellation. I also redesigned the Bat-mobile, which later served as inspiration for the TV show's version.

As always, I had tons of other work, and getting Kane totally away from his creation was a sticky situation. So Kane continued handling the interior of the regular *Batman* title. We noticed right away that the sales of *Detective Comics* I drew featuring Batman jumped much higher than the *Batman* issues by Kane. So I was assigned to draw the covers of all the titles Batman appeared in. By improving the character in general, through my Batman stories in other titles, plus doing all Batman covers, we saved the character.

The sales started to increase pretty quickly; Batman was coming back. We saved the book despite Kane, and the character was in demand again. About a year later, when the *Batman* TV show premiered, we had an all-out Batman explosion on our hands! There were toys, games, posters, advertising, plastic models, action figures, etc., and I drew the art for all of it, most often with Murphy Anderson's inks. Batman became the most popular comic book character in the world. We were getting an unheard of 95% sell-through with print-runs up to 900,000 copies per issue!

Later on, when I became Editorial Director around '67, I said to Kane, "Listen, Robert: What is your page rate? I know you're farming this stuff out, so here's what I want to do: I'll give you half of the page rate to *not* work on it. You don't have to do a thing, and I'll take care of everything. Just take the money." He went for it. That's what I did to keep decent talent on Batman. Ultimately it came out that Shelly Moldoff had been doing Kane's work, acting as what we call in the business a "ghost."

Success & the Newspaper Strip.

I'd helped Batman with all those covers and stories in *Detective Comics;* then the TV show took off. I was doing all Batman licensing art and they wanted me to also draw the *Batman* newspaper strip. Finally I had a newspaper strip — like I'd always wanted — but the funny thing was, I was doing so much work something had to give. I was afraid the quality was suffering. I went to Donenfeld and said, "Listen: You have to take me off something; I just can't keep doing all this." So he took the strip away, telling me he would rather see me on the books. So there went my dream of being the big newspaper strip artist! I accepted his decision as being best for the company, but honestly I'd hoped to be taken off something else.

In those days, I was making about $19,000 a year — almost $50,000 a year in today's dollars — and that was pretty successful for a freelance comic book artist. I had a car and I was running around a lot. My folks bought a nice suburban home in Queens, and I stayed there for a long time. Ultimately, I moved into the city and got an apartment in Greenwich Village.

Batgirl.

The *Batman* TV show enjoyed a terrific first season and *Batman* comics sales were fantastic. But the TV series began to lose momentum by 1967 and producer William Dozier called Julie to say he thought the show would do

YES, THIS IS GOTHAM CITY'S NEWEST CRIME-FIGHTER... BATGIRL!

better by introducing a new female character. I guess they got a great response to Catwoman, but she couldn't be in every episode. Julie and I got together to create Batgirl. It was Julie's idea that she be Commissioner Gordon's daughter. He asked me to design what she would look like in and out of costume. I also designed her motorcycle.

Gardner Fox wrote the first story, "The Million Dollar Debut of Batgirl," which I drew, and it ran in *Detective Comics* #359. I enjoyed drawing Batgirl even more than Batman. The TV people liked my designs and adapted them for the show. She first appeared on TV in the season premiere, September 14, 1967. The episode title was "Enter Batgirl, Exit Penguin." Yvonne Craig played the role in the episode, which looked like a pilot for a series.

We found out later that Bob Kane had a Bat-girl, the niece of his Batwoman. She was a ridiculous character whose only purpose was to pester Robin. In fact, the forgettable three appearances of Kane's Batgirl had her in a costume which imitated Robin's: nothing like a bat. When Julie and I created the Batgirl we all know and love, we weren't even aware of Kane's short-lived embarrassment of a character.

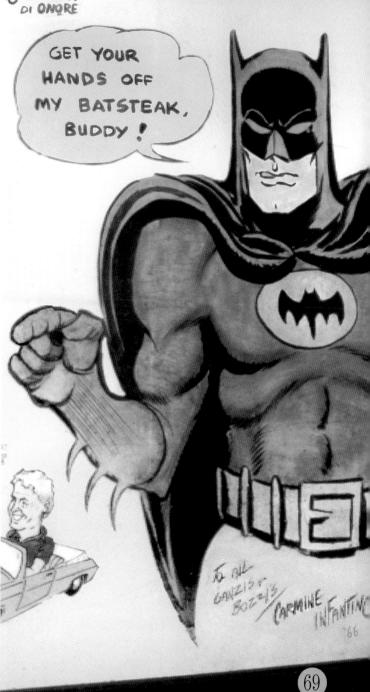

Carmine rendered this great image of the Caped Crusader on the wall of the The Palm Restaurant, New York City. Photo courtesy of proprietor Al Serpagli.

Arnold Drake on Infantino

One of my favorite stories to tell about Carmine Infantino involves the creation of Deadman. Shortly before Carmine was promoted from artist to Art Director at DC, I was in the office to pitch my latest idea to editor Jack Miller. Miller and Carmine shared office space, so Carmine heard the whole pitch. I told Miller about my idea for a new character named Deadman and even produced a rough sketch of what he might look like. Well, Jack let me know in no uncertain terms that the Comics Code censors would never allow a character named "Deadman." Fully rejected and with all the wind out of my sails, I prepared for my exit. At that point I noticed Carmine behind and out of Miller's view. He was gesturing with his fist up in the air, that I should not give up but really give it to Miller.

I have to tell you that gesture was a point of inspiration I doubt I'll ever forget. Following Carmine's instigation, I proceeded to lay into Miller; that we couldn't run around paralyzed in constant fear of what the Code might do. I told him the company had to proceed with every good idea and leave the Code's business

Deadman.
Arnold Drake and I created Deadman in *Strange Adventures* #205. It started with Drake writing the script; then I designed the character and made whatever suggestions I might have had. Drake and I completed the first issue, but I was becoming too swamped with executive duties to draw full stories. Neal Adams is a great talent, and when he requested to take over the feature as artist, I was happy to give it to him.

I did continue to lay out the covers, over which

Neal did finished art. I also plotted the next three or four "Deadman" stories, which Neal also drew and sometimes inked. Editor Jack Miller wrote the finished dialogue on those issues.

At a recent convention, Arnold Drake suggested he, Neal and myself team-up on a new *Deadman* mini-series. Neal and I very seriously considered it. DC heard about the idea and was interested. But after much thought, I think it's a bit more than I'm prepared to commit to.

Above: Classic Deadman image by Carmine. From the cover of his debut in Strange Adventures #205, Oct. 1967. ©2000 DC Comics.

Neal Adams.

When I first met Neal Adams he was doing freelance work for DC on *The Adventures of Jerry Lewis.* He'd talked someone into letting him work at a drawing board in one of the production rooms. This was shortly after I became art director. I was knocked out by his work. He was very talented, could draw anything, and was being wasted on a third-string title, so I started assigning him covers and pushed the top editors to hire him for interior work. He had a fresh new look that I wanted. Murray Boltinoff started using him on *The Brave and the Bold.* Then Julie started using Neal and ultimately even Mort Weisinger hired him.

Now Neal might say he was happy doing *Jerry Lewis* or that he could draw the humor stuff faster so he made as much money that way, fine. But if I hadn't pushed him and I hadn't pushed the editors, think of all the to the Code. Well, it worked and before you know it, Carmine and I were working together on the launching of "Deadman." Carmine took my idea of what the character might look like and updated it. He changed my skull's head to the uniquely intriguing, paste-white face we all know. His contributions to the character's design also included the addition of the tall collar and loose-top shoes. When Carmine showed me his interpretation of Boston Brand, the only suggestion I made was that the guy had been on his own since he was a kid and he had to have a broken nose, which Carmine immediately added.

Carmine did an excellent job on Deadman's premiere in *Strange Adventures,* and I'm happy to share credit for the creation of Deadman with one who has been so important to the industry for so many years. Before we could do a second issue, Carmine was promoted and off on his great executive career at DC. Neal Adams was proving to be a rising star then. When Neal expressed enthusiasm for Deadman, Carmine whole-heartedly endorsed and promoted the idea of Adams taking over the art chores, which proved to be one of Adams' career hallmarks.

I can't help but mention that there has been talk of Carmine, Neal, and myself teaming-up for an all-new, major Deadman project. I share the excitement of fans and pros alike for the prospects of such a stellar collaboration and I send my congratulations to Carmine on his 60-year career!

Neal Adams on Infantino

My time for my phase of comics fandom was the late '50s, a poor time. EC was gone, its artists scattered to the winds. Joe Kubert on *Tor*, then St. Johns was no more. He was back at DC doing war stories. Toth had gone to Hollywood; Leonard Starr to comic strips, as did Dan Barry. Even Jack Kirby, whose work I had endured for reasons I didn't understand, had teamed up with Wally Wood and gone to comic strips after *Challengers of the Unknown*.

So, who sustained me through the '50? The sappy stories at DC tried to, but it was the artists. Kubert (of course), Russ Heath, Mort Drucker and Gil Kane — and then there was Carmine Infantino. The impressionist/artist. Carmine — bold yet spacious. Did I say spacious? His backgrounds went on *forever*. Totally incorrect, sure, but wonderful. It smacked of a different kind of art. This kind of thinking, I knew, belonged in a finer art. It didn't really aim to be real. When others would ink Carmine's work it would be ruined *totally*. Frank, Joe, Murphy: I love your work, you

great covers, 'Deadman,' *The Spectre*, and *Batman* art we wouldn't have today!

I think our audience in the late-'60s and early-'70s were a lot more mature than other people realized. That's why the Denny O'Neil and Neal Adams *Green Lantern/Green Arrow* worked so well and won awards. That team was also very successful on *Batman*. They should have been even more successful, but Neal was doing so much work and was such a perfectionist, he was constantly up against the wall with the deadlines. This could cause his books to hit the stands a week or even two later than scheduled. This would reduce the book's on-sale time, causing it to be pulled from the rack by the distributors before all the fans could find them.

I've actually been criticized for making Neal Adams the DC house style in the early '70s. But, hey, if Aparo and Giordano wanted to start drawing like Adams, that was fine with me! Neal was a major part of a fine art staff.

Stan Lee's Offer.
So I was this big success at DC, drawing most of the covers and stories for about $19,000 a year, getting about $30 or $35 per penciled interior page. Suddenly Stan Lee, Editor of the competition, calls me up and offers $23,000 for me to come over to Marvel, about a $5,000 raise! Natural-

Boston Brand laments his violent demise in this classic Neal Adams cover image of Deadman from Strange Adventures #207, Dec. '67. ©2000 DC Comics.

WHICH ONE OF YOU IS MY KILLER? WHICH ONE?-- WHICH ONE!?

ly, I was ready to go, and I even gave notice to DC that I was leaving. Jack Liebowitz' secretary called and asked me to meet Liebowitz for lunch. Apparently, Donenfeld had spoken to Liebowitz about my departure, and Liebowitz consulted the editors about how valuable I was to the company. They agreed to offer me an in-house position as Art Director with a raise that was just short of Stan's offer. I thought that was more interesting than freelancing for page rates — even for more money at Marvel — so I accepted. Though I had been exclusive to DC for years, I had been doing the work at home and bringing it in.

Actually, while I was working freelance I wanted to get out of the house, so I said, "I'd like to work here in the office; I don't want to work at home any more." Irwin said, "Okay, come and work here." They gave me space, so I'd go there, work the day, and go home, but it was still for freelance page rates. I just did it at DC. I was doing that when I first met Joe Orlando turning in one of his assignments. After the situation with Stan and DC's counter-offer, I left freelancing and started working full-time at the DC offices as Art Director in late 1966.

Liebowitz & Donenfeld Sell DC.

DC was originally Harry Donenfeld's company. Irwin Donenfeld was Harry's son and he worked there. Jack Liebowitz was originally Harry Donenfeld's accountant. Then he became partners with Donenfeld. When Harry died, Irwin inherited some percentage of the company and focused on the comic book publishing. He was the Publisher and Editorial Director. As far as I know, Irwin and

know, but Carmine's art was never meant to be tightened up. That Infantino scratchy, bold ink style suited the work 100%.

But comics is a business and compromise is the way of things. It's all vanilla, and kids love it. I leave it for others to laud The Flash and Adam Strange and Batman. Good!

But as a young, struggling artist I cherished Infantino inked by Infantino.

At SIA, my art high school, DC Production Manager Sol Harrison visited and passed out original art pages. One was a Pow-wow Smith original. I sat and studied it because it was *nothing* like the other pages. It was a comic book page, but *not* a comic book page. It was art. How dare I say this?

The inking. *Skritch, skritch, skritch.* A sketch line. Not the thin-thick-thin contour line. Not the black with feathered edges to show comic book shadow. Nothing about it was *comic book*. Even the main character's eyes were a series of radiating lines with no black iris hole. Who would do this? And how did he get away with it? Did he even know he was not conforming? I think so.

I kept that page for a year after I'd met and worked with Carmine. Then I gave it to him. He probably doesn't remember, but I do. I lost my one Carmine-Infantino-penciled-and-inked page. Upper right hand panel, close up of Pow-wow Smith, no black dot in his iris. Cool.

Comic Book Artist as Architect

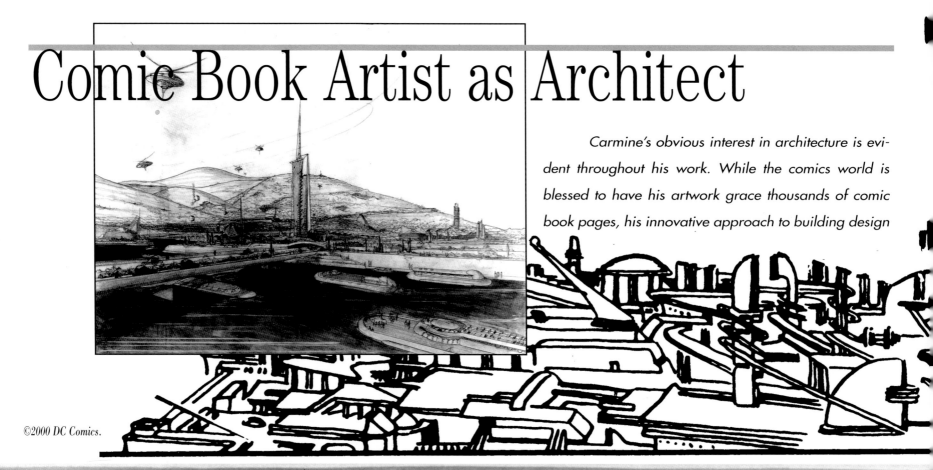

Carmine's obvious interest in architecture is evident throughout his work. While the comics world is blessed to have his artwork grace thousands of comic book pages, his innovative approach to building design

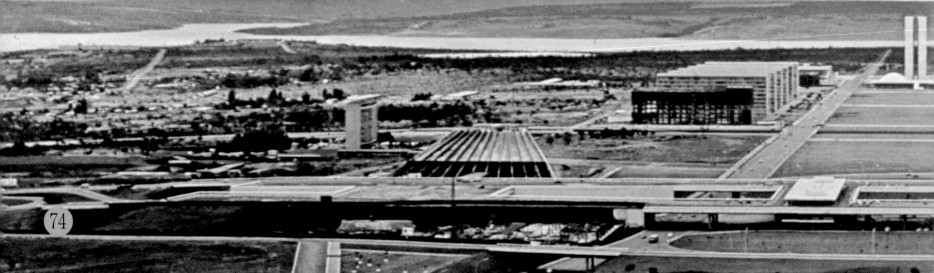

and landscapes within his comics work begs one to speculate the impact Carmine might have had in the field of architecture. On this spread are some examples of both the artist's influences and his own art, reflecting his passion for building design. At far left, the genius of Frank Lloyd Wright shines through in the great architect's ambitious (and unrealized) urban design, The Broadacre City Project, juxtaposed with Carmine's '80s view of the Space Museum from House of Mystery at right. Bottom is an aerial shot of Brazil's still-futuristic capital, Brasilia, the planned city designed by Oscar Niemeyer in the late 1950s. As complement see below Carmine's cityscape depicting a Rannian metropolis from Mystery in Space.

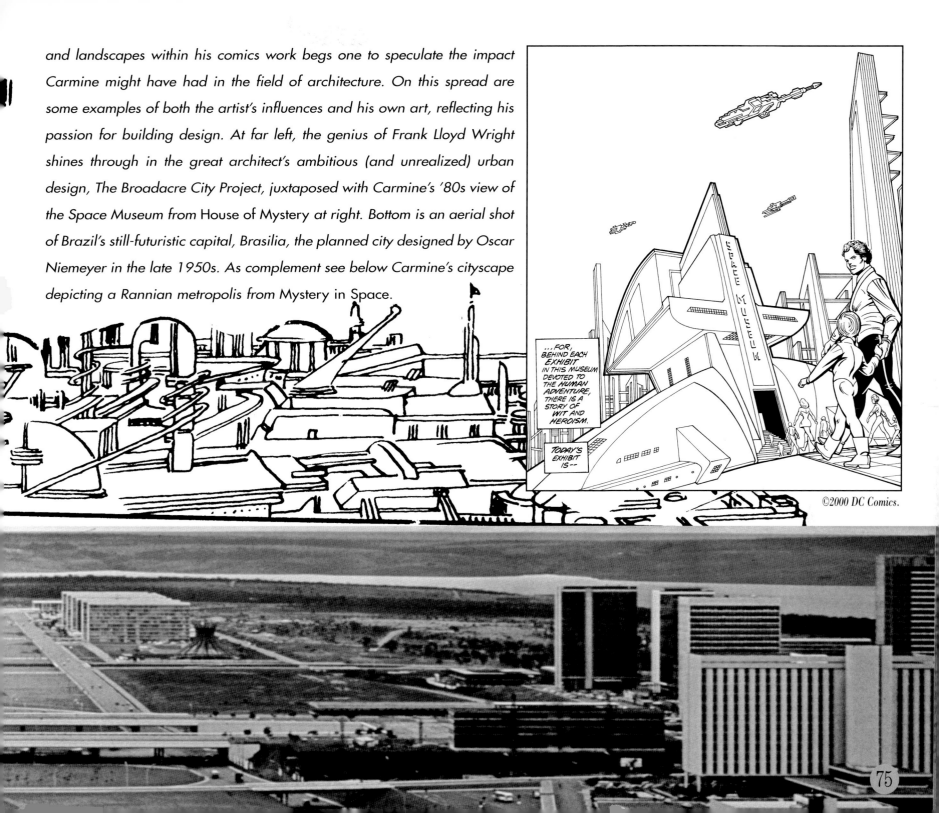

...FOR, BEHIND EACH EXHIBIT IN THIS MUSEUM DEVOTED TO THE HUMAN ADVENTURE, THERE IS A STORY OF WIT AND HEROISM.

TODAY'S EXHIBIT IS--

SPACE MUSEUM

At right is Frank Lloyd Wright protégé Taro Amano's Shin-Hanayashiki Golf Club (1959). Below is a similar Infantino house design from an 1980s issue of The Flash.

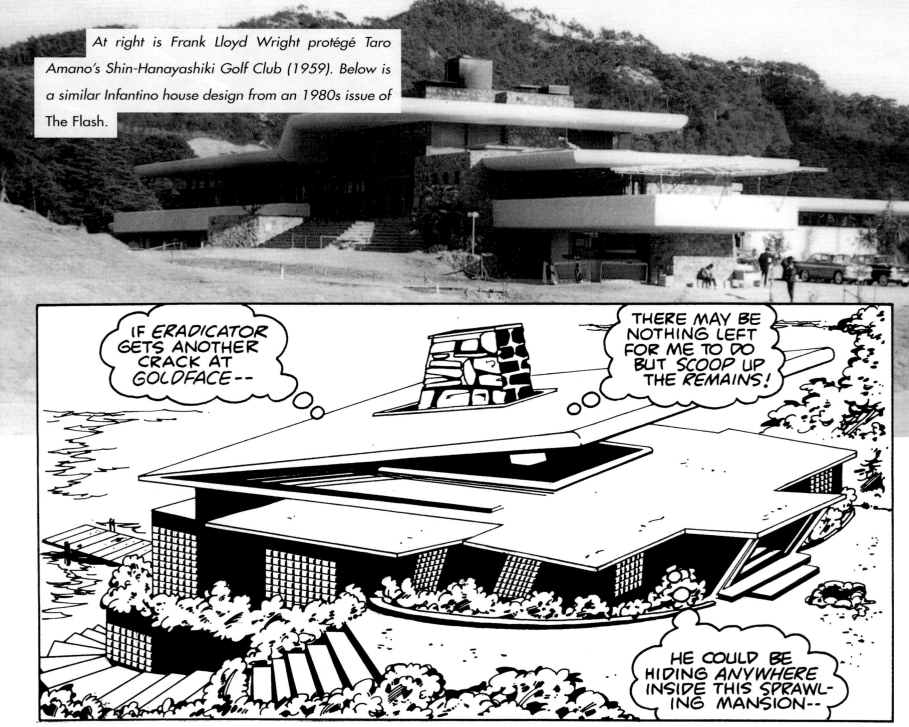

Jack got along fine.

Jack Liebowitz and Irwin Donenfeld made a deal to sell DC to Kinney National Services. Kinney was a huge company that ran everything from funeral homes to cleaning contractors to parking lots and more. DC's official name was still National Periodicals, so Kinney changed its name to Kinney National. I think Jack Liebowitz thought it was a good time to sell because Batman was so hot with the TV show and toys, and there was a movie. It was Liebowitz's decision to sell the company. I liked Jack; he was very straight. Shortly after Kinney bought DC, Donenfeld left.

Some people had problems with Liebowitz and Irwin's father, Harry (including Superman creators Jerry Siegel and Joe Shuster, who obviously didn't profit off their creation as much as the company did), but Irwin and I were good friends, and we'd often go out on the town together. And as far as Jack goes, he hired me, and was very dependable — no nonsense, honest, and direct. You can't beat that. I was very happy working for them both.

About a year latter, Kinney bought Warner-Seven Arts films. They gradually liquidated the early Kinney assets while expanding entertainment holdings and changing their name to Warner Brothers.

Above inset: The late Charles "Sparky" Schulz, creator of Peanuts, *drew this personal momento for Carmine, depicting a certain Darknight Detective taking a breather, beagle-style. Batman ©2000 DC Comics. Snoopy ©2000 Universal Features Syndicate.*

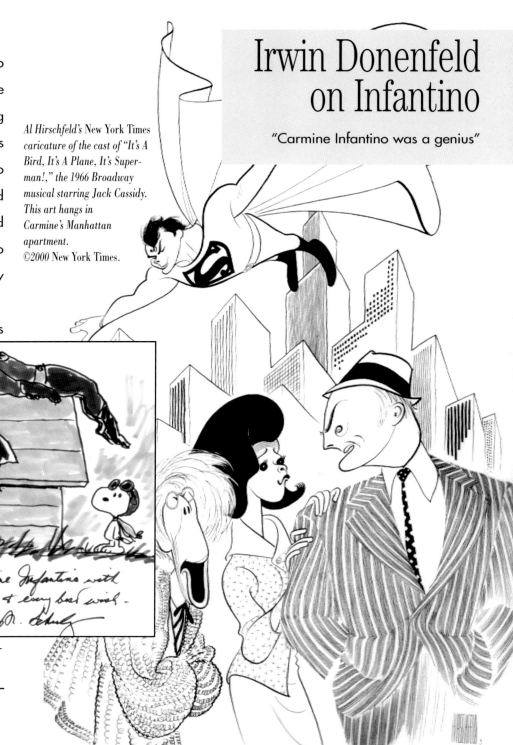

Irwin Donenfeld on Infantino
"Carmine Infantino was a genius"

Al Hirschfeld's New York Times caricature of the cast of "It's A Bird, It's A Plane, It's Superman!," the 1966 Broadway musical starring Jack Cassidy. This art hangs in Carmine's Manhattan apartment. ©2000 New York Times.

The Daring & The Different

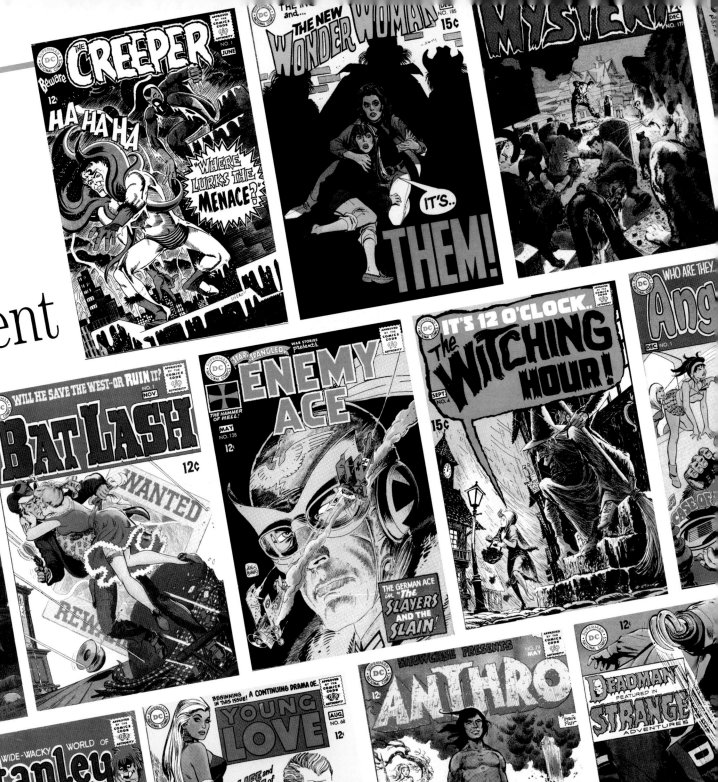

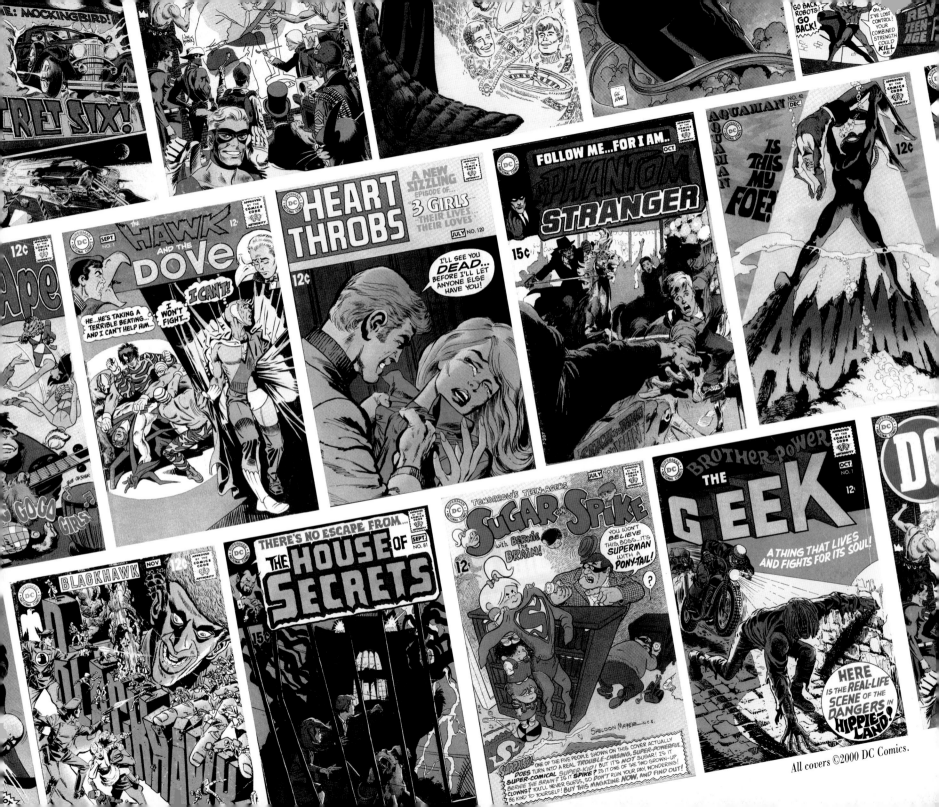

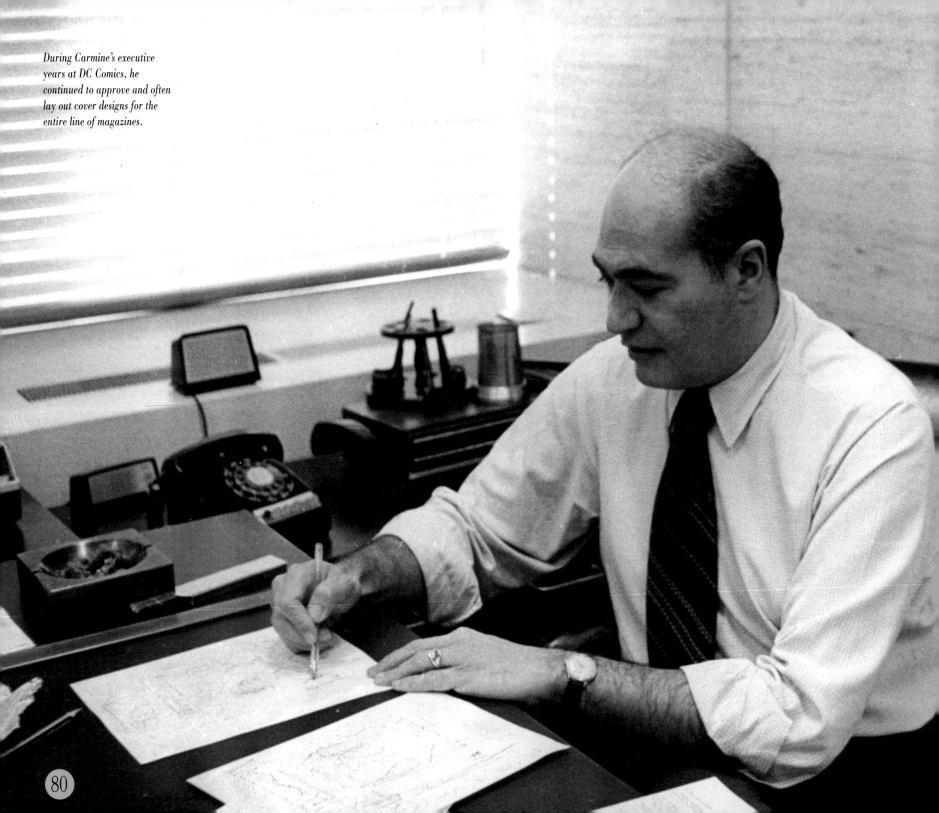

During Carmine's executive years at DC Comics, he continued to approve and often lay out cover designs for the entire line of magazines.

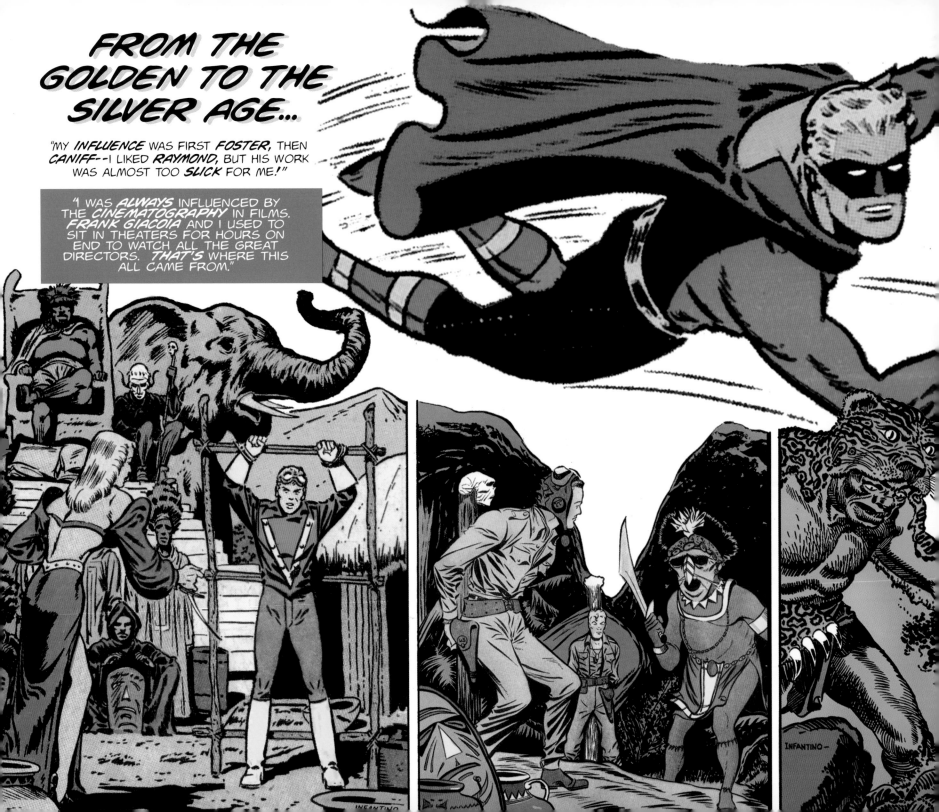

FROM THE GOLDEN TO THE SILVER AGE...

"MY *INFLUENCE* WAS FIRST *FOSTER*, THEN *CANIFF*--I LIKED *RAYMOND*, BUT HIS WORK WAS ALMOST TOO *SLICK* FOR ME!"

"I WAS *ALWAYS* INFLUENCED BY THE *CINEMATOGRAPHY* IN FILMS. *FRANK GIACOIA* AND I USED TO SIT IN THEATERS FOR HOURS ON END TO WATCH ALL THE GREAT DIRECTORS. *THAT'S* WHERE THIS ALL CAME FROM."

"DETECTIVE CHIMP WAS A FAVORITE OF MINE, BECAUSE HE WAS HUMOROUS, AND I ENJOYED DOING HUMOR.

"THE SCRIPTS WERE BY JOHN BROOME, AND THEY WERE TERRIFIC!

"IT WAS RELAXING FOR ME TO DO THIS CHARACTER, AS OPPOSED TO THE OTHERS; THE OTHERS WERE HARD WORK!"

"I HATED DOING HORROR --I THINK BECAUSE OF THE KEFAUVER HEARINGS!"

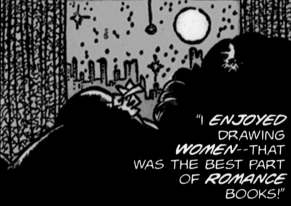

"I ENJOYED DRAWING WOMEN--THAT WAS THE BEST PART OF ROMANCE BOOKS!"

SOUL WITHOUT MERIT, SATAN WILL TEAR IT!!

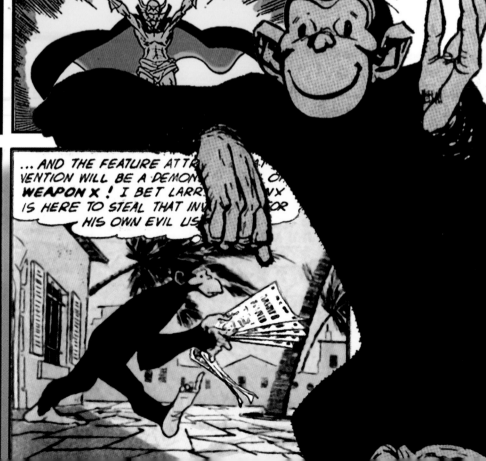

... AND THE FEATURE AT[TR...] VENTION WILL BE A DEMON[...] WEAPON X! I BET LARR[...] IS HERE TO STEAL THAT INV[...] FOR HIS OWN EVIL US[...]

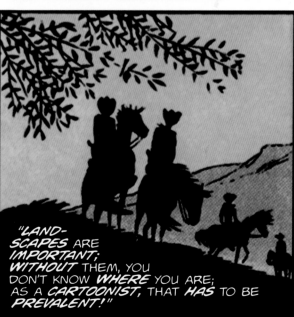

"LAND-SCAPES ARE IMPORTANT; WITHOUT THEM, YOU DON'T KNOW WHERE YOU ARE; AS A CARTOONIST, THAT HAS TO BE PREVALENT!"

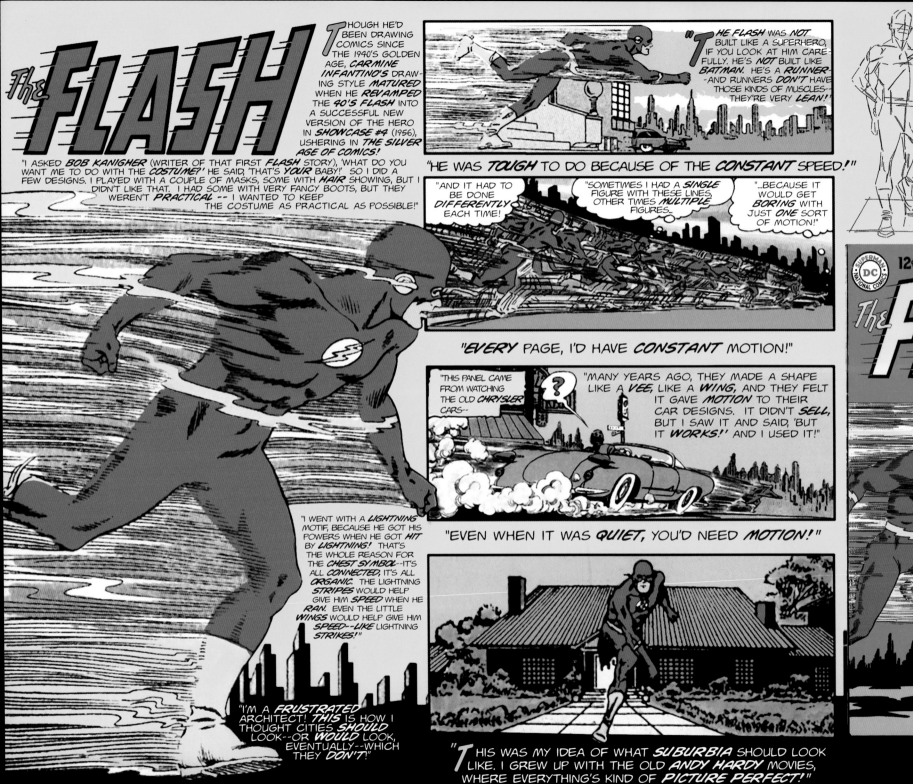

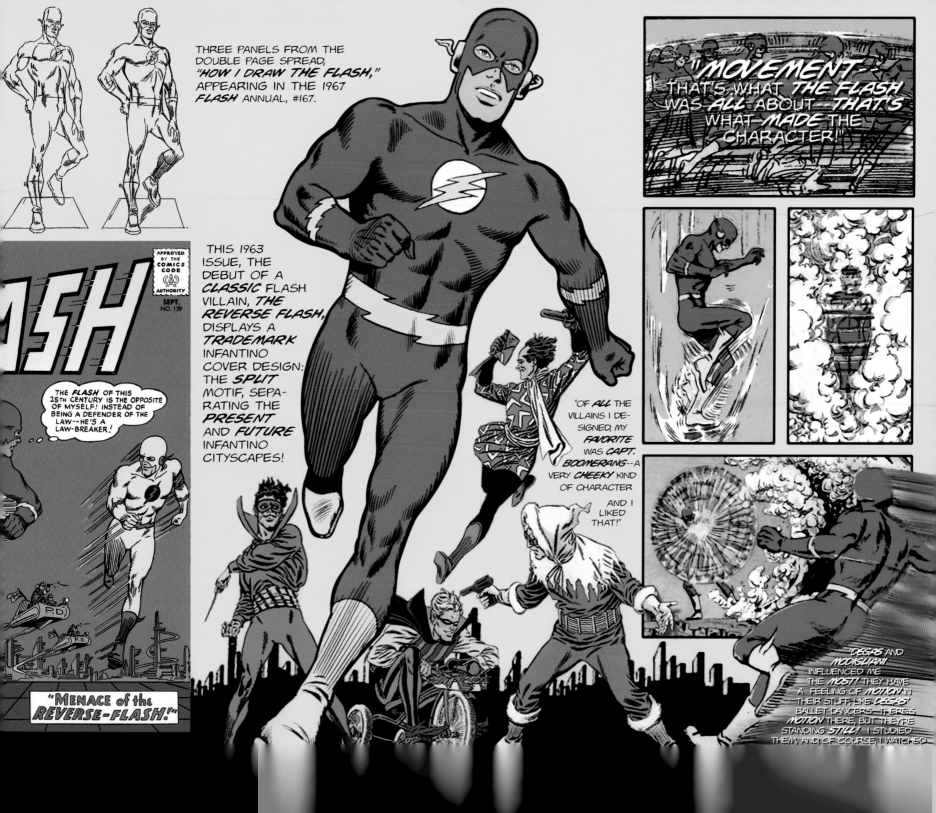

THREE PANELS FROM THE DOUBLE PAGE SPREAD, "HOW I DRAW THE FLASH," APPEARING IN THE 1967 FLASH ANNUAL, #167.

THIS 1963 ISSUE, THE DEBUT OF A CLASSIC FLASH VILLAIN, THE REVERSE FLASH, DISPLAYS A TRADEMARK INFANTINO COVER DESIGN: THE SPLIT MOTIF, SEPARATING THE PRESENT AND FUTURE INFANTINO CITYSCAPES!

"MOVEMENT— THAT'S WHAT THE FLASH WAS ALL ABOUT—THAT'S WHAT MADE THE CHARACTER!"

"OF ALL THE VILLAINS I DESIGNED, MY FAVORITE WAS CAPT. BOOMERANG--A VERY CHEEKY KIND OF CHARACTER AND I LIKED THAT!"

"DEGAS AND MODIGLIANI INFLUENCED ME THE MOST! THEY HAVE A FEELING OF MOTION IN THEIR STUFF, LIKE DEGAS' BALLET DANCERS--THERE'S MOTION THERE, BUT THEY'RE STANDING STILL! I STUDIED THEM, AND, OF COURSE, I WATCHED

ASH

APPROVED BY THE COMICS CODE CA AUTHORITY

SEPT. NO. 139

THE FLASH OF THIS 25TH CENTURY IS THE OPPOSITE OF MYSELF! INSTEAD OF BEING A DEFENDER OF THE LAW--HE'S A LAW-BREAKER!

"MENACE of the REVERSE-FLASH!"

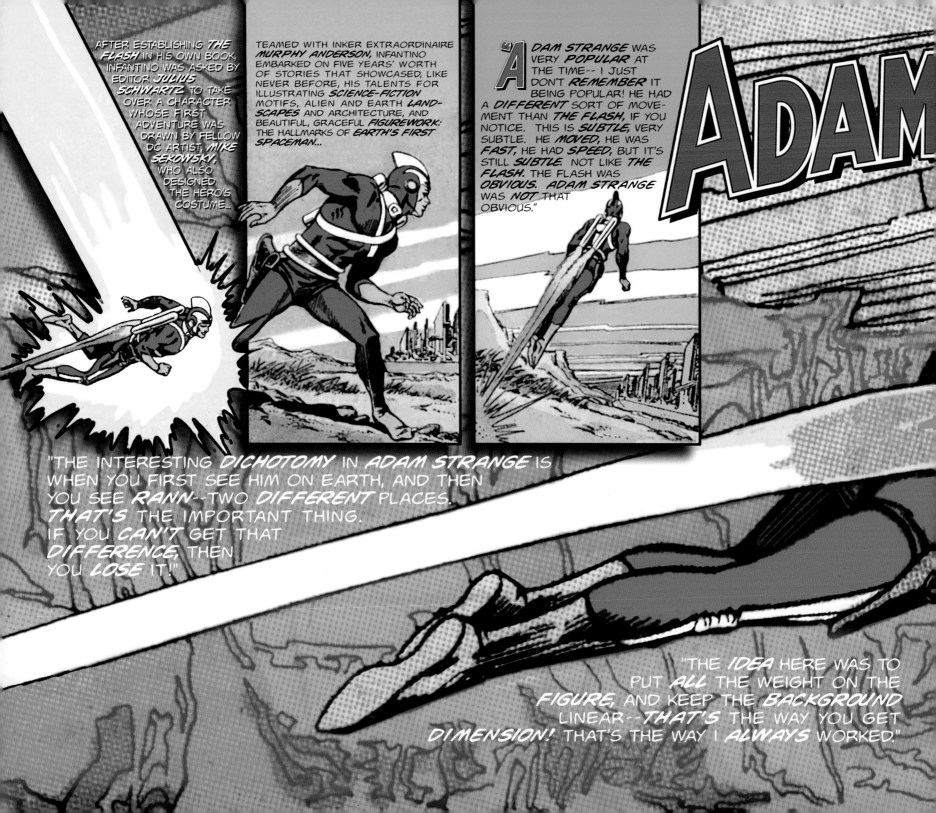

AFTER ESTABLISHING *THE FLASH* IN HIS OWN BOOK, INFANTINO WAS ASKED BY EDITOR *JULIUS SCHWARTZ* TO TAKE OVER A CHARACTER WHOSE FIRST ADVENTURE WAS DRAWN BY FELLOW DC ARTIST, *MIKE SEKOWSKY*, WHO ALSO DESIGNED THE HERO'S COSTUME...

TEAMED WITH INKER EXTRAORDINAIRE *MURPHY ANDERSON*, INFANTINO EMBARKED ON FIVE YEARS' WORTH OF STORIES THAT SHOWCASED, LIKE NEVER BEFORE, HIS TALENTS FOR ILLUSTRATING *SCIENCE-FICTION* MOTIFS, ALIEN AND EARTH *LAND-SCAPES* AND ARCHITECTURE, AND BEAUTIFUL, GRACEFUL *FIGUREWORK*: THE HALLMARKS OF *EARTH'S FIRST SPACEMAN*...

"*A*DAM STRANGE WAS VERY *POPULAR* AT THE TIME-- I JUST DON'T *REMEMBER* IT BEING POPULAR! HE HAD A *DIFFERENT* SORT OF MOVE-MENT THAN *THE FLASH*, IF YOU NOTICE. THIS IS *SUBTLE*, VERY SUBTLE. HE *MOVED*, HE WAS *FAST*, HE HAD *SPEED*, BUT IT'S STILL *SUBTLE*. NOT LIKE *THE FLASH*. THE FLASH WAS *OBVIOUS*. ADAM STRANGE WAS *NOT* THAT OBVIOUS."

ADAM

"THE INTERESTING *DICHOTOMY* IN *ADAM STRANGE* IS WHEN YOU FIRST SEE HIM ON EARTH, AND THEN YOU SEE *RANN*--TWO *DIFFERENT* PLACES. *THAT'S* THE IMPORTANT THING. IF YOU *CAN'T* GET THAT *DIFFERENCE*, THEN YOU *LOSE* IT!"

"THE *IDEA* HERE WAS TO PUT *ALL* THE WEIGHT ON THE *FIGURE*, AND KEEP THE *BACKGROUND* LINEAR--*THAT'S* THE WAY YOU GET *DIMENSION!* THAT'S THE WAY I *ALWAYS* WORKED."

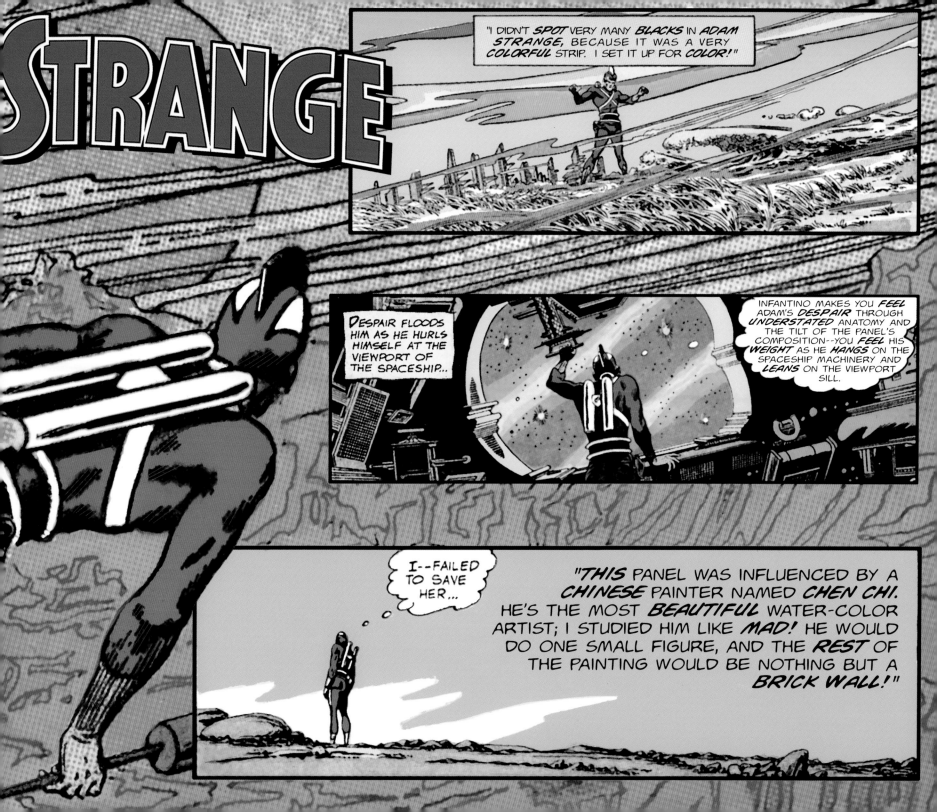

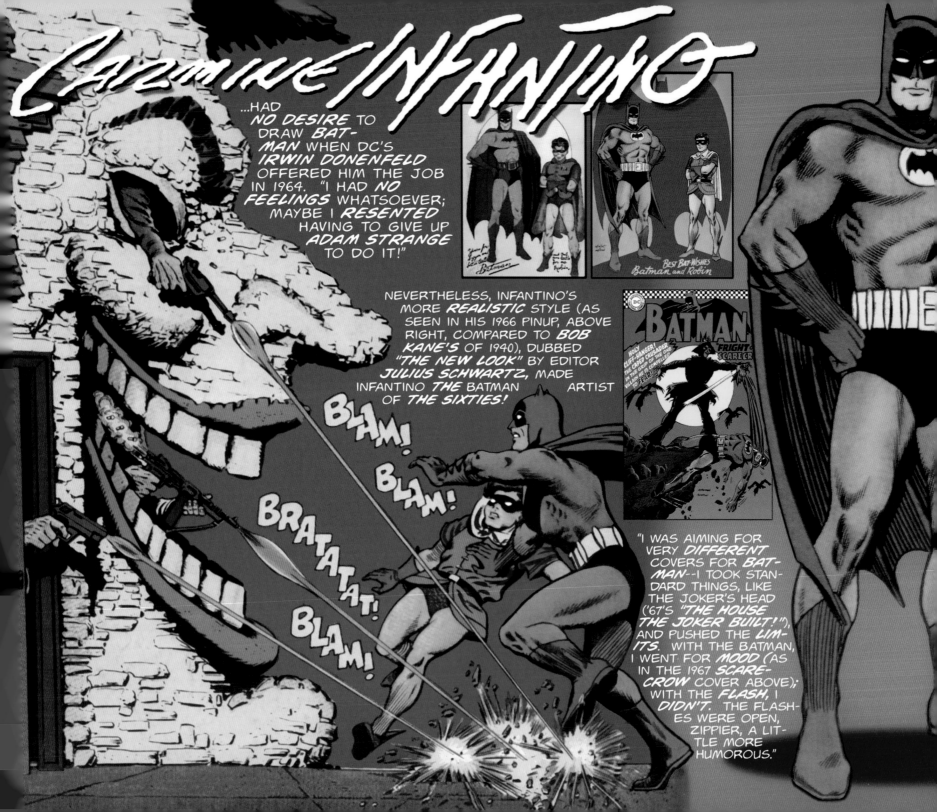

CARMINE INFANTINO

...HAD **NO DESIRE** TO DRAW **BAT-MAN** WHEN DC'S **IRWIN DONENFELD** OFFERED HIM THE JOB IN 1964. "I HAD **NO FEELINGS** WHATSOEVER; MAYBE I **RESENTED** HAVING TO GIVE UP **ADAM STRANGE** TO DO IT!"

NEVERTHELESS, INFANTINO'S MORE **REALISTIC** STYLE (AS SEEN IN HIS 1966 PINUP, ABOVE RIGHT, COMPARED TO **BOB KANE'S** OF 1940), DUBBED "THE NEW LOOK" BY EDITOR **JULIUS SCHWARTZ**, MADE INFANTINO **THE** BATMAN ARTIST OF **THE SIXTIES!**

BLAM!

BLAM!

BRATATAT!

BLAM!

"I WAS AIMING FOR VERY **DIFFERENT** COVERS FOR **BAT-MAN**--I TOOK STAN-DARD THINGS, LIKE THE JOKER'S HEAD ('67'S **"THE HOUSE THE JOKER BUILT!"**), AND PUSHED THE **LIM-ITS**. WITH THE BATMAN, I WENT FOR **MOOD** (AS IN THE 1967 **SCARE-CROW** COVER ABOVE); WITH THE **FLASH**, I **DIDN'T**. THE FLASH-ES WERE OPEN, ZIPPIER, A LIT-TLE MORE HUMOROUS."

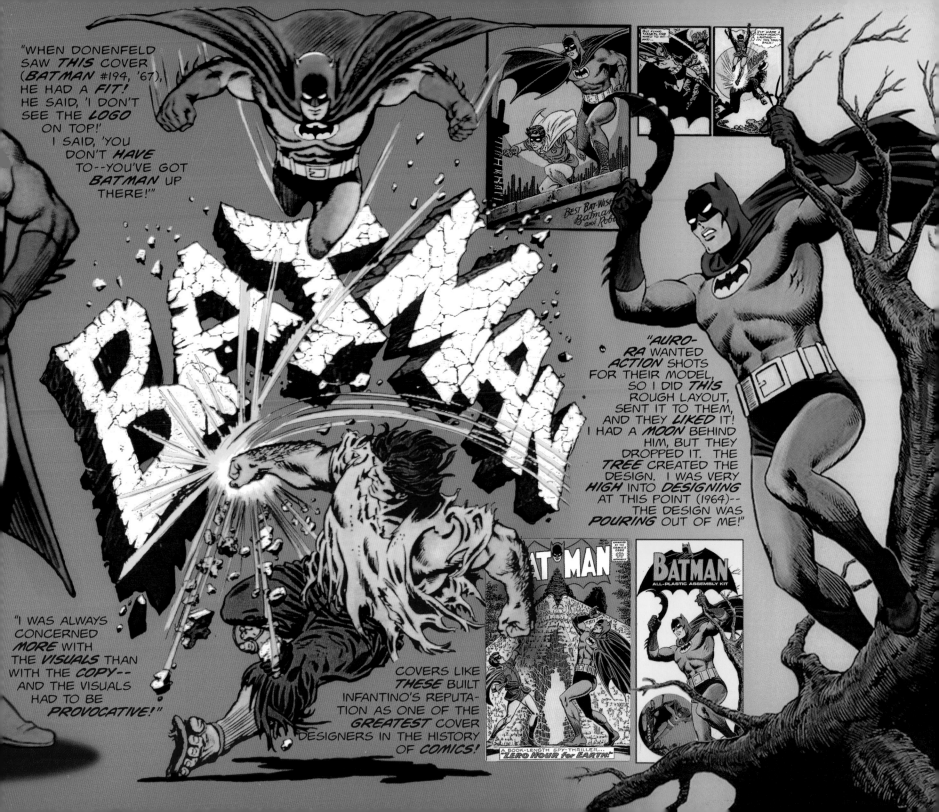

"WHEN DONENFELD SAW *THIS* COVER (*BATMAN* #194, '67), HE HAD A *FIT!* HE SAID, 'I DON'T SEE THE *LOGO* ON TOP!' I SAID, 'YOU DON'T *HAVE* TO--YOU'VE GOT *BATMAN* UP THERE!'"

"*AURO-RA* WANTED *ACTION* SHOTS FOR THEIR MODEL, SO I DID *THIS* ROUGH LAYOUT, SENT IT TO THEM, AND THEY *LIKED* IT! I HAD A *MOON* BEHIND HIM, BUT THEY DROPPED IT. THE *TREE* CREATED THE DESIGN. I WAS VERY *HIGH* INTO *DESIGNING* AT THIS POINT (1964)-- THE DESIGN WAS *POURING* OUT OF ME!"

"I WAS ALWAYS CONCERNED *MORE* WITH THE *VISUALS* THAN WITH THE *COPY*-- AND THE VISUALS HAD TO BE *PROVOCATIVE!*"

COVERS LIKE *THESE* BUILT INFANTINO'S REPUTA-TION AS ONE OF THE *GREATEST* COVER DESIGNERS IN THE HISTORY OF *COMICS!*

EIGHT *of the* Greatest COVERS *by the* TEAM SUPREME *of* ~

"I WENT THROUGH A *TRANSITION* IN MY WORK, WHERE I GOT *RID OF ALL* THE DRAWING, AND JUST WENT TO *PURE DESIGN;* BUT *MURPHY* WOULD PUT *BACK* THE DRAWING I TOOK OUT!"

INFANTINO

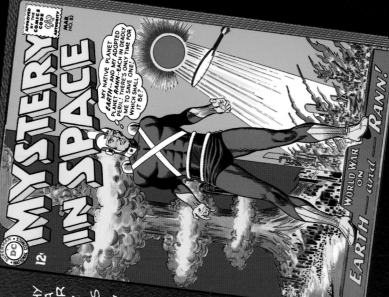

INFANTINO INKING INFANTINO

C ARMINE INFANTINO RARELY INKED HIS OWN PENCILS BETWEEN 1959 AND '67, BUT WHEN HE *DID*--HANDFULS OF *SPACE MUSEUM* AND *ELONGATED MAN* STORIES, MISCELLANEOUS WESTERNS--HE'D BRING OUT *DIMENSIONS* OF HIS *ARTISTRY* THAT HAD NATURALLY BEEN *SUBSUMED* BY HIS INKERS: A *LIVELY, LOOSE* PEN LINE, *STRONG* SPOTTING OF *BLACKS* (RIVALING *ALEX TOTH'S*), AND A STUDIED *FOCUS* ON *RICHLY* RENDERED *LANDSCAPES* THAT *ELEVATED* HIS *BACKGROUNDS* TO THE *FORE!*

"DC DID *NOT* LIKE MY INKING! BUT TO *APPEASE* ME AT TIMES, THEY LET ME INK!"

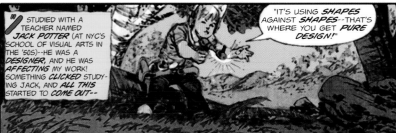

"I STUDIED WITH A TEACHER NAMED *JACK POTTER* (AT NYC'S SCHOOL OF VISUAL ARTS IN THE '50S)--HE WAS A *DESIGNER*, AND HE WAS *AFFECTING* MY WORK! SOMETHING *CLICKED* STUDY-ING JACK, AND *ALL THIS* STARTED TO *COME OUT*--

"IT'S USING *SHAPES* AGAINST *SHAPES*--THAT'S WHERE YOU GET *PURE DESIGN!*"

"I THREW *ANATOMY* OUT THE WINDOW! IF YOU TAKE MY STUFF *APART*, THE ANATOMY ISN'T *THERE* ANYMORE!

"BUT IT *WORKS*...

...BECAUSE IT'S *PURE DESIGN!*"

"*THE SPACE MUSEUM* STORIES WERE *INTERESTING* BECAUSE THEY WERE STAND-ALONE...

"I *DIDN'T* WANT TO DRAW *PHOTOGRAPHICALLY;* COMICS HAD A *DISTINCTION* ABOUT IT YOU *COULDN'T* GET WITH A PHOTO. I FELT YOU COULD MAKE SOMETHING *REAL* AND STILL DRAW IT *UNREAL*-- AND IT *WORKED!*"

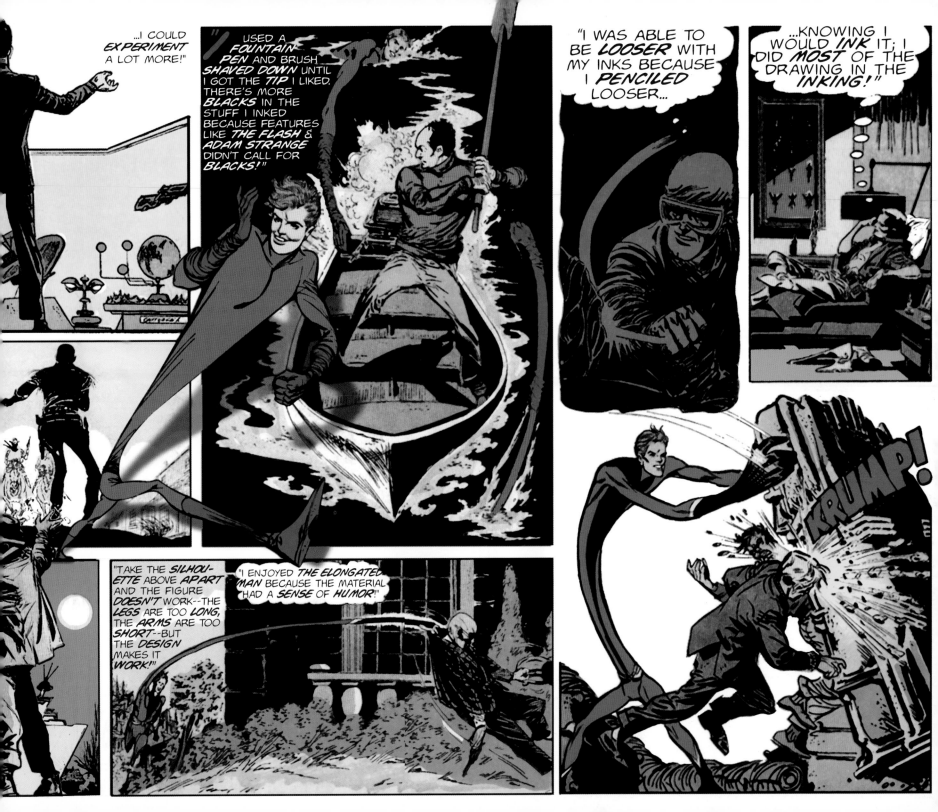

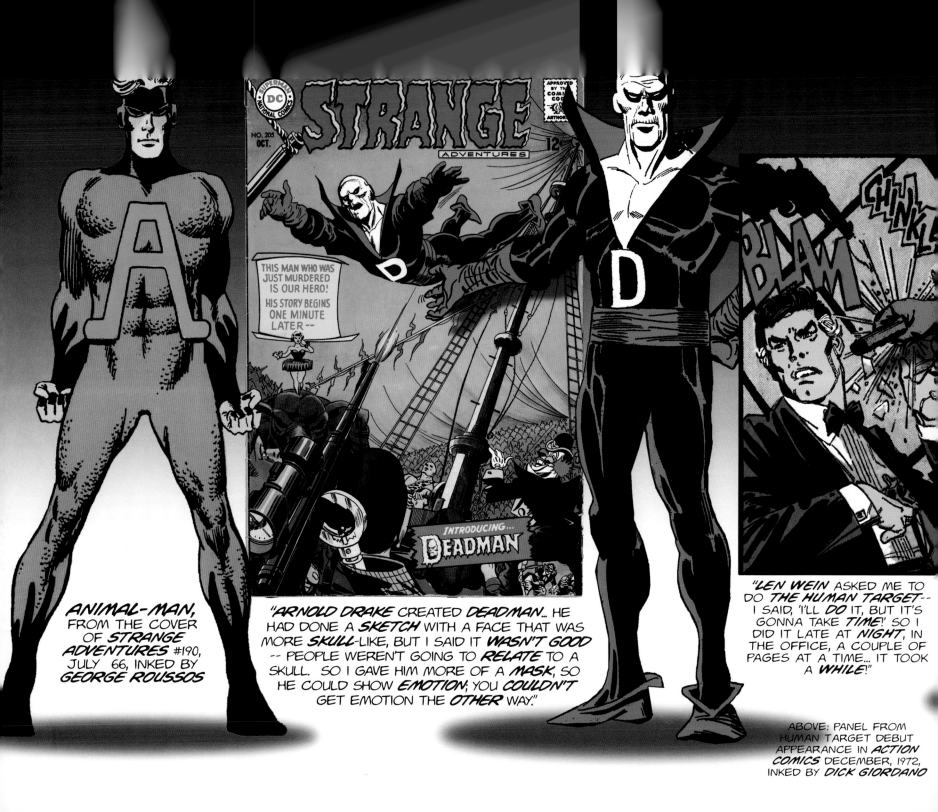

ANIMAL-MAN, FROM THE COVER OF *STRANGE ADVENTURES* #190, JULY 66, INKED BY GEORGE ROUSSOS

"*ARNOLD DRAKE* CREATED *DEADMAN*... HE HAD DONE A *SKETCH* WITH A FACE THAT WAS MORE *SKULL*-LIKE, BUT I SAID IT *WASN'T GOOD* -- PEOPLE WEREN'T GOING TO *RELATE* TO A SKULL. SO I GAVE HIM MORE OF A *MASK*, SO HE COULD SHOW *EMOTION*; YOU *COULDN'T* GET EMOTION THE *OTHER* WAY."

"*LEN WEIN* ASKED ME TO DO *THE HUMAN TARGET* -- I SAID, 'I'LL *DO* IT, BUT IT'S GONNA TAKE *TIME*!' SO I DID IT LATE AT *NIGHT*, IN THE OFFICE, A COUPLE OF PAGES AT A TIME... IT TOOK A *WHILE*!"

ABOVE: PANEL FROM HUMAN TARGET DEBUT APPEARANCE IN *ACTION COMICS* DECEMBER, 1972, INKED BY *DICK GIORDANO*

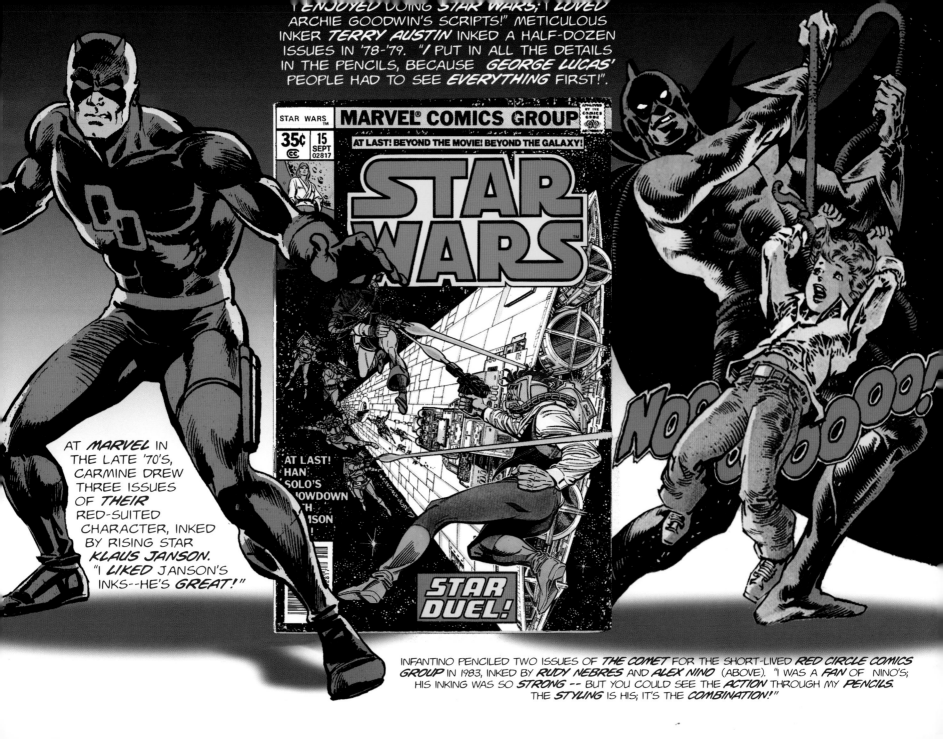

"I ENJOYED DOING *STAR WARS*; I LOVED ARCHIE GOODWIN'S SCRIPTS!" METICULOUS INKER *TERRY AUSTIN* INKED A HALF-DOZEN ISSUES IN '78-'79. *"I* PUT IN ALL THE DETAILS IN THE PENCILS, BECAUSE *GEORGE LUCAS'* PEOPLE HAD TO SEE *EVERYTHING* FIRST!".

AT *MARVEL* IN THE LATE '70'S, CARMINE DREW THREE ISSUES OF *THEIR* RED-SUITED CHARACTER, INKED BY RISING STAR *KLAUS JANSON.* "I *LIKED* JANSON'S INKS--HE'S *GREAT!*"

STAR WARS ™

MARVEL® COMICS GROUP

35¢ 15 SEPT 02817

AT LAST! BEYOND THE MOVIE! BEYOND THE GALAXY!

STAR WARS ™

AT LAST! HAN SOLO'S SHOWDOWN WITH CRIMSON JACK!

STAR DUEL!

NOOOOOOOO!

INFANTINO PENCILED TWO ISSUES OF *THE COMET* FOR THE SHORT-LIVED *RED CIRCLE COMICS GROUP* IN 1983, INKED BY *RUDY NEBRES* AND *ALEX NINO* (ABOVE). *"I* WAS A *FAN* OF NINO'S; HIS INKING WAS SO *STRONG* -- BUT YOU COULD SEE THE *ACTION* THROUGH MY *PENCILS.* THE *STYLING* IS HIS; IT'S THE *COMBINATION!*"

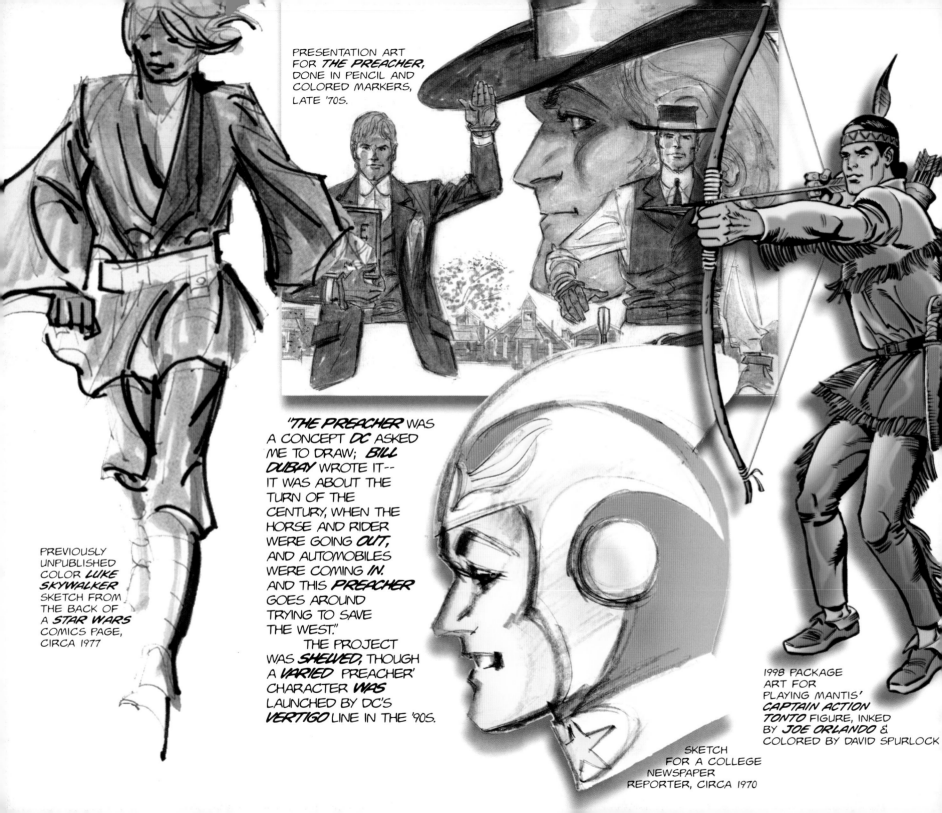

PRESENTATION ART FOR *THE PREACHER*, DONE IN PENCIL AND COLORED MARKERS, LATE '70S.

PREVIOUSLY UNPUBLISHED COLOR *LUKE SKYWALKER* SKETCH FROM THE BACK OF A *STAR WARS* COMICS PAGE, CIRCA 1977

"*THE PREACHER* WAS A CONCEPT *DC* ASKED ME TO DRAW; *BILL DUBAY* WROTE IT-- IT WAS ABOUT THE TURN OF THE CENTURY, WHEN THE HORSE AND RIDER WERE GOING *OUT*, AND AUTOMOBILES WERE COMING *IN*. AND THIS *PREACHER* GOES AROUND TRYING TO SAVE THE WEST."

THE PROJECT WAS *SHELVED*, THOUGH A *VARIED* PREACHER' CHARACTER *WAS* LAUNCHED BY DC'S *VERTIGO* LINE IN THE '90S.

SKETCH FOR A COLLEGE NEWSPAPER REPORTER, CIRCA 1970

1998 PACKAGE ART FOR PLAYING MANTIS' *CAPTAIN ACTION TONTO* FIGURE, INKED BY *JOE ORLANDO* & COLORED BY DAVID SPURLOCK

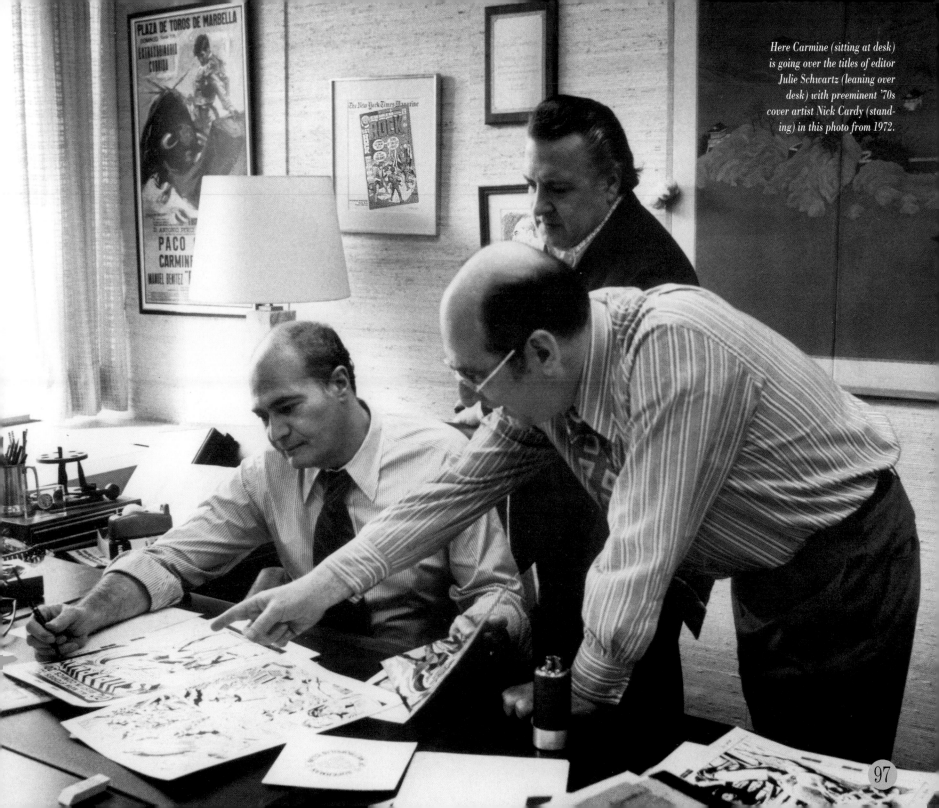

Here Carmine (sitting at desk) is going over the titles of editor Julie Schwartz (leaning over desk) with preeminent '70s cover artist Nick Cardy (standing) in this photo from 1972.

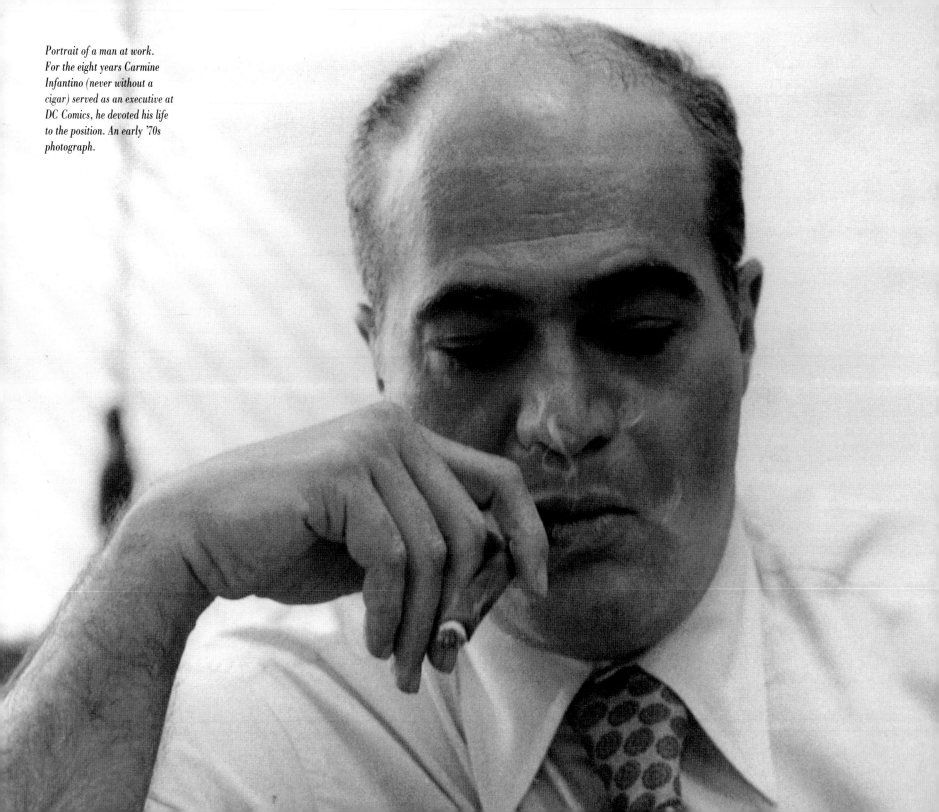

Portrait of a man at work. For the eight years Carmine Infantino (never without a cigar) served as an executive at DC Comics, he devoted his life to the position. An early '70s photograph.

Eight: The Executive Years

The Marvel Threat.
With the exception of Batman's success, Marvel was creaming DC in 1967. Sometime earlier I had started creating covers and Julie would have stories written around them. I'd be doing covers for *Batman, The Flash, Superman,* "Adam Strange," and I was enjoying it. And every time I'd do a cover, sales would jump. So they wanted me to design covers for the entire line! Suddenly I had to stop drawing *The Flash* and I started either drawing or laying out nearly all the DC covers. That was a big part of my duties as Art Director and, again, it was fun.

Shortly after DC was sold in '67, Irwin Donenfeld left the company, and his editorial position was thrust upon me. Liebowitz said to me, "You're running it now; you're the Editorial Director." I was shocked but I assumed the job, and that's when I started taking books apart, bringing new people in, and changing things all over.

Gil Kane.
I had met Gil Kane when we were both very young, growing up in the same area of Brooklyn. He was quite buoyant. Then we went our separate ways. His real name was Eli Katz — I remember his father was very upset about him changing his name — and he was talented

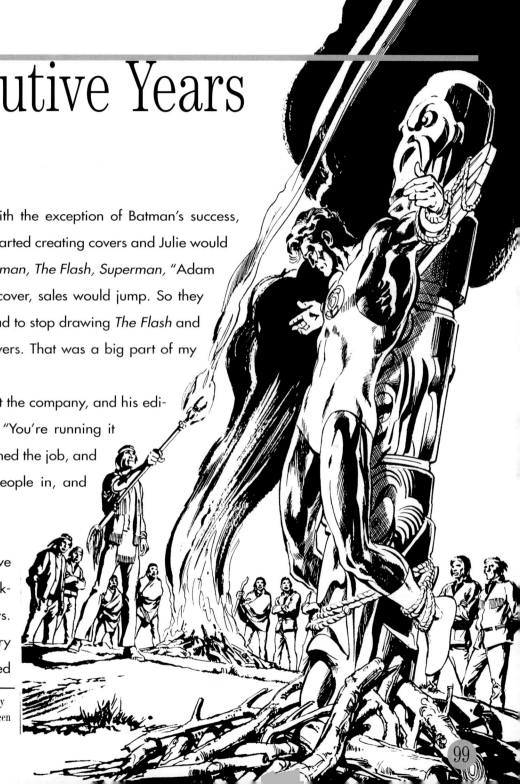

Right: One of Carmine's most notable mandates as Editorial Director was to infuse relevancy into the comics line. The most recognized series of its day was the lauded Green Lantern/Green Arrow. Here Neal's Adams' cover art to the second paperback collection. ©2000 DC Comics.

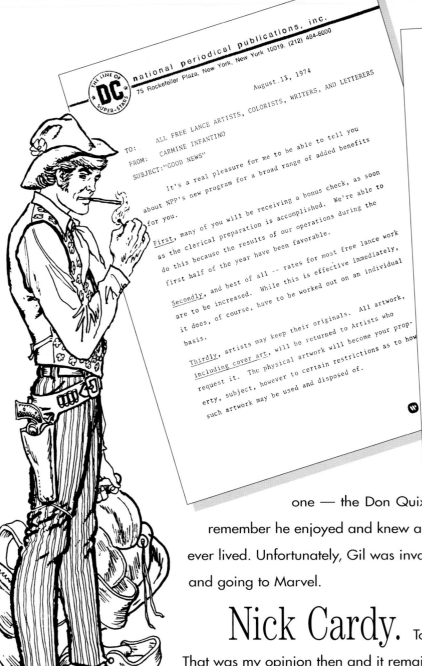

August 13, 1974

TO: ALL FREE LANCE ARTISTS, COLORISTS, WRITERS, AND LETTERERS

FROM: CARMINE INFANTINO

SUBJECT: "GOOD NEWS"

It's a real pleasure for me to be able to tell you about NPP's new program for a broad range of added benefits for you.

First, many of you will be receiving a bonus check, as soon as the clerical preparation is accomplished. We're able to do this because the results of our operations during the first half of the year have been favorable.

Secondly, and best of all -- rates for most free lance work are to be increased. While this is effective immediately, it does, of course, have to be worked out on an individual basis.

Thirdly, artists may keep their originals. All artwork, including cover art, will be returned to Artists who request it. The physical artwork will become your property, subject, however to certain restrictions as to how such artwork may be used and disposed of.

August 13, 1974

TO: ALL FREE LANCE ARTISTS,
 COLORISTS, WRITERS,
 AND LETTERERS

-2-

Fourthly, Scriptwriters, whose scripts are reprinted by NPP will be paid a fee for such reprints equal to 25% of their current rates.

Fifthly, Colorists will get back their colored silverprints, subject to the same restrictions applied to the artists above.

The above applies only to artists, colorists, and writers who are currently working for us and who submit their work exclusively to us (unless our editors and I have agreed that specific other activities create no conflict of interest) effective with issues scheduled to go on sale during October, 1974.

We are working on making all of the above happen just as fast as possible, but, naturally, some phases require a bit of "tooling up" time. We will try these new arrangements on a trial basis for one year, after which we will review the results.

This is the kind of memo I enjoy issuing. I sure hope you're as happy with the news as are all of us here at NPP.

ci

and developed significantly when he went back to school, after working professionally for a period. I believe he studied under Burne Hogarth at SVA. Gil and I were not really close, but he was very close with Julie.

Gil had a highly critical and often exaggerated opinion of everything and everyone — the Don Quixote of the comics field — but he could also be quite entertaining. I remember he enjoyed and knew a lot about films, and he could tell you anything about every actor that ever lived. Unfortunately, Gil was invariably late on deadlines and that had an influence on his leaving DC and going to Marvel.

Nick Cardy. To me, Nick Cardy and Joe Kubert are the best artists in the business.

That was my opinion then and it remains today. They have no peers. It bothers me that very few in the business know about Cardy's work, and he is so talented. He drew *Bat Lash,* and his artwork was just magnifi-

Above: Carmine announces sweeping changes to freelancers in this August 1974 memo, including most significantly, the new DC policy of giving freelancers back their original art. Left: A Nick Cardy drawing of one of Carmine's favorite comics characters, Bat Lash. Art ©2000 Nick Cardy. Bat Lash ©2000 DC Comics.

cent. After *Bat Lash* was cancelled, I used him as the main DC cover artist.

The day I took over as Art Director at DC, Nick came in and said he was quitting. He was dead serious, and he was hurt. I said, "What the hell's wrong?" He replied that Sol Harrison didn't like his work, telling me Sol told him he didn't put enough fishes into *Aquaman!* It was silly, but not to Nicholas. I said, "Give me a chance; I just took over. Try working with me, and if you're not happy, then, of course, leave." So he says, "Okay." He remained to draw *Teen Titans, Aquaman,* and some beautiful covers. And, of course, I always had it in my mind to use him on *Bat Lash.* And we did, and that to me was the most stunning stuff ever done in comics. That strip, by the way, didn't sell in this country, but in Europe, they would reprint them and reprint them, over and over, I don't know how many times! I loved plotting *Bat Lash,* but ultimately, I had to drop it because of the poor sells in the States despite its success in Europe.

Cardy's work was beautiful and, for comics, fairly sophisticated. This guy could do anything. His work reminded me of the very humorous and dynamic illustrator, Albert Dorne. I tried to keep Nicky in the worst way, but I couldn't. He was so good, he had a calling to do other things, and ultimately, he left.

Sol Harrison. Sol Harrison

was a production man. Ultimately, I made him Vice-President. But he was always a produc-

Right: Few artists draw beautiful women (even when they're weeping) as well as the versatile Nick Cardy. Here's a detail from Nick's cover to an issue of Girl's Love, *circa late-1960s. ©2000 DC Comics.*

Nick Cardy on Infantino

Carmine is the best. I have nothing but good things to say about him, either as a person or creatively. With Carmine being an artist, he understood my need to break out of the norm and take chances artistically. For the first time I felt like my work was appreciated.

Let me take this opportunity to speak for Carmine: When someone reaches a position as high as Publisher, as Carmine did, people think they have full license to criticize every decision that's made.. I can only speak for my own experience, but I think that's unfair. Carmine not only had to run the creative end of the business but also had to deal with employee issues, business affairs, Hollywood for the animation, merchandising, etc. Also, I don't think people understand that he had to answer to his own bosses.

Carmine was always a professional with me.

Joe Orlando on Infantino

I became involved in my job as a DC editor and Carmine and I became very good friends. In the course of our friendship we discussed our philosophy of comics and what we thought about them, how they should be done, and why DC was taking second place to Marvel. It seems that the editors at DC were so institutionalized, coming off all of these wonderful accomplishments—taking credit for the invention of the super-hero and maintaining it, and acting like no one else could do a super-hero as well as they did. DC had sued Fawcett over Captain Marvel and won. They felt invincible. During the industry criticism of EC for wrecking the business, they never bothered to read EC, and reacted to what they read in the papers. They were getting their asses kicked in by Marvel at the newsstands and they were not reading the Marvel books—never analyzing or trying to figure out what the competition was doing. They treated their competitor with total contempt. You would talk to these people and they wouldn't know

tion man, very conservative. I never had much of a problem with him because I didn't deal with him very much. He would pick and choose, and he had favorite artists, and things like that. Sol could make things very comfortable for them if he chose, but I had no problems with him. He didn't bother me, and I didn't bother him.

Publisher & President.

I became Art Director, then Editorial Director in 1967, then Publisher in 1971. Then Paul Wendell left, and I also became President. I just fell into these things, one after another. I never relinquished what else I was doing as I moved up the ladder. I never stopped drawing and laying out covers. Even when I was Publisher and President, I still did the covers. Irwin and Jack trusted me and didn't question many of the changes I began. Julie Schwartz, Mort Weisinger, and Murray Boltinoff were purely literary men. The DC books were very sterile-looking in those days. My feeling was that we needed visual people, also. So, I installed a

couple of artists as editors. I made Joe Kubert and Joe Orlando editors, and I brought Dick Giordano in from Charlton comics. I wanted a lot of talent from Charlton: Denny O'Neil, Steve Ditko, Steve Skeates, Jim Aparo, and others. So I said to Giordano, "You're coming, but I want them with you. I want the whole package."

So now we had visual people as well as literary people running the editorial department, and the books got better. I started infusing new blood into the company, and I always looked for ways to improve things for everyone. We used to talk about reprint money — all kinds of things. As we started making more and more money, I raised the page rates that we offered. I eventually set up a royalty situation; I instituted that if any book sold over a certain percentage, the creative team got a bonus. When *Swamp Thing* hit 60% or 65% sales, I gave the editor, artist, and writer all something like a $1,000 bonus. Every time a book would hit a certain mark, I would give out bonuses.

The one thing I had to do was make the artists and writers feel comfortable with me.

what was going on in the business except at DC Comics. The editors had this great little gentleman's club: Every day a two-hour lunch, they wore leather patches on the elbows of their tweed jackets, sucked on empty pipes, and debated the liberal issues of that day. There was this contempt for the artist by this exclusive club of writers and editors; artists were replaceable.

It was the foresight of a man like Carmine who, number one, hired me— which allowed me to hire an artist like Sergio Aragonés. Do you think that the old DC publishers would have hired Sergio to draw? Maybe now because he's a proven winner, but not when I hired him! Would anybody have hired Sergio Aragonés as a writer? They would look at me like I was crazy and say, "What, are you crazy?" Did I get that attitude from Carmine? Absolutely not. Carmine loved Sergio and recognized his sense of humor and obviously recognized my talents, and the abilities of Dick Giordano, Joe Kubert and Jack Kirby.

To Carmine's credit, he always gave me projects he knew I could handle. He gave me complete freedom and then he pushed me to the limit.

Stan Lee on Infantino

Carmine was both a competitor and a friend.

My fondest memories of him go back many years to the time when he was Publisher of DC and I was Publisher of Marvel. He and I used to meet for drinks on the rare Friday evenings when we were free at a neighborhood bistro called Friar Tuck.

At these meetings, he was usually accompanied by a few DC artists and/or writers while I'd often be with some Marvel staffers.

The talk was always fast and friendly as we'd rib each other good-naturedly while kidding about the fact that the outside world thought we were all mortal enemies.

Those were good times, they were warm enjoyable times, and I always looked forward to seeing Carmine, with his ever-present big cigar and his never failing good humor, "holding court" at Friar Tuck. They were happy occasions that I'll never forget.

By SAUL BRAUN

That's the way I worked. And I would take my jacket off and open up my tie the minute I got in my office. I kept the doors open — anybody could walk in. I felt contact was very important there. And I couldn't come across very stiff, though I did need the suits to go to meetings. I always wanted to be accessible. There were a lot of unhappy people up there at the time I took the executive position; Marvel was killing them on the stands. Artists were unhappy, feeling beaten from the strain. The place was in a knot, and my job was to loosen it up, so that's what I did.

Despite assertions in *DC Comics: Sixty Years of the World's Favorite Comic Book Heroes*, my tenure at the helm ran very smoothly. I recall a memo from the late Warner chairman Steven Ross congratulating me not only on winning every award in the comic business, but also for bringing in for DC and Warner's a very profitable 1974. We had a couple of years there in a row where we did very well. We did so well I was giving out raises constantly. I kept raising rates, and, contrary to popular opinion, DC started paying reprint money while I was running things. In 1974, I sent out a memo that — effective immediately — artwork would be returned to the artists and reprint money would be paid.

When I was penciling in the early '60s, I worked about six hours a day. I would do two pages a day, taking about six hours. Then I'd go out about town and enjoy myself. When I became an executive, suddenly I'm at DC for 12 or 13 hours a day, doing all sorts of things and working all sorts of hours. Though I've enjoyed some healthy relationships (my current one is the most important), the workload was definitely cutting in on my social life.

SPIDERMAN. *As in everything today's kids (some grownups) demand "relevance" in their comic books. The industry has responded with the likes of teen-ager Peter Parker, left, who doubles as Spiderman, but still can "make dumb mistakes, or have trouble with girls." Above is the author, Stan Lee.*

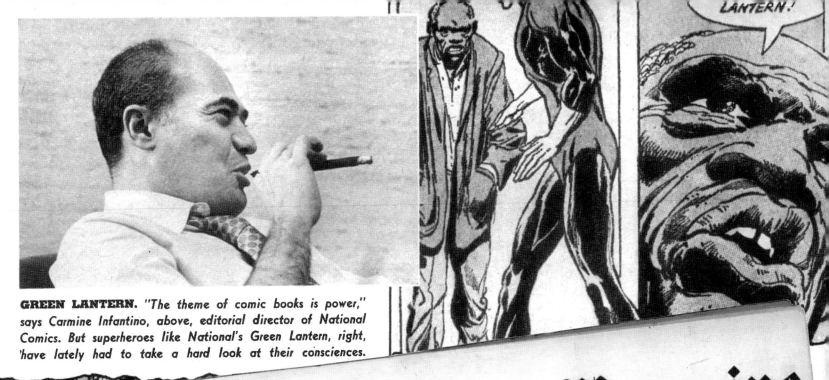

GREEN LANTERN. "The theme of comic books is power," says Carmine Infantino, above, editorial director of National Comics. But superheroes like National's Green Lantern, right, have lately had to take a hard look at their consciences.

Carmine's infusion of current events and issues of the day garnered a fair share of media attention, including this hefty cover featured article in the May 2, 1971 New York Times Sunday Magazine. Also interviewed was Carmine's competitor and friend, Stan Lee of Marvel Comics (at left). ©2000 New York Times.

A Short, Strange Trip.

Sometime in the way-out, cyclonic heyday of the late-'60s, I bumped into Stan Lee, a.k.a. "Old Smiley." We would see each other every now and again at a nice little place, Friar Tuck's. On this particular evening, we had a few drinks together as we would do when we saw each other. Stan said he had an invitation to an exclusive party in Murray Hill. It seemed Stan's wife, Joan, was out of town and he wondered would I care to go along? Well, we went to the party, a very fashionable affair with all the right people. Everyone looked great. I think there were models and photographers, maybe some authors, perhaps a playwright. I'm enjoying the party, the people, food, and drink, when things start striking me differently. I mentioned to Smiley that I was oddly a bit dizzy. He said, "You're not eating those brownies, are you? They're loaded with *pot!*" The rest of the evening, I not only stayed away from the brownies, but analyzed all the *hors d'oeuvres* with a very discriminating eye!

Other Genres.

Super-heroes were doing well in the late-'60s and early-'70s, but I always looked for other types of characters to do, just in case the super-heroes died off again. I threw out a barrage of different titles partially as a smoke screen. I wanted to sneak out *House of Mystery* and *House of Secrets* without Marvel noticing. We launched a chain of light-

Right: Moody and effective Nick Cardy cover art (for #6) of Carmine's favorite DC Western, Bat Lash. Carmine co-plotted a number of the scoundrel's misadventures. ©2000 DC Comics.

I'LL GET YOUR KILLER, MA...PA!

weight horror/mystery books, and they were successful before anyone at Marvel realized what we were doing.

I knew Joe Orlando would be perfect to put those kinds of books together and his books became bestsellers. Marvel tried to compete, launching *Tower of Shadows* with a Steranko cover story, and then using some of our own talent — Neal Adams, Wally Wood, and Bernie Wrightson all did a few stories for them. But they couldn't get Orlando and he was our best-kept secret weapon!

So now we had the mystery and the superheroes going for us. Mort Weisinger was still handling all the Superman books. When he left, I put Julie and Murray Boltinoff on his titles. Meanwhile, I kept experimenting with different things, especially in *Showcase*.

Writing Bat Lash.

I always loved writing, sometimes more than the art. Earlier on in the '50s, I'd written a lot for Ed Cronin at Hillman, plus a number of newspaper sample strips, which I also drew.. When I took over as Editorial Director at DC, I did a lot of writing – plotting mostly. After Arnold Drake left Deadman I plotted 3 or 4 issues with Jack Miller finishing the dialogue. When Jack died I let Neal Adams take over the writing. There was about 5 issues of *Wonder Woman* that I plotted. Miller finished the dialogue on the first, which co-stared Supergirl. After that, I gave the plots to Denny O'Neil and Mike Sekowsky, who would take it from there. But it was

Above: Showcase #89 cover detail. Sekowsky, and Giordano bring Infantino's Jason's Quest newspaper strip concept to life. ©2000 DC Comics.

Denny O'Neil on Infantino

"Carmine is a brilliant comics artist, one whose contributions are not as recognized as they should be. He was, and is, also an eminently decent man."

Denny who came up with the I Ching character. Jason's Quest was similar. I originally created Jason's Quest as a newspaper strip idea. Mike Sekowsky was looking for work, so we did it as a comic book series in *Showcase.* I would give the plot to Mike, who would draw it. Either Mike or Denny would finish the dialogue.

Possibly my all-time favorite was *Bat Lash*, which I created with a little inspiration from the James Garner TV series, *Maverick.* I assigned Joe Orlando to edit the comic, and I told Joe I wanted a different kind of Western with a young, good-looking, fun-loving, girl-loving, flower-loving hero. I pictured Robert Redford in the role. Joey made up the name based on two of his favorites, Lash LaRue and Bat Masterson. I told Joe to assign the script to Shelly Mayer, my mentor from the Golden Age, who was now doing freelance work for DC (I kept my mind open for projects that might be good for him).

Shelly wrote the first story, but it was too flat. My character needed to be totally fresh, so I rewrote it. The art was already drawn and lettered, so I whited-out all the text and rescripted the first issue myself. On the following issues, I dictated the plots to Joe, who took notes. I liked to establish Bat's womanizing tendencies by starting the stories with him being chased out of town by a disgruntled lover. Joe would then go over the story with Sergio Aragonés, who would do thumbnail sketches and pace-out the story. Nick Cardy drew the finished art and then Denny would write the final dialogue. This was actually the Marvel method, where the art's done to a plot and the dialogue was written on the finished pencils. Joe had worked that way with Stan Lee at Marvel on *Daredevil* and preferred it that way. That method worked well for us on *Bat Lash* and the other books I plotted.

Bill Gaines on Infantino

"I got to see first hand the way Carmine ran DC. He has my admiration for the job he did there. It's a habit of mine to only go to lunch with people I like. Carmine and I have had many, many lunches together."
Quote courtesy of Mad Editor Nick Meglin.

Bill Gaines.

When Kinney bought DC, they also purchased *Mad* and Independent News Distributors. By the time I took over as Publisher, Kinney had changed its name to Warner Brothers. Warner Publishing Chairman Mark Iglesias suggested Bill Gaines come in once a week to work with me as a consultant, since he'd been publishing for a long time and was so successful with *Mad*. Bill insisted I keep copies of memos, notes, and sales figures relating to my time

Above: Final cover of The Amazing World of DC Comics #8, Oct. 1975, with Infantino cover art. ©2000 DC Comics.

at DC. He said, "One day you may need them; you never know." We sat down together, checked over expenses, and discussed policy. He'd ask what I was planning, and I'd tell him, "I'm focusing on these characters and this kind of book." He kept out of editorial, really. I was rushed into the position and it was good to have Bill consult because he'd been publishing for decades. Sometimes he would say, "I'm wasting your time here, you don't need me." And for us it became a big joke – his getting paid for doing little more than having lunch.

Few people knew that Bill actually had an office next to mine in the DC offices. Though he was usually at his *Mad* magazine office, he would sometimes use the office next to me to sneak in a midday nap. Bill was single at the time and had a beautiful girlfriend, Annie. One time, I knew Bill was there and walked in to surprisingly find Annie had stopped by. I humorously said, "Hey, you love birds: Knock it off! This is a place of business." Bill was nice to work with and became a good friend. We got together to talk and have lunch every week for years and, on occasion, Annie would join us. Bill and Annie got married after that.

Nine: The Bronze Age

Jack Kirby.

Jack Kirby and I were old friends. We had done that strip that never sold and, in the '50s, I worked for him and Joe Simon. While Jack was at Marvel, we would talk from time to time. In '69, I was flying back and forth to California overseeing Hanna-Barbera's work on DC's *Super-Friends* TV show. I called and said, "Jack, I'm coming out to California. Do you want to get together and have a drink?" He said, "Absolutely." So we did. And when we talked, he showed me these three covers. They were *Forever People, New Gods,* and *Mister Miracle.* I said, "They're sensational. When is Marvel putting them out?" He said, "They're my creations and I don't want to do them at Marvel. Would you make me an offer?" I said, "Absolutely." He wanted a three-year contract. I said, "No problem; you got it." So I made him an offer, which was more than what he got over there, and then I gave him a contract. It was that simple. He was very unhappy at Marvel and wanted to come over to DC. Marvel wouldn't pay him for writing and I would, so he made more money with us.

Below: Carmine with long-time girlfriend Sandy Farrel and longtime friend Jack Kirby at a comics convention appearance in the early '70s.

Kirby requested to draw *Superman's Pal, Jimmy Olsen.* In fact, Jack wanted to write and draw the entire Superman line. But I said, "Well, we'll try you on *Jimmy Olsen.* Let's see what

happens. If it works, you'll get them all." Now, Mort Weisinger was editor on all the Superman titles, including *Jimmy Olsen*. He was a good friend of Jack Schiff, a longtime DC editor who had recently left the company. Schiff and Kirby had been involved together on *Challengers of the Unknown* and the newspaper strip *Sky Masters of the Space Force* back in the late '50s, the last time Kirby had worked for DC. Kirby and Schiff got into a legal dispute over *Sky Masters* and ended up suing each other in court. Well, Schiff basically had Kirby blacklisted at DC, and Jack went over to Stan and started doing all the monster stories those few years before they began their super-hero line.

I informed Mort Weisinger he had a new artist/writer on *Jimmy Olsen* and it's Jack Kirby. Well, the fact that I just acquired Marvel's hottest talent didn't impress him. All he could think about was that Kirby had sued his friend Schiff, and that Kirby should still be blacklisted from DC. Mort went to Irwin Donenfeld to complain. Donenfeld called me in and I really had to go to bat for Jack. I told Donenfeld I wasn't interested in personality problems; I was only interested in business. Donenfeld said okay and that was the end of the discussion.

I was very surprised when Jack's version of *Jimmy Olsen* didn't sell. Jack's art was better than what had been in the title before, but it didn't help the sales. I don't know how you figure these things; while Jack's fans may have started buying the book, it might have been too different for the regular readers.

There's been a lot of controversy about changes and corrections that were made to some of Jack's pages. We didn't enjoy changing an artist's work; it takes time and costs money, but sometimes it is necessary. Walt Disney wouldn't allow Mickey Mouse to be altered, for instance. In fact, later on, Jack worked for Disney on *The Black Hole* newspaper strip, and they did many more changes to his work than DC ever did. That was with

Center: Jack Kirby's original concept drawing of Orion of the New Gods, one of a number The King originally pitched to Carmine in 1970. Orion ©2000 DC Comics. Art ©2000 The Jack Kirby Estate.

Bernie Wrightson on Infantino

Before I became a professional, I attended one of my first comic conventions around '68. That's where I first met my friend Carmine Infantino. Carmine was attending the con with his editors, Joe Orlando and Dick Giordano, and they were looking at artist samples. Carmine took one look at some work that I brought and he says, "This kid is good. We ought to give him work." And he punches me in the arm, puts his arm around me, and says, "You friggin' kid!" I didn't know what to make of it because these guys were like Mafia, fast-talkin' Italian guys. These guys looked like gangsters! I had never met people like this before! So I was a little intimidated and there was Carmine who looked like a really big Edward G. Robinson with the cigar and everything!

It was a pleasant experience working with Carmine.

Above: Kamandi, The Last Boy on Earth, as drawn by Jack Kirby with Mike Royer inks. Cover detail from Kamandi #13, Jan. 1974. ©2000 DC Comics.

much less known and recognizable characters than Superman. Jack himself never objected to Superman's face being touched up. He understood that when you had a licensed character, like Superman, the look must be very consistent. It was never an issue with Jack.

He did several issues of *Jimmy Olsen,* as well as his new titles *New Gods, Forever People, and Mr. Miracle,* and I gave him as much freedom as possible on those books; but in the long run, the numbers just weren't there to keep them going. Jack was a great talent and he had more success than anyone else in the business, but unfortunately his Fourth World series didn't make it. Now, *Mr. Miracle* did last longer than the others. Overall, they were great creative works that deserved to make it, and the fans still remember them very fondly. I liked and was excited about Jack's Fourth World books. Believe me, as a publisher and a close friend of Jack's, I wanted them to succeed, but you have to run a company based on the distribution reports. I always thought the world of Jack Kirby. If anyone thinks differently, they are sorely mistaken.

So we moved into Stage Two of Jack's tenure with *The Demon* and *Kamandi.* I had seen the movie *Planet of the Apes* and thought it was great. We could see that *New Gods* and *Forever People* weren't doing as well as we'd hoped, and we needed something new for Jack. Inspired by *Planet of the Apes,* I suggested we do a comic book with a boy in a post-cataclysmic world run by animals. Jack liked the idea and revived the name *Kamandi* from an idea he had in the '50s for a newspaper strip about a prehistoric caveman. *Kamandi* did well and continued even after Jack went on to other things. If we're keeping score, you could consider Jack and me co-creators on *Kamandi.*

Edgar Rice Burroughs.

Some of what we brought in, in the way of other genres, were pulp characters. Edgar Rice Burroughs was one of the best and most famous writers, who had launched many characters in pulp magazines. He had science-fiction, lost worlds, swords-&-sorcery, and of course, the jungle adventures of Tarzan.

I was very eager to make a deal with Burroughs, Inc. Jesse Marsh had been drawing *Tarzan* for Gold Key comics. I knew we could do better and I told that to Bob Hodes at Edgar Rice Burroughs, Inc. I said nobody could compete with the artist I had for Tarzan: Joe Kubert! I also let them know we wanted other Burroughs characters, including Carson of Venus, and we made a deal.

Of course, nothing goes without a hitch and the Burroughs books seemed to have some distribution problems. ERB, Inc., complained to me that, "We're not getting any of those *Tarzan* comics out here in Tarzana, California!" So I went to Independent News and said, "For Christ's sake, I'm dealing with this man — Bob Hodes at ERB — and he can't get the books in his own town! What's going on?" I was fighting with them constantly. Their attitude was, "If it doesn't sell, it's the product." But, if it sold, they wanted the credit. I was glad to have the Burroughs books and Joe did absolutely fabulous work on *Tarzan*, obviously the bestseller of the bunch.

Above: Cover detail from the "First DC Issue" of Tarzan of the Apes (#205), debuting the dead-on rendition of the Jungle Lord by artist/writer/editor Joe Kubert. ©2000 DC Comics. Tarzan ©2000 Edgar Rice Burroughs, Inc.

Bernie Wrightson & Swamp Thing.

Like I said above, no new artists came into DC for ages, and Neal Adams had been the first in many years. But when I became Director, I wanted new blood, so the doors were opened. That's when we got Bernie Wrightson, who did a lot of great work in Orlando's mystery books. Joe hired Bernie but I was aware of him from the start and was very supportive of Bernie getting work.

During this period, Orlando, Wrightson, and Len Wein created *Swamp Thing*, which not only was a hit comic book, but also went on to produce multiple movies. Orlando had given Wrightson and Wein both their starts as pros. *Swamp Thing* was initially Joe's brainchild and he knew Wrightson and Wein would be perfect for the assignment. As time went by, Joe's name would be mistakenly left off the list of *Swamp Thing* creators. If asked about it, Joe would point out that DC knew, because every time a *Swamp Thing* movie was made, Joe would get a check for being one of the creators.

A funny thing about *Swamp Thing:* It premiered at the same time as Marvel's character Man-Thing. Stan Lee sent me a letter saying Man-Thing came out a month or so before Swamp Thing and if we didn't drop Swamp Thing, Marvel would sue. I reminded Stan of the character I'd worked on decades earlier: The Heap! Not only were Swamp Thing and Man-Thing both derivative of The Heap, but a case could be made that so was The Incredible Hulk! Well, I didn't hear any more complaints from Stan about *Swamp Thing*.

Mike Kaluta & The Shadow.

One day, someone walked into my office with some art samples for me to look at. I said, "Who did this work?" He said, "A young man named Mike Kaluta." I said, "Give him work; I don't want to lose

him. Don't let him leave the building without an assignment." When we got Burroughs' "Carson of Venus," Kaluta was given that assignment. He also did some work for Joe Orlando on the mystery books and some Batman covers.

But Kaluta's big break came with *The Shadow*, another classic character from pulps and radio that I wanted. It seemed everybody had an interest in *The Shadow*. Jim Steranko was a top artist for Marvel (who had never worked for DC), and he wanted to write and draw the book. Alex Toth also wanted to draw the character. And then there was the young Mr. Kaluta, another personal favorite. I assigned the book to Denny O'Neil, one of our best young writers, to write and edit. He did great award-winning work with Neal Adams on *Green Lantern/Green Arrow* and he was starting to edit as well. Steranko and Toth both had some problem with O'Neil's script and there wasn't much they could do about it because he was the editor, too. As interesting as it would have been to see Toth or Steranko draw *The Shadow*, as a publisher, I couldn't favor freelancers over my own editors.

In the long run, it was made obvious Kaluta was our man. I was very pleased with Michael's work on *The Shadow* as were the fans.

Michael Wm. Kaluta on Infantino

When I first went to DC (late winter of 1969) in hopes of a job, a page, anything *please*, I was in the constant company of Bernie Wrightson. Bernie was working with Dick Giordano *and* in May of 1969, Dick gave me several two-page stories. I've no idea if Dick's decision to give me those jobs was run past Carmine. But that work dried up soon after. Hanging out did the trick again by July 1971. This time it was Joe Orlando who gave me the nod and we worked together for many years thereafter.

In November 1971, I'd balked at heading out on a DC field trip. Instead I hung out at the offices in "Neal's Room." I'd been drawing "Carson of Venus," had a few more mystery stories and *House of Mystery* covers under my belt. I sat at Neal Adams' desk, doodling on something when Carmine appeared at the door — *loomed* is more like it — a big guy, Carmine.

"Mikey!? What are *you* doing here? I thought you'd gone off with the gang…"

I explained myself and, out of the blue, Carmine says, "Have you ever thought about doing some *Batman* covers? I think you'd be good at it. Give it a shot — something moody — in a cemetery or something… bring it to me and we'll talk."

I started right in, choked on the first several ideas. But in a few hours I got some okay ideas and Carmine gave me the thumbs up. It feels like I worked directly with Carmine on those covers, but Julie was right there, too.

On some occasions, I'd be handed a cover sketch done by Carmine and I'd balk, thinking I had a better Idea... "Go ahead and give it a shot, Mikey" was always Carmine's reply. I think I got about 50% of the covers my way. When I wasn't working over Carmine's layouts, my approach to a cover was straight on. Almost every time I'd bring one of these in, Carmine'd turn the paper 30 degrees to the right and demand that, that made the composition 100% stronger. One time Joe Orlando and I got to laughing about the tilting, we walked to Carmine's office; our feet along the base of the left wall and our shoulders rubbing along the right. Carmine's "What are you idiots up to?" just made us laugh that much more.

Denny O' Neil cleared my name with Carmine in 1973, for me to draw DC's *Shadow* comic. I wasn't in Carmine's office during that meeting, but in the coffee room waiting. By saying "yes," Carmine made the single, most pivotal decision in my career.

Lastly, at a fancy DC dinner, Wrightson, Chaykin, and I got to talking to this terrific-looking woman. We were knocked out that someone so classy would show us such attention. Then Carmine eased around the corner, dressed to the 9's, spotted us with the woman and got a wry look on his face. He moved in, took her arm, and walked off with her. Over his shoulder he said, "You boys couldn't afford her." She was his date, of course!

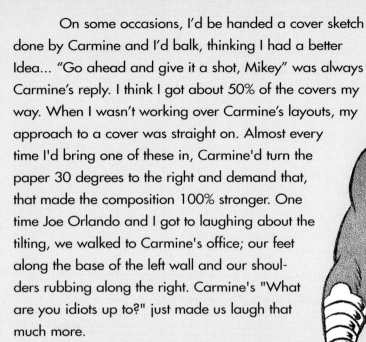

The Return of Captain Marvel.

In the super-hero boom of the 1940s, it seemed anyone in colored tights could sell comic books. There were many success stories, but few truly rivaled the success of Superman. Fawcett published a line of super-hero comics including *Captain Marvel Adventures* and *Whiz Comics* (where Captain Marvel originated). A boy named Billy Batson would say the secret word, "Shazam!," and be magically transform into the super-powered Captain Marvel. The "Big Red Cheese" not only rivaled Superman; from time to time he actually surpassed the sales of Superman's titles. National (DC) sued Fawcett, claiming Captain Marvel was so similar to Superman it was a legal infringement. The case went on for years, until super-hero sales were so low it was ridiculous to continue. So all these years later, around 1970, I decided to bring the charac-

Left: C.C. Beck, the original Captain Marvel artist, returned for an ill-fated but memorable run as artist of Shazam! Captain Marvel ©2000 DC Comics.

ter out of mothballs. I called Fawcett, who were now just publishing books, not comics. I negotiated a deal and acquired the rights to publish the character. I gave him a fresh shot with the original Captain Marvel artist C. C. Beck back on board.

There were some legal concerns, though: I acquired the rights to the original character for DC, but the title *Captain Marvel* had gone long unused; Marvel was able to call a new character by the same name. There couldn't be two books called *Captain Marvel,* so we titled ours after the famous magic word, Shazam! I teamed Beck with editor Julie Schwartz who decided the title needed to end with an exclamation mark for emphasis — *Shazam!* — but teaming Beck and Schwartz was a big mistake. Somehow those guys just couldn't work together. I might have done better if I had given Beck a shot at writing as well as drawing, like I did with Kirby. I guess it worked out okay for DC in the long run. There was a *Shazam!* TV show, and DC got full rights to the property, and the once-forgotten character continues to show up to this day. I even drew him a bit, years later, in the third *Super Powers* mini-series.

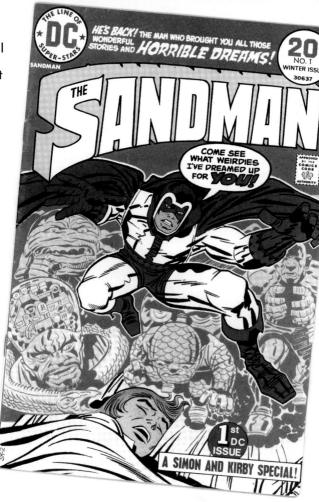

Simon & Kirby Reunion. Joe Simon and I

were old friends from my Simon & Kirby days, and we'd talk every so often. At some point, he had some free time and I asked if he'd like to do some comics for DC. He did *Brother Power, the Geek* and *Prez.* Those titles attempted, with little success, to capitalize on the late-'60s to early-'70s youth movement. Sometimes — when Joe and I or Bill Gaines and I would talk — we'd try to reason why the Simon books and the Kirby books weren't doing as well as we thought they should. Frequently the idea would come up that if we could get them back together as a team, great things might happen.

Joe was fairly open to the idea but, for the most part, Jack was not. Jack had done so much great work over so many decades, billed second to Simon and then Stan, that going back was not a pleasant idea. But I'd still bring the idea up to Jack from time to time. We were talking about Jack doing a new version of The Sandman.

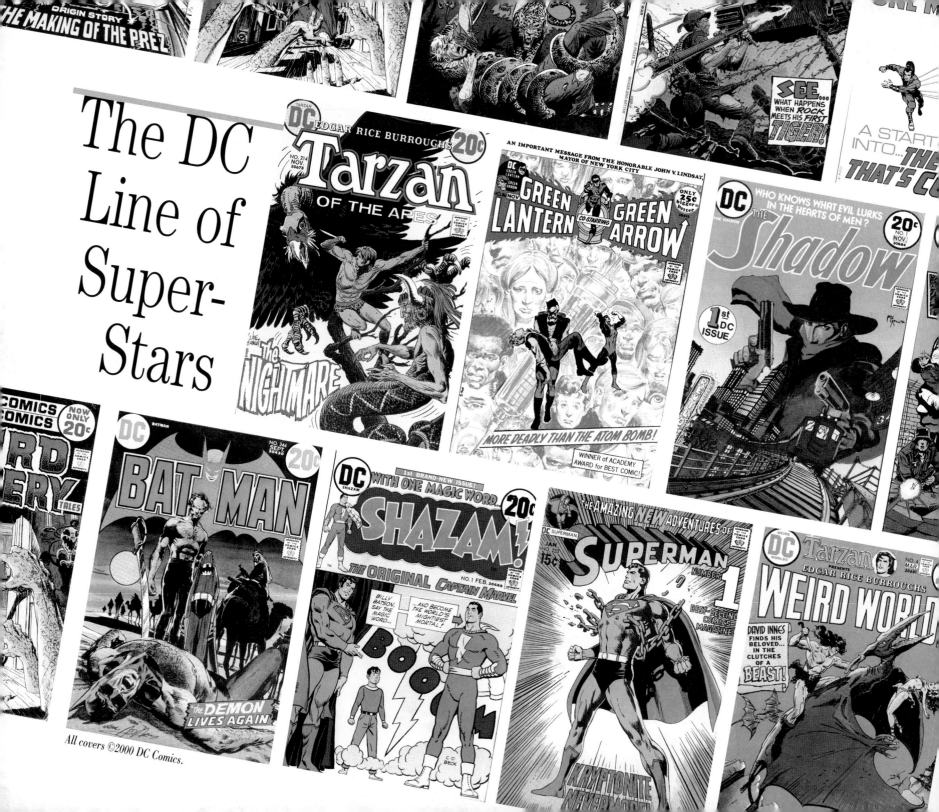

The DC Line of Super-Stars

All covers ©2000 DC Comics.

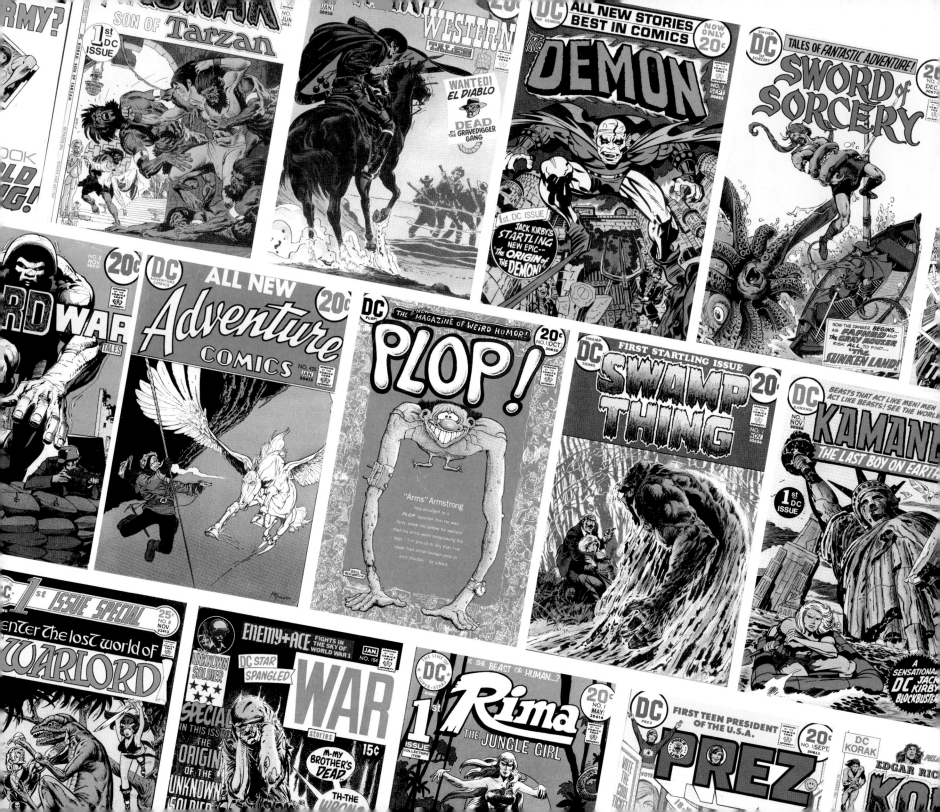

Simon & Kirby had done Sandman work for DC way back in the '40s. I pitched a one-shot Simon & Kirby *Sandman* reunion issue. To my surprise Jack said okay! So they did the book and guess what? It was a smash hit. The distribution numbers were great. I said, "Jack, we've got a hit; we've got to do more of these." Jack said, "Okay. But, Carmine, I'd really rather do them on my own." So that was my short-lived Simon & Kirby reunion. A little later, that title also featured a one-issue reunion of the famous art team that first worked together at DC — on *Challengers of the Unknown* — Jack Kirby and Wally Wood.

Comic Book Unions. Over the years, the idea of a comic-book artists union has popped up now and again. Arnold Drake spearheaded the first one I remember hearing about. He gathered a bunch of people together and said he'd represent them. Then he went to see Jack Liebowitz, owner of DC at the time. I wasn't in the meeting and I didn't hear what was said, but the talk was that Drake told Liebowitz he was

starting a union, everybody in the industry was joining, and they were going to set prices. I understand Liebowitz said, "Fine; you get everybody else in the industry to join, then I'll participate." That killed them, because Marvel said the same thing. That union withered on the vine right there. That was just before the big Batman craze, about 1963 or '64. That's what I was told. It seems believable, because the talk did quiet down after the meeting with Liebowitz. It was actually a clever ploy on Liebowitz' part.

Later on, around 1970, Stan Lee and Neal Adams started the Academy of Comic Book Arts — ACBA. I attended the first meeting, with Stan, Neal, and others. They wanted me to run for president. I said, "That's ridiculous! I'm *management;* I don't belong in this. I don't think it's wise or fair. I can't be a part of this." Stan boldly proclaimed, "I'm staying!" Of course, he became the first president. But it didn't do anyone any good, because Stan was management!

They couldn't figure out what they wanted ACBA to be: a guild or a society or a union.

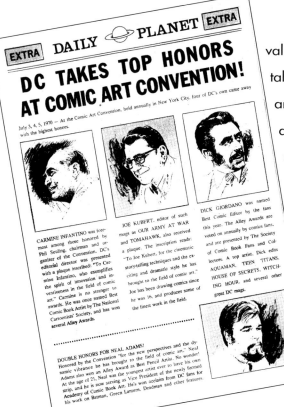

Above: House ad appearing in late-1970 comics announcing DC's award-sweep at the Phil Seuling 1970 Comic Art Convention. Pencil portraits by Neal Adams. ©2000 DC Comics.

I still think what I did was valid. You can't wear both hats. They talked about wages and benefits and all. They tried to get a hold of an AFL-CIO representative, but the real union people considered the business too small to pay it any attention. Later, Neal became president and they created a creed or mission statement, declaring they believed art should be returned to the artists. Well, some well-known staff people at Marvel were afraid to take that stand and when they pulled out, the group started falling apart.

Later in the '70s, there were a couple of artists who planned to lead a strike. It was rumored they intended to attack DC first. They were ready to break our back, and it was a tough situation. I thought, "We'll see about that."

Tony DeZuniga was a Filipino and he was working for us as an artist. He said there was a group of talented guys in the Philippines and we could get them. I said, "Well, we better get somebody, because if this union thing happens, we're dead!"

The Filipino Invasion. So, Joe Orlando, Tony DeZuniga, and I all went to

the Philippines. DeZuniga was the brother-in-law of somebody connected with Ferdinand Marcos, the dictator in power, which helped us cut a little red tape. We went to Manila and met all these wonderful artists. Some of them

came shoeless to show their work. It was a remarkable scene! I selected a dozen or so and said, "These are the artists we'll work with." And then Tony DeZuniga said he would stay there and set up a shop.

Now, we had heard that these guys out in the Philippines worked for $2 or $3 a page. But I said, "No. We have to pay a fair wage." So I think we paid something like $45 or $50 a page, plus 20% for the DeZunigas who were running the shop in the Philippians.

We would send them scripts and they would get the artwork done and send it to the States. Things were running very smoothly for a while, but then every once in a while I'd ask for the top talents like Alex Niño and Nestor Redondo. (I love everything Alex Niño does; his work is genius! He's one of the guys that I brought over from the Philippines). Those two were the best. But I wouldn't get any work from them. I'm wondering, "What the hell is going on over there?"

A young Filipino came up to me at a convention in San Diego and said, "We are very upset with you in the Philippines. You're paying us $5 a page." I had no idea what he was talking about. I told him we had a contract, and were paying $50 per page. What happened was, the people running the shop were keeping almost all the money. They were ripping their own people off and living like kings! As soon as I got back to the office, I wrote them a letter and told them I could not tolerate this and it's got to change. They responded with a scathing letter saying, "How dare you!" They wrote that I couldn't tell them what to do, and why don't I mind my own business! They were ripping each other off terribly.

Center: Another Infantino concept, the extraordinary comics adaptation of The Bible, an oversize DC publication with the notable collaboration of Sheldon Mayer, Joe Kubert, and Nestor Redondo. This is a Redondo text page illustration. ©2000 DC Comics.

Below: Sal Amendola's light-hearted depiction of the Academy of Comic Book Arts (ACBA). From the 1973 Comic Art Convention souvenir book. ©2000 Sal Amendola.

So I contacted Nestor Redondo, and I said, "Nestor, can you organize getting scripts and art back and forth with the artists there? Because I won't deal with these crooks any more." He agreed and handled the thing for a while. But gradually it was phased out. However, I had covered myself with the foreign talent and that was the end of the strike threat by the American artists. It was my job to protect the company. And that's how I did it.

Superman: The Movie. At DC

Comics, I worked around the clock, including weekends, and never took a vacation in the ten years I served as an executive. Not only was I creating new titles, designing most of the covers, plotting stories, acquiring talent, and going on the road overseeing the distribution of the magazines; I was also doing radio and newspaper interviews and, in 1974, I made the deal for DC to receive $500,000 up front, and 7.5 % of gross worldwide (not net — *gross!*), in exchange for the Superman movie license. That was an excellent deal for DC. *Superman I* and *II*, starring Christopher Reeve, were to be shot simultaneously, so I was running back and forth out to California to work with writer Mario Puzo and the producers. Time got so tight that I would design covers on the way to the airport and have the driver deliver them back to Sol Harrison, who in turn gave them to the waiting artists. I would be at my desk from 7 A.M. to 9 P.M. It began to be quite a grind.

When the script for the first *Superman* film was presented for my approval, I couldn't believe it. This was not Superman! It was ridiculous. This movie was supposed to make DC money and promote the comics. The original script

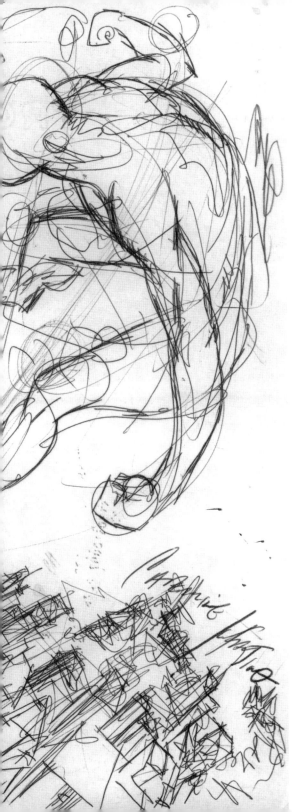

would have bombed and been a terrible embarrassment to the company. So now I was in a bungalow at the Beverly Hills Hotel writing a new screenplay with Puzo and the producers. I never thought of asking to be paid, because I saw my efforts as all in the line of duty as President of DC. They did, however, promise me co-writing credit on the films.

The End at DC. 1974 had

been a huge success for DC. I was the toast of the town, receiving thank yous and congratulations, but when I reminded my immediate superior at Warner that he had promised me some profit sharing, his memory failed. So I quit. By the time I got to my apartment, he was on the phone offering me a nice bonus, so I went straight back to work.

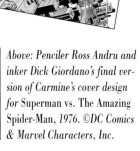

With rare exceptions, like the super-hero boom of the early '40s and the Batman boom of the mid-'60s, the comic book business tends to make more money on licensing of characters for film, TV, toys, etc., than it does in publishing. If I remember correctly, we did about $800,000 in publishing alone in '74. I had brought the company up from being creamed by Marvel to being dead even with them. Comics sold for 25¢ a copy at the time; they sell for $2.50 now. Wouldn't that mean $800,000 then would be equal to $8,000,000 today?

My tenure at DC ended very simply: Our printer told me late in 1974 there might be a paper shortage in '75. Marvel was launching a huge expansion which, among other things, could tie up all the available paper. Marvel knew that, in the long run, most of their new books would-

Carmine looking over final proofs for the Famous First Edition oversize reprint of the comic that started the whole super-hero she-bang, Action Comics #1.

n't make it. But they also knew there would be a demand for any new first issues. The retailers and distributors would most likely favor the new Marvel books over any existing, moderate-selling DC titles. This strategy would force DC titles off the comics racks. Personally, I believe that was Marvel's plan, all along.

The only way I could protect DC's rack space position was to go head to head with Marvel's expansion. I knew many of the new Marvel and DC titles would lose money, but if I didn't match their production, we would lose existing titles and be blown off the racks by the new Marvel books. The resulting loss of our share of the market would be devastating and take much longer to recoup than calling Marvel's bluff long enough for them to come to their senses and cancel the poorer-selling titles.

In January 1976, I had just returned from a whirlwind promotional tour for the Superman/Spider-Man treasury edition. Marvel and I worked out a deal that made this first-ever, landmark crossover book possible and, to my memory, the thing sold an amazing 500,000 copies! The promo tour included radio and TV interviews, and convention appearances. When I got back into the office, I was called to a meeting with some Warner Bros. brass. Honestly, it was not a surprise to me to find out both Marvel and DC showed financial losses in 1975. The much-speculated paper shortage never occurred. Faced with 1975's final numbers, the Warner Bros. executives above me decided to withdraw their support. I was understandably quite upset. Warner's own people noted I had been doing the work of four or five people. I'd given the company everything, leaving little time for any personal life. It was time to move on and, in many ways, it was a relief.

It is my understanding that, the year after I left, sales were the worst in DC history. People there told me that *Batman* had only a 12% sell-through, the lowest of the Caped Crusader's career. To handle the workload I'd had, it took promoting Joe Orlando to Editorial Director, Sol Harrison to President, Paul Levitz to Editorial Coordinator, hiring Vince Colletta as Art Director, and Jenette Kahn as Publisher.

The following year was salvaged for DC by the *Superman* movie, which I had worked so hard on. Strangely enough, now that I was no longer with the company, the co-writing credit I was promised wasn't on the screen as the films were released.

Above: Nearly ten years after leaving DC Comics, Carmine received this letter from then-Publisher Jenette Kahn lauding his positive creative impact at the company, ranking him as one of the fifty most important people in the history of DC Comics.

Ten: Back to Freelancing

Warren Publishing. Jim Warren was the first comics publisher to contact me after DC. I said, "I'll do work for you, but nothing full-time because I'm busy with other things." He said, "Okay, whatever you're willing to give me." I wasn't really comfortable with the Warren material — it was the sexiest work I'd ever done! Jim had an older audience and wanted it that way. My feelings about the material never affected the mutual respect Jim and I had for one another.

Jim was a strange bird! Still, he gave me plenty of room, so we never had any problems. A lot of brilliant talents did work for Jim including Bernie Wrightson, who inked a couple of my stories at Warren, including the "Dick Swift" story. It was a lovely story which Bill Dubay wrote. Bill could be brilliant and that was one of his best moments — just a stunning story. I really worked on that, enjoyed drawing it, and I think it shows. Alex Niño loved working on my pencils at Warren. He told me we had very compatible styles. I did quite a few stories for Jim, considering horror really isn't my genre.

When I left Warren, they were to mail my originals to me. But somebody walked off with a number of stories. They just disappeared. There was a space story called "The Last Super-hero on Earth," written by Cary Bates (who also worked with me on *The Flash*). I penciled, inked, and toned that one. A story with Bernie and another with Alex Niño were also stolen. All kinds of beautiful art gone! The police called and asked me if I suspected anyone. I said, "I'm not going to blame anybody. What's gone is gone!" It might still come out, though, who took the art.

Above and background: Panel details of Bill DuBay's poignant turn-of-the-last-century story, "Dick Swift and His Electric Power Ring," penciled by Carmine and nicely inked by Bernie Wrightson. From Creepy #86, Feb. 1977. ©2000 Warren Publishing.

Opposite and following four pages: Unpublished Cronk story penciled by Carmine and inked by Allen Milgrom, written by Cary Bates. Art ©2000 Infantino & Milgrom.

James Warren on Infantino

The first time I met Carmine was on an airplane going to a comics convention in Canada. We sat next to each other. I remember saying to him, "Carmine, I wish I could like you — but I have to hate you because you're a potential competitor. You might someday come out with black-&-white comics like *Creepy* and *Eerie*, so I have to try hard not to get friendly with you." Looking back on it, it was a shallow thing to say — but Carmine understood. Despite my bravado, I liked him.

Historically, Carmine helped build DC just as Julie Schwartz did. Just as Jerry Siegel and Joe Shuster did. Carmine was a giant who gave years of his life, talent, and energy to the industry.

When I heard about his departure from DC I contacted him. I asked him to come to Warren Publishing and work for us. Actually I didn't ask him; I begged him.

The conversation went something like this: "Carmine, every hour you're not at that drawing board is the fans' loss, and the world shouldn't be deprived of that. We're not huge like DC and I wish we had plush offices, but we don't. However we'll rearrange some space and give you your own office. The ground rules are: You

don't have to let anyone into your office unless they knock first, ask permission, and are invited in. This includes me. Will you do it?"

Carmine agreed, and was I thrilled! It was the same exciting feeling I had when I asked Will Eisner to come aboard, and Will said yes. During the time Carmine was with us he raised the *esprit de corps* of everyone there… a living legend was at a drawing board in our office! There were times when I deliberately walked past his area just so I could sneak a peek at this man as he penciled those pages. And what pages they were! It was terrific that he stayed as long as he did. I'll always be grateful to him.

I never got the chance to wish Carmine a proper happy 75th birthday, so I'll do this in print right now — and say another "Thank You" for adding so many pages of glory to the industry's history.

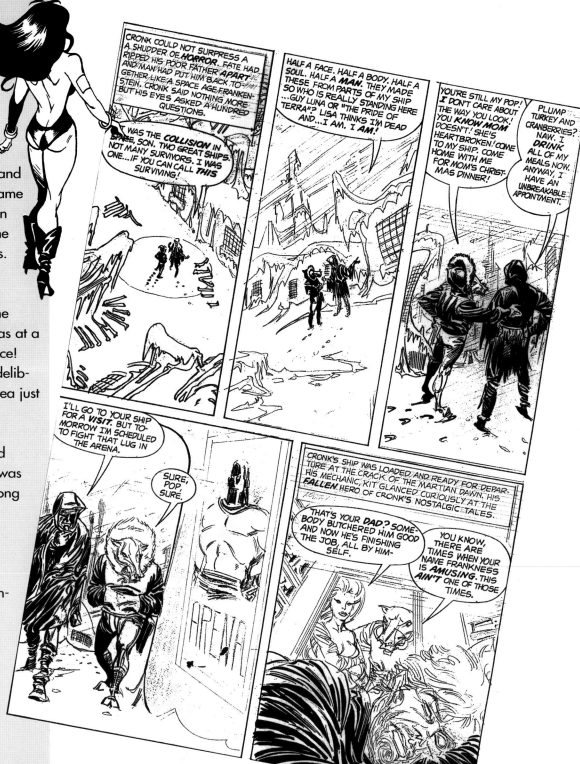

AS GAME TIME NEARED, A TENSE MURMUR REPLACED THE RUMBLINGS OF THE CROWD. FOLLOWED BY TOTAL SILENCE AS GOVERNOR TOBE ASCENDED TO HIS THRONE.

THROUGHOUT THE BOWL OF THE THEATER THE CLICKITY-CLANG OF HEAVY MESHING GEARS ECHOED. THEN, THE CENTRAL PLATFORM SLUGGISHLY ELEVATED THE COMBATANTS.

THE CROWD EXPLODED. CHEERS, AND WHISTLES, THREATENED TO TOPPLE THE STADIUM. THE MEN WERE WELL MATCHED PHYSICALLY. THE CHALLENGER, WHO SOUGHT THE CONFLICT, HAD EVERYTHING TO WIN. SHOULD LAGO, THE UNDEFEATED CHAMPION, DIE IN BATTLE, GUY LUNA WOULD BECOME THE NEXT CHAMPION OF DEMOS!

THEY CANTERED THEIR CONGLOMERATE MOUNTS TO THE EDGE OF THE ISLAND. TURNING TO FACE ONE ANOTHER, THEY SWITCHED ON THEIR LECTROSWORDS AND WAITED FOR THE CUE TO BEGIN THE CHARGE.

LAGO MOVED FIRST, STEALING THE ADVANTAGE!

GUY'S SWORD CLEAVED AN ARCH THROUGH THE AIR AS HE CLUMISLY INITIATED THE PRIMARY AGGRESSION. THE SKILL LAGO DISPLAYED IN AVOIDING THE DEADLY LIGHT BLADE PLACED THE ODDS OF THE DUEL HEAVILY IN HIS FAVOR.

LAGO'S FIRST BLOW LANDED. CURRENT RAC[ED] THROUGH GUY'S BODY, THREATENING TO S[NAP] HIS SPINE IN TWO.

ANIEE!

GROGGILY, HE STRUGGLED TO REMAIN CONSCIOUS. HIS STOMACH THROBBED WITH AGONIZING PAIN. THE ODOR OF HIS OWN SEARED FLESH FILLED HIS NOSTRILS. AND HE WAS BEING DRAGGED TO THE EDGE OF...

...THE PIT! HE'LL TA[KE] ME OVER THE EDGE W[ITH] HIM IF I DONT—

NEEEEEiiiiii

TIME, GUY HEARD THE CLATTER OF LAGO'S GALLOPING MOUNT. HE PULLED A FIREBALL GRENADE FROM HIS BELT AND *HURLED* IT AT HIS ATTACKER.

WHOOSH!!

THAT ENDED THE PROBINGS...THE TESTS FOR SKILL AND STRENGTH. EACH MAN NOW KNEW THE OTHER AS WELL HE NEEDED TO KNOW HIM. EACH HAD PROVED A THREAT TO THE OTHER'S EXISTANCE. THE IMPERSONNAL OPPONENTS HAD BECOME DESPISED *ENEMIES*.

NEVER HAD THERE BEEN SUCH A SWORD FIGHT! THE MEN FACED EACH OTHER FOR A FULL *HOUR*, MUSCLES ACHING, DRAINED OF BLOOD, SWEAT FLOWING FROM EVERY PORE, TILL FINALLY--

ZWOR!

ZWOOEZ!

KROOSH!!

BUT THE CROWD, CAUGHT BY THE HEROISM OF THE COMBAT, HAD LOST THEIR TASTE FOR DEATH. THEY DEMANDED MERCY IN VIGEROUS BOOMING CRIES THAT ROCKED THE STADIUM. AND CRONK WAS STANDING BY ...IN CASE ANY *BACKUP* OF THEIR DEMANDS WAS NEEDED.

GOVENOR, WHEN LAGO LOOKS UP HERE, I'D BETTER SEE YOUR THUMB POINTING STRAIGHT UP TO *HEAVEN*...OR I'M GOING TO SEND YOUR *SOUL* TO *HELL*!

LUNA IS A *DEAD* MAN. HE INSISTED ON THE COUP D' GRAIS WERE HE TO BE DEFEATED. HE WILL NOT BE THROWN INTO THE PIT...BUT I CANNOT GO AGAINST HIS *WISHES.*

YOU CAME TO THIS ARENA TO FIGHT ME...AND YOU FOUGHT *MASTERFULLY*. BUT YOU INTENDED ALL ALONG TO DIE. TELL ME *WHY*...BEFORE I CARRY OUT YOUR DESIRE.

WHY!? LOOK AT ME! SINCE WHEN IS HALF MAN BETTER T[...] NO MAN AT AL[...]

SWISH!

GO *HOME*, LUNA. SIT BY YOUR FIREPLACE, SING CHRISTMAS CAROLS WITH YOUR FAMILY AND BLESS YOUR GOOD FORTUNE!

WHAT ARE YOU DOING GRANT ME NO *HOLIDAY MERCY*! *SLAY ME*! THE DISASTER OF '25 ROBBED ME OF ANY DESIRE TO SEE ANOTHER *CHRISTMAS*!

I WOULD SLAY A COWARD OR A HERO BUT NOT A *FOOL*!

...MERRY CHRISTMAS FROM THE *DISASTER* OF '07!

133

Warren Work

...AND STALKED OFF WITH PAK STAVOS' PRIZE COW.

ZZZZZZZZT!

HE'S UP! HE'S ALIVE! CHRIST, HE DID IT!

DUJO, BURY HIM QUICKLY AND QUIETLY. SKIP THE RELIGIOUS *MUMBO JUMBO*.

THEN COME INTO THE HOUSE. I WANT TO SPEAK WITH YOU.

YES, *MASTER PAK*.

I'M SORRY, PAK. THOSE STUPID ALARMS ARE ALWAYS GOING OFF, A BIRD OR A COZUMA C... TRIGG... THE...

WORK, MAC.

THANKS, HARRY. *WHEW!* ALMOST *BOUGHT* IT THERE. FOR A SECOND! COULDN'T GET THE *DOOR* OPEN.

SO NOW THE WAGNER BOY IS SUMMARILY *EXECUTED* AT FEDERATION CONTROL LIKE SO MUCH *HORSE MEAT*...VERY NICE.

EXCUSE ME, GENTLEMEN...

HEY, WAIT UP!

I DIDN'T THINK—— UNG!

STUPID WITCH!

I *DON'T* CARE MUCH ABOUT YOUR LIFE, SINCE YOU HAVE SO LITTLE CONCERN FOR IT... BUT THAT CREATURE MIGHT HAVE HARMED *MY SON!*

I *HATE* YOU AND I *HATE* THIS PLANET. I'D DESTROY YOU *BOTH* IF I COULD.

Infantino's work for
Warren Publishing includes
some of his finest non-DC
art in a wide variety of
styles as finished by a
variety of inkers. Still,
Infantino's trademark
design and storytelling
are ever present.

TWICE
YOUR
*ORMAL
EIGHT !

HEIGHT !

Heh! Heh! THAT'S
MY *BAMBI*, ALWAYS
THE KIDDER !

Bill Sienkiewicz on Infantino

As a child, and new to the world of super-heroes, my first favorite comic book was *The Flash* (I've had others since then of course, but that was definitely my first.) The stories and characters thrilled my young sensibilities, but mainly I loved the artwork of Carmine Infantino: his interesting use of silhouettes, cityscapes in that flat design style, Flash's serpentine speed trail, and those great caption boxes with the gesturing hands, which, more than anything else, showed me the possibilities inherent in the language of comics — that reality could be interpreted, rather than simply translated into a series of little boxes. I enjoyed it as theater, with a sense of pure fun. Carmine seemed to be enjoying himself, to the point where he was anthropomorphizing blocks of text. He actually made me want to read all those captions, which is one of the highest accolades I can give to an artist (no slight of the writer or letterer is intended.)

With Carmine, I particularly loved his own inking… the linework was just so alive… freer; there was a quality to his ink work that I saw nowhere else. When others inked Carmine,

Hollywood.

Shortly after I left DC, I went to work for Hanna-Barbera animation studios. I knew Joe Barbera from dealing with him on the DC animated projects including *Super Friends*. H-B called after I left DC and asked me if I would like to come out and do some work for them. I said I'd give it a try, and I moved out to Hollywood for a while and worked in the animation business.

At H-B, I was designing characters and working on the *Barbie* cartoon. What I didn't care for in animation was other people watering down whatever I did. It was hard to recognize my contribution in the final product. But the money was good and Hollywood was a refreshing change after so many years in the comic book business. I enjoyed learning the animation process. I know how to storyboard now, and how to break the stories down. I learned the whole business, which is good. After I'd learned the ropes, my mother had a stroke and I had to come back to New York.

Later on she got a little better and I moved back out, this time working for Marvel Films. I also did work on a few major, live-action features

and I had some ideas of my own I hoped to develop.

Then my mother got much worse and she couldn't be left alone. I had nurses around the clock, but I had to come back again to New York, and that put the brakes on my Hollywood career. Life dictates these things, and you live with your responsibilities.

Star Wars. I did

quite a series on *Star Wars.* It was tough work learning all the equipment and characters. I went into it as just another Marvel job, but Archie Goodwin was a very good editor and he got me to pay more attention to *Star Wars.* I enjoyed working with Archie and I think that showed in some of the *Star Wars* work. I can't recall if it was Archie, but to my memory somebody told me George Lucas had requested me personally. If that was so, Lucas was probably an Adam Strange fan. *Star Wars* probably holds up as well as any-

Center: Two unused Star Wars *images from Carmine's memorable stint on the series. ©2000 Lucasfilm, Ltd.*

as talented as they were, they had a tendency toward making his pencils …normal, rounded, too much of a representation of reality — rather than a stylized version of it. Carmine's work always reminded me of fashion illustration, of architectural/gestural drawings, of the vocal stylings of Nat King Cole. I don't think his intentions were to capture reality — he looked like he was having too much of a grand old time making stuff up: rockets, jet packs, great Mies Van der Rohe-styled homes, coolly statuesque cyber-babes before cyber was even a term, the coolest cars, fabulous drapery (yes, I said drapery — if you haven't been jazzed by some kick-ass folds, then give up any dream of becoming a comic book artist right now). All these things his inking captured exquisitely.

It wasn't until just recently that I had the pleasure/mixed emotions of finally meeting Carmine and talking with him, and my old buddy Tom Palmer, at a restaurant on a snowy afternoon after the funeral for the wonderful Joe Orlando. It seems to take something like the loss of a colleague to get most of us out from behind the board.

In speaking with Carmine, I was glad to finally and personally let him know just how much I loved his work, and what an inspiration it had been to me. When I brought up the quality of his inking and his great architectural style, he informed me that he loved architecture and had seriously considered becoming one professionally. I wasn't surprised, but I love it when pieces of a puzzle fall into place like that. It was an "Of course!" moment.

Carmine would have made one terrific architect. But the world of comics would have lost out on an incredible stylist and I, for one, wouldn't have bothered to read all those damned captions.

FIN

Spider-Woman

ALL MY LIFE I
LIVED APART
MANKIND--TRA
IN A WORLD WIT
GENETICALLY A
ANIMALS AS
COMPANION

A
TH
AL
HU
ST
M

CALL ME JACK,
HEY--HOW'D
YOU KNOW
MY NAME?

WE MET
ONCE BEFORE*
--THOUGH I
DOUBT YOU'D
REMEMBER.

I'D BE GLAD TO
TELL YOU ALL ABOUT
IT, BUT FIRST I'D
LIKE TO KNOW WHAT'S
BEEN GOING ON HERE.

*BACK IN SPIDER-WOMAN
#6. --R.

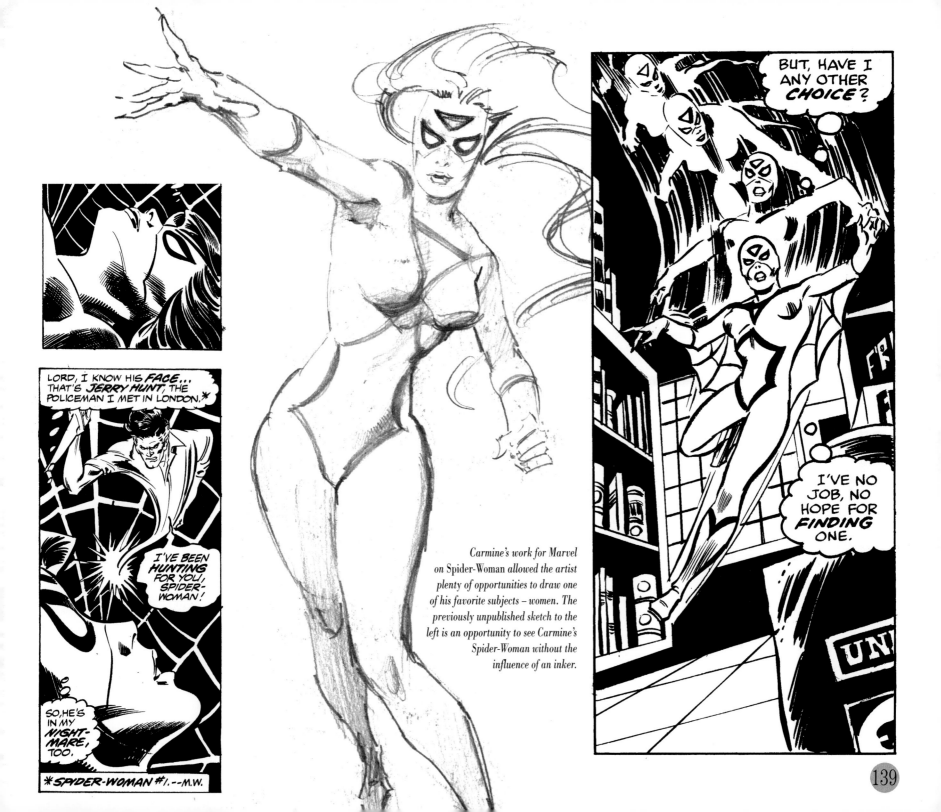

Carmine's work for Marvel on Spider-Woman allowed the artist plenty of opportunities to draw one of his favorite subjects – women. The previously unpublished sketch to the left is an opportunity to see Carmine's Spider-Woman without the influence of an inker.

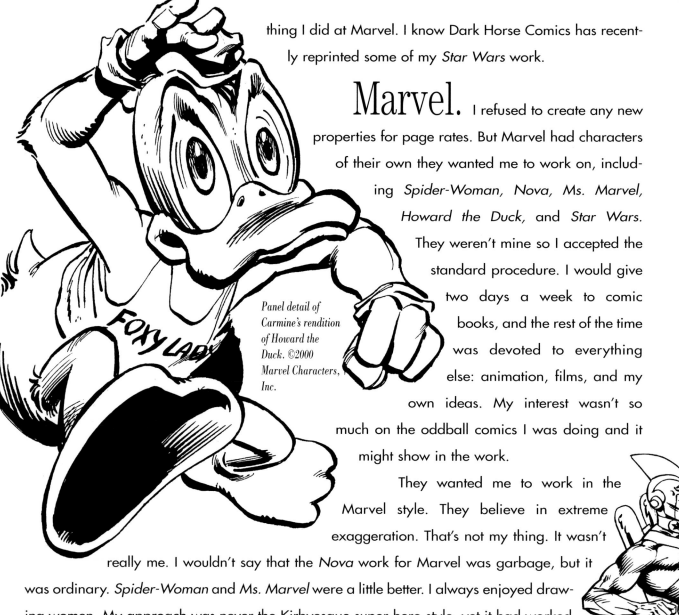

Panel detail of Carmine's rendition of Howard the Duck. ©2000 Marvel Characters, Inc.

thing I did at Marvel. I know Dark Horse Comics has recently reprinted some of my *Star Wars* work.

Marvel. I refused to create any new properties for page rates. But Marvel had characters of their own they wanted me to work on, including *Spider-Woman, Nova, Ms. Marvel, Howard the Duck,* and *Star Wars.* They weren't mine so I accepted the standard procedure. I would give two days a week to comic books, and the rest of the time was devoted to everything else: animation, films, and my own ideas. My interest wasn't so much on the oddball comics I was doing and it might show in the work.

They wanted me to work in the Marvel style. They believe in extreme exaggeration. That's not my thing. It wasn't really me. I wouldn't say that the *Nova* work for Marvel was garbage, but it was ordinary. *Spider-Woman* and *Ms. Marvel* were a little better. I always enjoyed drawing women. My approach was never the Kirbyesque super-hero style, yet it had worked perfectly well on The Flash, Adam Strange, Phantom Stranger, and Batman. I was really focused on the animation work I was doing at the time. I was the regular artist on *Spider-Woman* from the beginning of the series, and on it for a couple of years. I think I did about 25 issues of that title.

A Piece of the Action.

When I returned to New York, one of the comic book houses called me in and offered me a position. The salary was good, but part of what they wanted me to do was create new characters for them. I said, "I want a piece of the action." They said they couldn't do that. I said I would absolutely not create properties for them unless I got a percentage of the ownership. I wasn't going to knock myself out the way I had at DC without some profit sharing. One after another, I turned down opportunities like that.

Back at DC Comics.

After I left DC, Joe Orlando had been promoted to Editorial Director. He called me regularly and tried often to get me to return to *The Flash*. I'd given DC my all, and was very hesitant to return. But Joe was relentless, assuring me I'd only be dealing with him. Ultimately, because of our close personal relationship, I caved in and accepted, but for some reason he started me off in late 1980 on an "Adam Strange" back-up in *Green Lantern Corps* #137. Then there was a silly little feature, "Dial H for Hero," which appeared in *Adventure Comics* in '81.

I then found out sales on *The Flash* had been steadily slipping and Joe was hoping my return would save the book from cancellation. I guess I did pretty well, taking over in late '81, somewhere around #290. And I continued — through the special 300th issue — all the way to #350, quite a run! We stopped the series at that point and killed off the character.

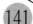

141

Star Wars

Of all the series he did for Marvel (Spider Woman, Ms. Marvel, Nova, Star Wars, etc.), Infantino's best-remembered work for the company has to be Star Wars. It's also the only Marvel/ Infantino material to be reprinted, albeit by Dark Horse Comics.

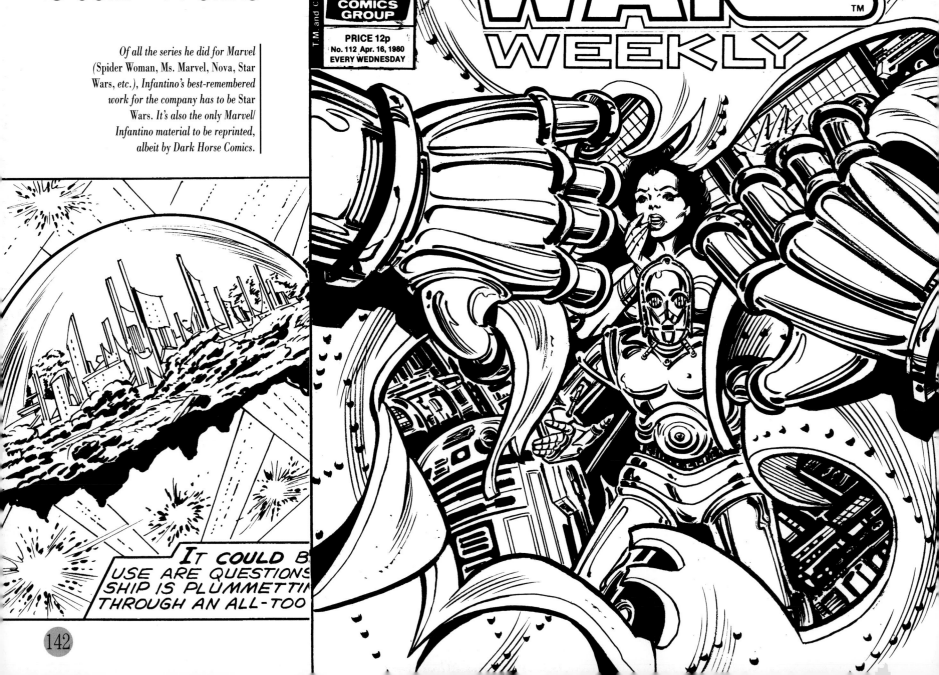

Sam Viviano on Infantino

Way back in 1968, I was a 15-year-old Detroit boy whose dream in life was to be a comic book artist. I collected pretty much every comic published in those days, but there was a very special place on my shelves and in my heart for *The Flash*, "Adam Strange," and *Detective Comics*. They contained the smartly-designed and cleanly expressive work of my hero and role model, Carmine Infantino. In those days before fandom became the industry it now is, I never imagined I would ever have the chance to meet my idol face-to-face. When that event actually took place in July of that year, I was (pure and simple) awestruck.

My excuse for travelling east was to visit Aunt Babe and Uncle Vince in Brooklyn, but my secret hope was to take one of those tours of the DC offices I had read about in the letters pages. I anxiously called to make an appointment, but was crestfallen when I learned the tours had been discontinued. Maybe the receptionist sensed my extreme dejection and felt sorry for me, for she brightly suggested I just come by that afternoon and visit with Mr. Infantino (who at that point was Editorial Director of the entire DC line).

I couldn't believe my ears. "Simply come by"? Just drop in on my hero who also was head muckety-muck of the whole she-

All this time they had me doing other books, too. All of a sudden I'm one of DC's top artists again. And I have to admit it felt more natural working at DC than drawing comics for other companies. One day, Joe called and said, "Julie Schwartz wants you to draw his new *Supergirl* series. Will you work with Julie?" Well, it's *Julie;* he was my editor since the late '40s! So I said, "Yeah, I'll work with Julie." And we did a nice series on *Supergirl.* I started with #1 and drew about 25 issues, very capably aided by Bob Oksner. The comic based on the science-fiction TV show *V* was another series I did in this period, over 15 issues, inked by Tony DeZuniga. Yes, him.

Return to Batman.

As I've said before, since childhood my dream was to be a famous newspaper strip cartoonist. Various sample strips in the '40s and '50s (including a collaboration with Jack Kirby) all failed to captivate the comic strip syndicates. I had helped others on their strips, but it wasn't until I was the popular, overworked artist of *Detective Comics, Flash, Mystery in Space,* and other comic-book titles that I finally was given my own strip, *Batman,* only to see it taken away because the company valued my work most on the regular comic books.

Well, somewhere around 25 years later, I received a phone call from a young newspaper syndicate woman who

--NEVER BEFORE HAS HE BEEN PROPELLED BY SO MUCH ANGER...

RESENT-MENT...

RIGHTEOUS INDIGNATION!

Left: Carmine also returned to do significant work on his most beloved character, The Flash. Here's a panel from the early 1980s. ©2000 DC Comics.

wanted to know if I were available to pencil a new *Batman* newspaper strip. Ahh, a chance at some unfinished business! So I accepted the assignment, naturally with enthusiasm, even from an old pro like me. I enjoyed it, and I was a bit surprised when I started getting my returned original art. Willie Nyberg was inking me in a cross between my style and the then-new *Batman Adventures* animation style. I didn't have a problem with that style; I ended up doing a lot of that kind of work for DC Special Projects division. I was just surprised because the syndicate hadn't mentioned anything about it.

Because of the inking style, and to make room for all the names — the writer, inker, Batman creator Bob Kane, as well as myself — I signed the work "Cinfa," short for C. Infantino. I'd done that years earlier when I used an unexpected inking style. I was a little disappointed in some of the scripts, which struck me as rehashes of old stories. But who knows? If the writer, Loebs, is young, he might have thought they were totally original. We did the strip — both dailies and Sundays — for a few years. I was happy to do it.

DC Special Projects.

DC's Special Projects division develops style guides for licensing and creates special comics for advertising and corporate education. Joe Orlando really did a lot to make that a money-making division of the company. After my return to DC with *The Flash, Supergirl,* and then the *Batman* newspa-

Above center and right: By the late 1980s, Carmine was doing a lot of licensing illustration work for the DC Special Projects department headed by Joe Orlando. ©2000 DC Comics.

bang? Just show up and display for my idol the precious adolescent artwork which I just happened to be carrying with me in a red-rope portfolio? You can believe I hopped on the next IRT train into the city and made my way up to 575 Lexington.

To be honest, what happened that afternoon is now something of a blur. I was ushered into Mr. Infantino's office and he greeted me warmly. I would say he was about ten or twelve feet tall, or maybe I had shrunk a bit as I entered his doorway. He politely looked through all my amateurish drawings of Batman and The Flash, and said something about someone showing promise. (It might have been me, but I was too mesmerized by the glowing aura about him to be sure.)

He really didn't spend much time with me, for when someone walked by his door, he called out, "Hey Neal! Why doncha look at this kid's stuff?" "Neal" turned out to be Neal Adams, who in 1968 was to comic books what Tom Cruise is to the movies today, and he generously spent an hour with me telling me how bad my work was. I loved every minute of it. I did end up getting that tour of the DC offices, too, and all in all I spent the entire afternoon there.

Thirty years or so have passed, and I have had a wonderful career as an illustrator and art director (but not, oddly enough, as a comic book artist). And all these years later I still recall as one of the high points of my life those few minutes I spent with Carmine Infantino.

Sam Viviano is the Senior Art Director for Mad *magazine.*

Batman Syndicated

Infantino returned to Batman by way of the early-'90s newspaper strip. Though he penciled in his style, a Batman Adventures cartoon-style inker was assigned to the strip. The result is a hybrid somewhere between Infantino's Batman and the animated Batman. Infantino has on occasion worked in the Batman animation style, including the licensed children's book Plant of Peril (above, right).

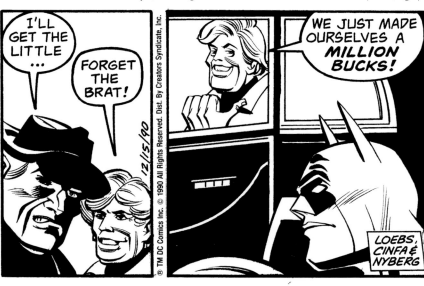

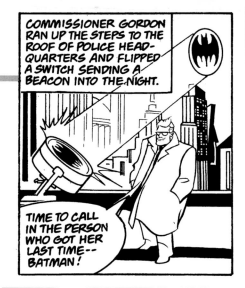

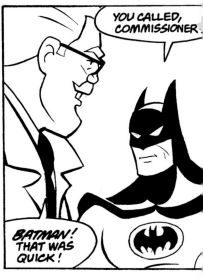

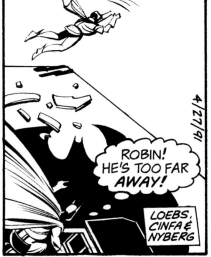

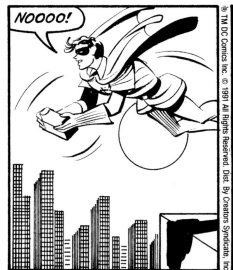

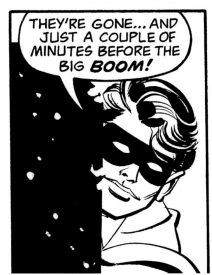

1/3/91

LOEBS, CINFA & NYBERG

11-3-90

LOEBS, CINFA & NYBERG

12/10/90

LOEBS, CINFA & NYBERG

147

per strip, I wasn't really interested in more comic book work, but Joe contacted me, inquiring if I could do some work for Special Projects. I ended up doing quite a bit of special projects and licensing work, including tons of Batman art, and it paid very well. I was doing a piece or two a week for the longest time, plus making good money.

Teaching at SVA.
Since 1992, I've been teaching at the School of Visual Arts in Manhattan. I started out with one class, and peaked with about five classes at one point. The classes were popular with students. Now that I'm 75, I've cut back to teaching only two days a week. I teach composition, design, cartooning, and life drawing. Young people I've taught are very appreciative and I get lots of letters from them.

SVA is one of the best commercial art schools in the world, and they have a cartooning department. Cartooning has been a specialty of the school since Burne Hogarth helped to found it in the late 1940s. Many great comics professionals have taught there, including Burne Hogarth, Will Eisner, Harvey Kurtzman, Joe Orlando, Gene Colan, art spiegelman, Angelo Torres, Walt Simonson, Joey Cavalieri, Klaus Janson, Sal Amendola, David Spurlock, and myself. That's quite a list!

This spread: A recent project for Carmine was packaging illustration for the relaunch of the fondly-remembered Captain Action. ©2000 the respective copyright holders.

Return to Hollywood.
My work in Hollywood was cut short back in the '70s when my mother suffered a stroke and resulting complications. After my first two

years teaching at SVA in New York, I was contacted once again by my old friend Joe Barbera of Hanna-Barbera animation studios. He asked if I could help them out on some projects. I was already in my late sixties, and was ready to cut back on my workload. But I enjoyed California and felt like I had unfinished contributions for the fields of animation and film.

So I took a little break from SVA and went out to California, and they had me designing characters and villains. They were mostly concepts — that is, creative development of properties that would be considered for animated shows. I was out there a while when I started getting homesick and realized I could do the same work back at home in New York. I pitched doing just that to Joe Barbera and he accepted. I returned to New York and split my time between working for H-B and teaching at SVA. I never really followed whether or not any of my characters were being developed into TV shows. Around the time I turned 70, I decided I was ready to retire. I gave up the work for H-B and limited my teaching to a few days a week.

The Revival of Captain Action.

Offers come my way from time to time. My normal reaction is, "I'm retired," but every now and then I get an offer that's too good or interesting to refuse. I was contacted by an advertising agency in 1997. The toy and game company Playing Mantis had bought the rights to the original action figure Captain Action. I had done work on the character back in the '60s. The original developer wanted a figure boys would collect, and would offer more variety than G.I. Joe, their only competition.

In the '60s, Ideal Toys acquired the licensing rights from DC, Marvel, and King Features to create changeable costumes for Captain Action. This way you could buy Captain Action and with a change of clothes, you could have Superman, Batman, Capt. America, Spider-Man, Flash Gordon, Green Hornet, etc. They approached DC during the developmental stage and presented their idea, adding that they wanted us to design the character and publish a comic with him. This was shortly after I became Art Director. I think we were still in the wake of the *Batman* TV show boom. We did it all. They wanted me to do the comic but I didn't have time, so I just worked on the covers. Wally Wood did the interior of the first issue, scripted by the young Jim Shooter. After that Gil Kane and Wally teamed up on the art. I did work on the merchandising and some ads. I'd pencil the box art and someone else would finish it. I believe a number of my drawings were rendered as paintings. I don't recall who did the final art.

So in '97 this agency said, "Since you designed the character, and they want a classic look in the packaging, we want you to do it." Well, I know I worked on the thing in the '60s, but I'm a little fuzzy about actually sitting down and designing him. I don't doubt it; the costume looks like my design. I just don't want to take credit for anything I don't directly recall. Anyway, I took the new job. They wanted finished art — pencils, inks, color — and they wanted to keep the originals to hang on the office wall. There was quite a series: Captain Action, Dr. Evil (the original, not from *Austin Powers*), Kid Action, Flash Gordon, Ming the Merciless, The Phantom,

Kaba Singh, The Lone Ranger, Tonto, Green Hornet, and Kato. They needed two poses plus a background for each character. I did them all with some help from Joe Orlando and J. David Spurlock. There was one job left to be done when we lost our dear friend Joe Orlando on December 23, 1998. Dave and I handled the last one, Kid Action, without Joe.

It turns out Playing Mantis not only bought the rights, they bought the old molds as well. The new figures are made with the same molds that made the original figures in the '60s!

The Warner Store. A few years ago, I got a call from Ed Bolkus, DC's Warner Bros liaison, about producing items for the chain of Warner Bros. Studio Stores. They wanted to produce a limited edition lithograph of Batgirl, and since I co-created Batgirl with Julie Schwartz, they wanted me to produce a number of new sketches that would be reproduced as "remarks" along with a few of my classic Batgirl panels. I agreed and also signed each of the prints. It was fun working on Batgirl, whom I enjoy drawing even more than Batman. The print quickly sold out.

Recently we produced a new print of a rare drawing I did featuring a host of DC characters including Batman, Robin, Flash, Superman, and others. This one was in a loose but crisp fine-line style that I inked myself. There is talk of more prints and I recently appeared for signings at the New York and St. Louis stores.

This spread: Carmine's love for architecture is combined with his Batman legacy in this sketch of Gotham City, for a DC Special Project. Also: Carmine with Irwin at C.I.'s WB store appearance in St. Louis and an invitation, based on his print, to Carmine's appearance at the WB store in New York City

Progression By Staying In Place

Carmine Infantino's Brilliant Career. My friend Carmine

once told me about the time when he was Publisher of DC Comics and was interviewed by a Warner Bros. efficiency expert. Carmine was going through a list of the many duties he had in his position with the expert : Visiting the many distributors across the country; discussions with Independent News (the national distributor who supplied local distributors); laying out many of the DC Comics line's covers; conferences with the entire editorial staff as well as meetings with each of them; occasionally penciling a cover or a story; meeting with Warner executives; attending conventions, etc....

The efficiency expert interrupted Carmine's litany for a moment and declared with incredulity, "You're doing seven different jobs! How do you do it?" I didn't get to hear Carmine's end of that little anecdote because I blurted out, "That's because the expert didn't understand that he was dealing with a *creative* person — someone who is not like a normal person. It's like comparing oranges and apples."

Our conversation turned toward how I thought the eventual death knell of the comics industry began when the comics company owners sold their concerns to larger corporations and conglomerates. In the transition the meaning of creativity in comics art was lost to the notion of comics books as products. Corporate minds think in terms of buying services or products and reselling to a client/consumer, all at a hopefully high profit. It's looking at comics as a matter of product rather than as art. The bottom line dominates over any other factor in creating a product. But back in the '60s and '70s, Carmine was a creative force, producing and creating some of the best comics ever printed.

As you've already read in this memoir, in early 1956, Carmine was called into editor Julius Schwartz's office and was asked to pencil a new version of the super-hero character The Flash. Now, understand that sales reports on all magazines in that era were totaled and updated constantly. With monthly magazines, first initial sales figures

The late Mark Hanerfeld, life-long comics fan and one-time DC editorial assistant, wrote this essay — an adaptation of a previously published CAPA-APA article — for Comic Book Artist magazine in 1998. Mark was a longtime friend of Carmine Infantino, and he passed away in early-2000. It is printed here courtesy of CBA and is ©2000 the Estate of Mark Hanerfeld.

by Mark Hanerfeld

came in to distributors about six weeks after going on sale. Then, after about three months, came the secondary figures. Then came the sixth month figures, and the actual finals came after about a year. Bi-monthlies took a little longer to get final figures.

After the release of *Showcase #4*, initial sales on the issue came in and stirred quite the fuss. The numbers were quirky, weird, almost unbelievable! The report showed the issue selling far better than expected; final sales were about 59% of a 350,000 or so print run, a very good sale. But weren't super-heroes passé? This situation commanded verification; it may have been just a fluke. Eight months and four issues later, *Showcase #8*, The Flash was given a second tryout, earning similar sales results. Still, could this be an anomaly? The Flash was featured in *Showcase #13* and 14. DC brought up the print run somewhat with these issues, and came up with the sales percentage at about the same elevated level. Although super-heroes had been declared virtually dead, The Flash sold and the Silver Age had begun!

During the early part of the 1950s, the sales of all comic books were in a real slump. It was so bad that all of the artists at DC Comics were asked to take a three-dollar-a-page decrease, or the company couldn't afford to use their talents. Most of the artists concurred. In the interim years, the overall sales of the comic books rose to a good, but not great, gross receipts point. The appearance of *Showcase #4* was a turning point in the continuation of comic books publication in the U.S. But it was unfortunate DC Comics didn't raise the per-page-rate, considering the somewhat more stable sales.

Marvel Comics took note of the increasingly popular DC super-hero line, countering with *The Fantastic Four*. And even Archie Comics tried starting a new line of super-hero titles in mid-1959 with *The Adventures of The Fly* and the revamped Shield (in *The Double Life Of Private Strong*).

In the early '60s Carmine was just an illustrator of comics art.. It was noted by Irwin Donenfeld, DC's Edito-

The late Mark Hanerfeld was the real-life model for House of Secrets host, Cain. Above is Joe Orlando's original concept sketch for the character. Cain ©2001 DC Comics.

rial Director and son of DC's co-owner Harry Donenfeld, that Carmine's covers sold at a higher percentage overall than the rest of the line. So, in the course of his trying to maintain a steady number of assignments, Carmine also began to develop cover ideas for editor Julie Schwartz's titles, and was saddled with the job of designing covers for the entire DC line — but no title, just the job.

Then comes the matter of Batman: Around 1963, the Batman titles were simply not performing as well as they had. Also, the 1967 deadline for trademark and copyright renewal on the character was pressing on the company. DC could have renewed the rights or allowed the rights to the strip revert to the creator of Batman, Bob Kane. The challenge was to bring up the sales enough on the Batman line, and continue publishing the exploits of the Caped Crusader. Giving Julie editorship of *Batman and Detective Comics,* Donenfeld also brought in Carmine to help give the characters a new, more salable artistic emphasis. Given only six issues (about eight months), Carmine and Julie felt the pressure to boost Batman's marquee value, and they met the challenge: with Carmine's issues, sales percentages went up ten percent, and continued to grow. Although the "New Look" helped sales, the '66-'67 *Batman* TV series caused the sales of the comic book to go well beyond anyone's expectation — something like 99% sales!

When Carmine became Art Director, his business sense put him on the executive side. Since he was working at the office and was getting a regular check, he decided to have any reprint money due to him shared equally with those who were due the least on the reprint payroll.

Jack Liebowitz's nephew Jay Emmett was given the licensing on the Batman property, from which he created the sister company LCA — Licensing Corporation Of America (which eventually handled all of the DC Comics characters' licensing as well as other properties, such as the major league baseball franchises), and Batman became an extremely hot property. Carmine started doing the art chores on the Batman licensing material as part of his official job as Art Director. Batman was doing so well that they again tried the feature as a newspaper strip. Carmine did the first Sunday story, to set the look of the Batman strip, and expected to continue on the feature. But the brass at DC thought Carmine's pay rate (one of the highest rates tat DC) was too high for the new, somewhat risky venture back into newspaper syndication. And, of course, he was needed to do the Art Director chores at the DC offices. Too bad he couldn't stay on the feature; in the long run, it may have been a far better newspaper strip if he had been able to keep that assignment.

In the year 1968, Kinney Services merged with National Periodicals Publications (DC) and renamed the new corporation Kinney National Services, Inc. (Shortly after, in 1969, the company bought Warners-Seven Arts Limit-

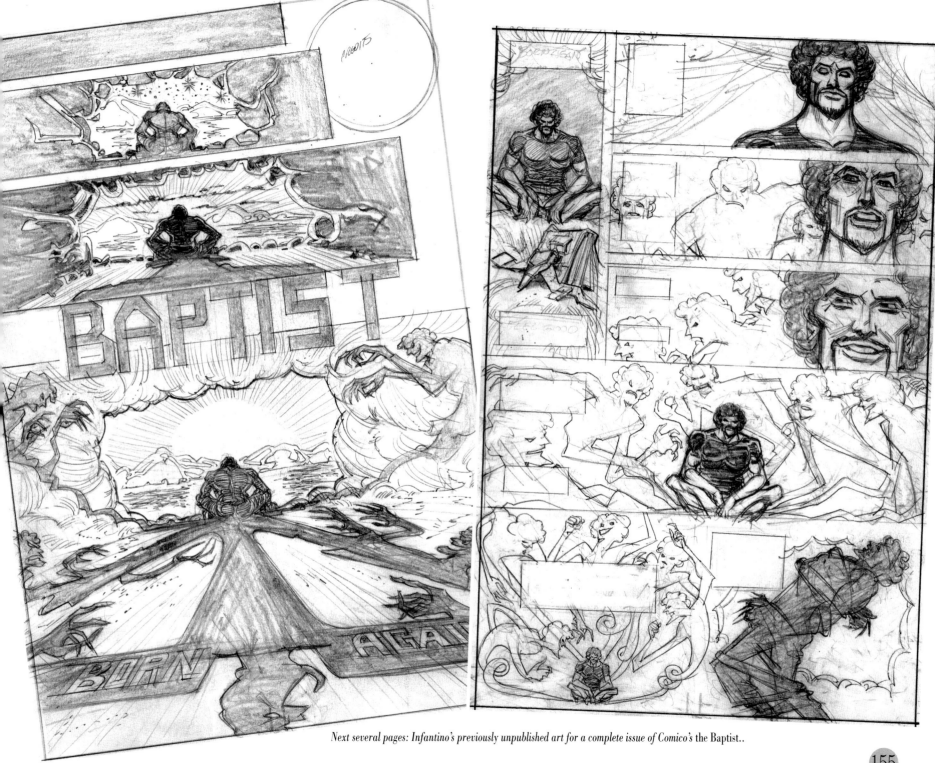

Next several pages: Infantino's previously unpublished art for a complete issue of Comico's the Baptist..

Stalker # 2 1975 the Ditko-Wood-Levitz-Orlando project, Stalker was just one of the grand projects launched in Infantino's last year as DC's Publisher

ed, which eventually was to beget the current monolithic AOL/Time-Warner, the largest communications conglomerate in the world). Indirectly, it caused Carmine to become Editorial Director of National Periodicals. Jacob (Jack) S. Liebowitz became Chairman of the Executive Committee of the new corporation, and was only nominally at the DC offices. For whatever reason, Editorial Director Irwin Donenfeld left the company, leaving DC Comics with a big hole to fill. Hence, Carmine was chosen to fill that great void. It was the logical choice.

As Editorial Director, Carmine began to prove his creative worth to the industry. In the ongoing newsstand war with Marvel, Carmine started a plethora of "daring and different" titles, most of which started with a launch issue in the on-going *Showcase*: He saw the birth of *Beware The Creeper* by Steve Ditko. He helped Howie Post re-plot *Anthro*. With *The Hawk and The Dove*, there goes a little story: Carmine had this concept of two brothers — one good, one bad — but he just couldn't come up with the right handle. Then one night, while listening to the news on the radio, he heard something about the Vietnam Conflict then raging in Southeast Asia, something about "hawks and doves." At that moment, everything gelled, and he called Steve Ditko that night. *Angel and the Ape,* he had little to do with this title, except enjoying E. Nelson Bridwell's scripts and loving Bob Oksner's art. Unfortunately, DC was caught in a pitched battle with the burgeoning, unceasing Marvel domination of rack space, and the new series all had rather short runs.

Along with long-time staffers Joe Kubert and Mike Sekowsky, Carmine brought in Dick Giordano and Joe Orlando and used all of these accomplished artists as editors. Realizing that DC Comics had been using primarily editors with a literary background, he had the gut feeling that the company also needed several editors with an artistic background, because comics are, after all, a graphic medium.

Joe Kubert edited "Sgt. Rock" and other war books. Mike edited *Wonder Woman, Supergirl* and other titles. Dick oversaw *Aquaman, Teen Titans, Beware The Creeper, The Hawk and The Dove, Witching Hour* and others. Joe Orlando restarted the teenage titles at DC with *Leave It to Binky, A Date with Debbi, Scooter, Binky's Buddies, Debbi's Date,* plus revitalizing such titles as *House of Mystery, The Phantom Stranger* and others. All this happened when Carmine was doing his regular strip assignments, as well as the layouts of almost all of the covers in the DC Comics line. When he had gotten far too busy doing everything else, he brought the team of Ross Andru and Mike Esposito in to draw *The Flash* and a Superman series; and had Irv Novick transfer his talents from the war titles, and — with veteran newspaper strip artist Frank Robbins—they helped revitalize the Batman titles.

INSTRUCTIONS FOR TWO-PAGE SPREAD

Jack Kirby on Infantino

Carmine was and is a fine artist. Joe Simon and I used to have an apartment. All the guys got together and I think we helped each other. That was the main purpose back then as none of us had a school; we became each other's school. There were things that Carmine knew that I didn't. It was an exchange and that's basically how artists learned back then. We took standards from each other.

I think that [Carmine] hit on the right gimmick (with "Strange Sports Stories"). I feel that sports books are the toughest books to do. To do it in the first place is a challenge. To do it effectively (as Carmine did) was an achievement of some kind.

[DC is] a different company today [run by Carmine] the right executive to revitalize the company. Over here [with Carmine at DC], I have the chance to go beyond [the limitations I encountered at Marvel].

—From interview in
Comic and Crypt #5, 1971

Carmine, plotting along with Denny O'Neil and Mike Sekowsky, changed the look and emphasis on *Wonder Woman* by killing off Steve Trevor and introducing I Ching (which incredibly brought up the sales of the initial issues up to a 60% level). After about three issues, he left the plotting to Mike and Denny, his schedule becoming far too hectic. With *The Secret Six,* he just asked E. Nelson Bridwell for the same suspense and mystery as was being done on the hit TV series *Mission: Impossible* and to keep the identity of the leader a secret — even from Carmine! (Carmine also came up with the gimmick of the first issue's action starting on the cover.) Carmine penciled the origin story of "Deadman" and was involved with the plotting of a few subsequent stories on that series. His pattern would be to be intensively involved with launching of new titles, then rely on the creative team to carry on the titles.

When Jack Kirby left Marvel and came to DC in mid-1970, he requested the entire Superman line to edit, write, and pencil. While Carmine had great respect for Jack's talent, his business side nixed that idea. Instead Carmine gave Jack *Superman's Pal Jimmy Olsen* and Jack converted his ideas into the other three "Fourth World" titles — *New Gods, Forever People,* and *Mister Miracle.* When Jack needed a replacement title when the Fourth World titles ended, Carmine sent Jack a note suggesting a decimated future Earth, impressed by the visuals and concepts in the film *Planet Of The Apes,* but the hero of the book should be a boy. Jack took the name Kamandi from an earlier aborted attempt at newspaper strip syndication, circa 1956, called *Kamandi of the Caves.*

Somewhere around early 1971, all of the publishers would be forced, due to rising cost of paper and printing, to raise the cover price of comics from 15¢ to a higher price, and DC led the way. Instead of just increasing the cover to 20¢ from 15¢, DC decided on a 25¢ cover price, raising the interior page-count to 48 by adding another 16-page signature. Initially the extra pages were to be used for old (hopefully Golden Age) reprints. Marvel followed DC's lead, and produced 48-page comics for a quarter.

But Marvel didn't have the long-term resources in reprint material. And, crafty as

Above: The DC 100-Page Super Spectacular *is one of Infantino's many format innovations*

can be, Marvel Publisher Martin Goodman switched, after two months, back to the 32-page package, at the new 20¢ price. However (and here comes in the craft), Goodman cut the Marvel price to the retail dealers back to only 50% (the standard rate for distribution of comic books had always been 60%), leaving DC and the rest of the industry hurting. DC was shortly thereafter forced to bring the line back to the 32-page package priced at 20¢, and eventually compete at the 50% level. (Don't forget that direct sales was in its pre-infancy.) Marvel's tactics were and are to produce enough material to dominate the field. The comic book business has always been competitive, but this move by Goodman made it a far more cutthroat business.

In 1971, Carmine was trying some new formats for the growing fandom that was first really starting to make an impression on the comics market. He was sure that the concept of the larger, longer format he tried in the three *DC 100-Page Super Spectaculars* at a price of 50¢ was a sure winner. Without any real figures, he instituted the 100-page format for several on-going titles. (They were, for the most, annuals for the DC line; with the institution of the distributor's higher fee, the 100-page magazines went up to 60¢.) Then the initial sales figures came in on the 100-page packages at a dismal 38% sell-through! Carmine was so unsettled that he had so miscalculated what he thought the readers wanted, he almost immediately brought the 100-page comics back to the old regular size and price; but then came in the actual final annual results. Despite all the predictions according to the pundits in the field, the original numbers were way off. Overall finals were all in the 50% region. Unfortunately, due to numerous other factors, it was too late to go back to that format. Such are the dangers of publishing comics.

The year 1971 was an interesting year, all right! Mainly because it had basically became a war between DC and Marvel at the newsstands, with Gold Key, Archie, Harvey, and a few smaller comics companies somewhere in the battlefield. (Now, this following bit of information comes from hearing it from several different sources during my career in the comics, and Carmine has only third-hand or fourth-hand knowledge of it). I have heard that someone at Kinney/Warner had approached Stan Lee with a proposal about his leaving Marvel and becoming Publisher at DC. (If so, they would have taken the quintessence of Marvel — Jack and Stan — and left Marvel rudderless in a very big ocean.) I don't know Stan's actual answer to that offer, but I believe it was along the line that he had a long-term contract with Marvel and no thanks. Whether or not it was true, somewhere in the middle of the year, one of Carmine's friends who was one of the executives from Warner, V.P. Marc Iglesias, told Carmine that President and Publisher of DC Paul Wendell was too busy and had no trouble in giving up the position of Publisher to Carmine.

Mark Waid on Infantino

Carmine's inimitable impact on the comics medium is well documented, if impossible to estimate generously enough. If you lined up all the professionals who've been substantially influenced by his tremendous body of work, you'd be counting heads for days. And I'd help you... except, despite the fact that I'm a writer and not an artist, I'd be standing in line myself.

Growing up, nothing ever drew me faster into a comic book than Carmine's work. His unique, outstanding covers, his incredible splash pages... Carmine taught me from a very early age that Job One is to grab the reader's attention with images he's never seen before, and I've never forgotten that, not once in the 300+ times I've sat down before the keyboard at this job.

To this day, his artwork sparks my imagination and commands me to innovate... not imitate.

That was great, but there was no salary raise with the promotion. Carmine wasn't very happy with that situation. So, after some negotiating, starting with the cover-dated Sept. 1971 issues of DC Comics, Carmine officially became Publisher.

Carmine's primary course of action in his new position was to curb Marvel's lead that had been building up since the late '60s, and to put DC Comics ahead. In 1972, DC Comics (and I quote from Carmine) "didn't lose any money that year." And again, in 1973, but other things happened. In that year, Paul Wendell, President of DC and a Vice President at Warners, was fired. He took his possessions, said his good-byes, and just left. Carmine suddenly found himself President of DC! It was nice to have the title, but it didn't change his emphasis on his job.

In 1974, sales from comics did very well, with DC's sales finally coming neck-to-neck with Marvel. Still trying new formats for the current comic book, he instituted the $1.00 tabloid-size series, which consisted of Golden Age reprints, and sometimes collections of newer material. But something much more important was happening: the *Superman* movie! As best Carmine can remember, the initial script by Mario Puzo had Superman trying to stop the assassination of the Pope; and a scene in which Superman was on a worldwide search for Lex Luthor, during which he swoops down on a bald man, who turns out to be Telly Savalas sucking on his trademarked lollipop, uttering to the Man of Steel, "Who loves ya, baby?" The memory of that screenplay has faded with the years, but Carmine recalls it was definitely not acceptable.

In the first of many trips to California, Carmine, writer Puzo, and the producers Salkind spent many a working day together at a hotel room in Beverly Hills forging out the essentials of the soon-to-be lensed movies. The original idea was to film both *Superman* and *Superman II* back-to-back, non-stop, as they had filmed *The Three Musketeers* and *The Four Musketeers* a year or so earlier. In fact, Carmine was asked in advance to view both *Musketeers* films and see if the producers, Alexander and Ilya Salkind, were up to the task of making the Man Of Steel really fly on the big screen.

In the final version, seven Phantom Zone super-villains escape, each of the bad guys wreaking havoc on the populace of the seven continents (I think Zod got Antarctica), and Superman has to stop them. Obviously, the filmmakers truncated the threat in the final version, due to cost. Carmine never got paid for his services nor any screen credit for his efforts (despite promises to be credited). He consid-

Christopher Reeve in the role that Carmine made possible with his involvement in the making of Superman the Movie.

ered the work as part of his job as President and Publisher of DC Comics.

In 1975, even though Martin Goodman had sold Marvel a couple of years earlier to another company, Marvel started to once again give DC conniptions. Early in the year, the major printer of comics in the U.S., World Color Press — those folks in Sparta, Illinois — came to Carmine's office to warn him that there might be some trouble with the supply of paper in the upcoming year. It seems Marvel had reserved presstime for their projected 60 titles a month — significantly higher than Marvel had printed the previous year. So, in an effort to keep the major competition from totally dominating the market and keep the rack space that his job said he was to protect, he set out to match output comic book-to-comic book, meeting Marvel's challenge at all costs. Neither Marvel nor DC made any profit that year from publishing (although DC did make money out of licensing their characters).

Besides his ongoing part in Hollywood, Carmine was constantly meeting distributors, making cover sketches, leading editorial meetings, etc.

At the 1975 year-end budget meeting for DC's expenditures for the forthcoming 1976 plan, one of the executives complained about the terrible 1975 losses. Carmine explained they had to fight Marvel tit for tat at the stands, or DC was liable to lose rack presence. The Hanna-Barbera TV cartoons and upcoming *Superman* movie, plus the various licensing fees, should easily ease that loss. But the executive complained to Carmine, "Don't you care that you *lost* money?" This insult upset Carmine so much that he sent a memo to the executive telling him how wrong he was, and Carmine hoped that would settle the matter.

Carmine continued his duties, and on January 19, 1976, he returned from California, where he was promoting the newly-released first DC-Marvel special, the tabloid-sized *Superman vs. The Amazing Spider-Man* edition. He was told by a different Warner executive that they "no longer agreed with his position." Very well. Carmine took his possessions and just left, very much like his predecessor in the position of Publisher and President of DC Comics, Paul Wendell. Only this time they lost a needed creative force that was difficult to replace; perhaps they never really did.

In the preparing of this article, I've called Carmine numerous times to verify these facts, those dates. During one of the conversations, I asked him, "By the way, what was the ending of that anecdote about the efficiency expert?" He replied, "I told the expert that he didn't have to know how I did it; I just did it!" Which makes all the sense in the world: Artists do art, and great comic book artists make great comic books.

Infantino's unpublished art for Comico's the Baptist.

Infantino's unpublished art for Comico's the Baptist.

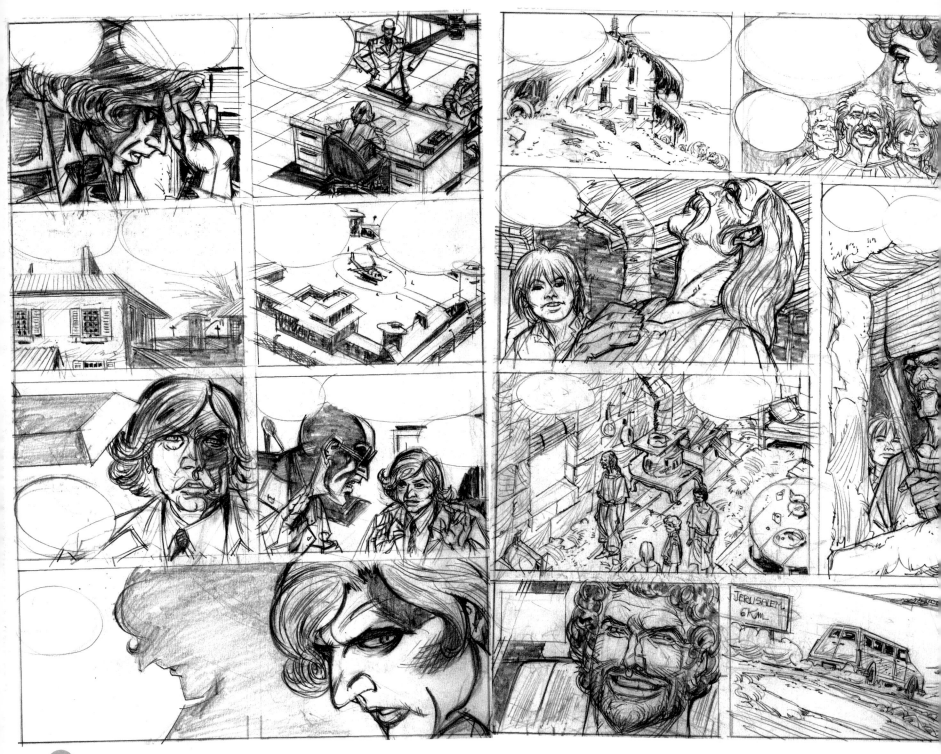

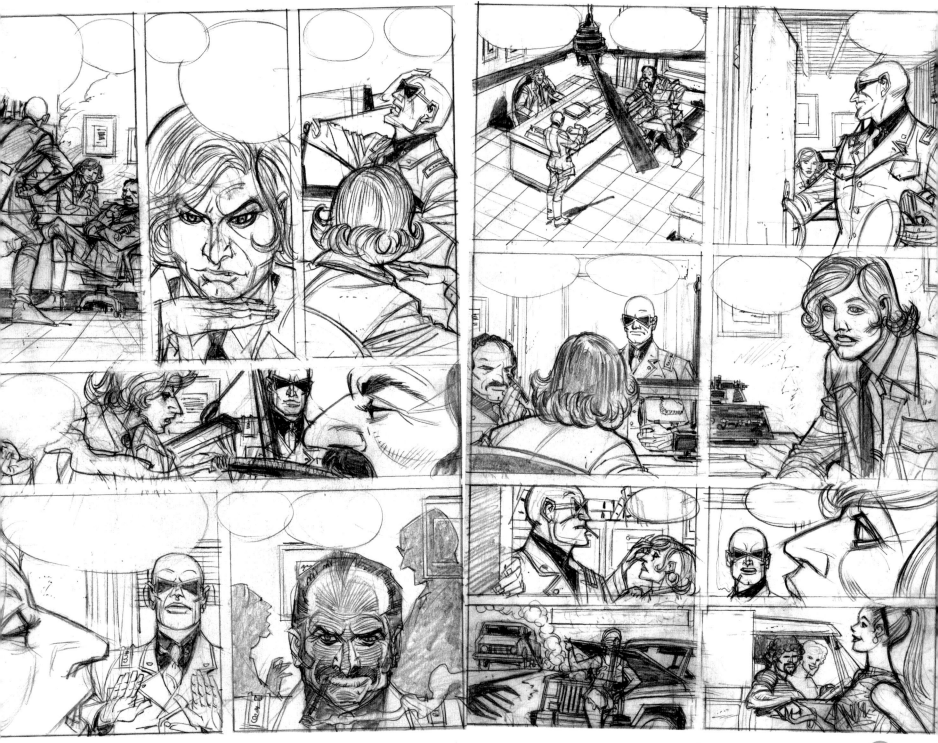

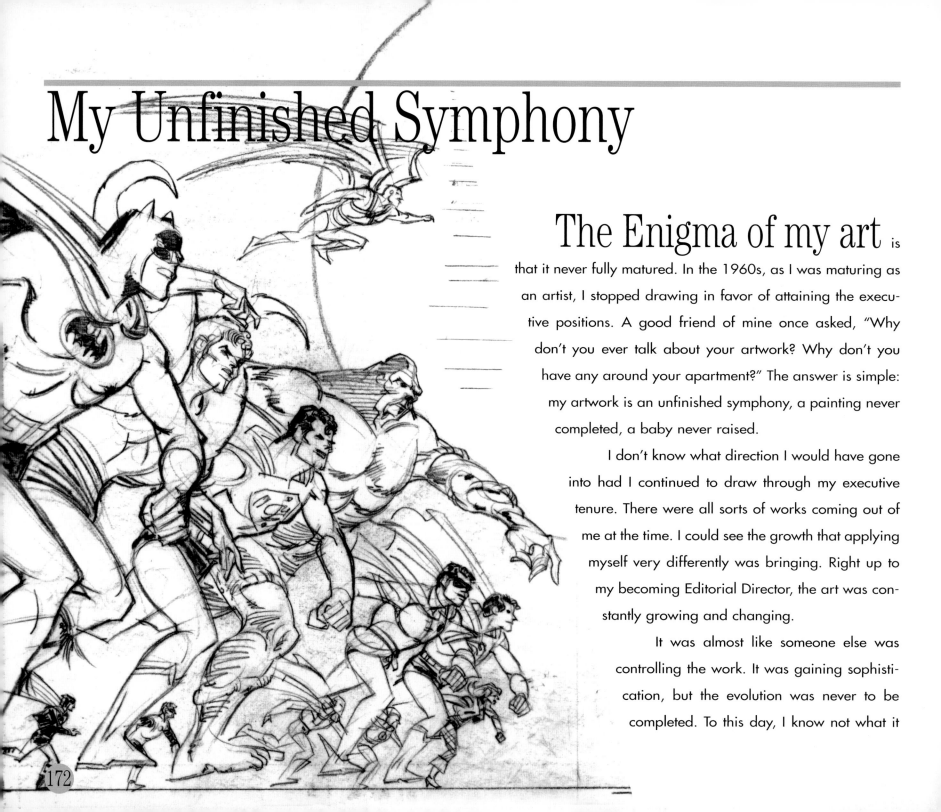

My Unfinished Symphony

The Enigma of my art is

that it never fully matured. In the 1960s, as I was maturing as an artist, I stopped drawing in favor of attaining the executive positions. A good friend of mine once asked, "Why don't you ever talk about your artwork? Why don't you have any around your apartment?" The answer is simple: my artwork is an unfinished symphony, a painting never completed, a baby never raised.

I don't know what direction I would have gone into had I continued to draw through my executive tenure. There were all sorts of works coming out of me at the time. I could see the growth that applying myself very differently was bringing. Right up to my becoming Editorial Director, the art was constantly growing and changing.

It was almost like someone else was controlling the work. It was gaining sophistication, but the evolution was never to be completed. To this day, I know not what it

was to have become. Or it might not have grown any further. Considering I was working in the commercial medium of comics, it could have stopped quite naturally at that point.

Toward the end, I was enjoying every challenge that came along. At DC, when they asked me to do a cover, I'd create it from the ground up. When I'd take on a story like "Deadman," it was my vision. Artistically, anything I touched could go in a different direction. It was no longer about learning the trade; it was now about innovation, following the muse, and it had become something I really enjoyed.

It was ten years later that I returned to freelance art! I was focused on Hollywood then. With some entertaining exceptions, my comic book art had become busy work. I'm not

lamenting the creative loss; nobody forced me to stop drawing. When the staff position was offered, I was quite enthusiastic. Marvel wanted me in their most exciting period and had all the work I might ever want. I made the decision to go corporate and it was glorious, captaining such a ship — its sole mission, adventure. But what direction my unfinished symphony might have taken remains a mystery.

Good Night.

I want to thank all the comics fans who have shared adventures with me over the years. And I really want to thank all the wonderful artists, writers, editors, and staff that I worked with. They were all great and I enjoyed every minute with them. They made my job a joy. I also want to share my grateful thanks to Jon B. Cooke, Arlen Schumer, and especially J. David Spurlock for their magnificent efforts in creating this voluminous chronicle. We'll finish with an ancient quote attributed to Solomon: "To everything there is a season, and a time for every purpose under heaven: a time to be born, and a time to die; a time to sow and a time to reap. A time to weep, and a time to laugh; a time to mourn, and a time to dance; A time to cast away stones, and a time to gather stones together."

Thank you all,

Opposite: Neal Adams' portrait of Carmine Infantino. Below: Carmine drew these head shots of his most memorable DC characters for the Infantino tribute issue of The Amazing World of DC Comics in 1975. It was recently released as a limited edition, signed and numbered, color print by the Warner Bros. Studio Stores.

Afterword by Steranko

Style.

In the world of art, from fine art to commercial art, style is often a primary element in the realization of a creative work. From the viewer's perspective, the perception of that style is frequently the key factor in the success or failure of the work — or more precisely, of its acceptance or rejection.

Comic art has always leaned heavily on the aspect of style to sell its content, whether as fantastic as a galactic invasion from another dimension or as mundane as a romantic interlude on a living-room sofa. In the past few decades, many comics have sown the seeds of their own destruction by predicating their appeal entirely on style, rather than content. While the approach may be reasonable for artists who concentrate on solitary images (such as LeRoy Neiman and Peter Max), it is inappropriate for comic illustrators because the foundation of their medium is narrative and linear, rather than singular and monolithic. No comic artist has observed that tenet better than Carmine Infantino in any phase of his long and productive career. It would not be unreasonable to relegate his comics work into either of two areas: the first, in which his style is based on that of other artists (such as Milton Caniff, Noel Sickles, Robert Fawcett, and Albert Dorne) and the second, where his creative statement is essentially his own. The first, a period of learning and experience; the second, one of intensely personal expression.

To Infantino's credit, he rarely, if ever, allowed the idiosyncratic style he ultimately developed — the bold use of negative space, heavy reliance on floor-level shots, minimalist patterns and textures, and a lively, energetic line — to obscure the stories he told. A consummate craftsman always in control, Infantino relentlessly made his style serve the material. Even through the crushing demand of long-running series, his work appeared fresh and vital, often graceful and dignified, but never at the expense of dramatic power.

Under his guidance, Adam Strange conquered two worlds and a generation of loyal readers; the Elongated Man simultaneously stretched the boundaries of earthly physics and the comics form; and Barry Allen's alter ego revealed more artistic flash than dozens of other super-heroes combined. Infantino brought something rare, almost unique, to his four-color formula: An originality that did not violate comic tradition, but strengthened it — and with an authority of style that will endure the erosion of many decades yet to come.